HEALING
SCHIZOPHRENIA

HEALING
SCHIZOPHRENIA

*Complementary Vitamin
& Drug Treatments*

DR ABRAM HOFFER, MD PhD, FRCP (C)

CCNM
PRESS

Copyright © Abram Hoffer, 2004.
All rights reserved.

First Printing 2004.
Second Printing 2007.

The author would like to thank Bob Hilderley for editing this book.

The publisher does not advocate the use of any particular treatment program, but believes that the information presented in this book should be available to the public. The nutritional, medical, and health information presented in this book is based on the research, training, and personal experiences of the author, and is true and complete to the best of the author's knowledge. However, this book is intended only as an informative guide for those wishing to know more about good health. It is not intended to replace or countermand the advice given by the reader's physician. Because there is always some risk involved, the author and publisher are not responsible for any adverse effects or consequences resulting from any of the suggestions made in this book. And because each person and each situation is unique, the author and the publisher urge the reader to consult with a qualified healthcare professional before using any procedure where there is a question as to its appropriateness.

ISBN 1-897205-08-4

Edited by Bob Hilderley.
Design by Sari Naworynski.

Printed and bound in Canada.

Published by CCNM Press Inc., 1255 Sheppard Avenue East,
Toronto, Ontario M2K 1E2 Canada.
ccnmpress@ccnm.edu

CONTENTS

Introduction	7
So You Have Schizophrenia ...	22
What Are the Symptoms of Schizophrenia?	37
What Causes Schizophrenia?	79
When Does Schizophrenia Begin?	122
How Can Schizophrenia Be Treated?	148
Who Will Be Treating Me?	184
Can Schizophrenia Be Prevented?	198
HOD (Hoffer-Osmond Diagnostic) Test for Schizophrenia	203
Recommended Reading	210

INTRODUCTION

Healing Schizophrenia is an extensively revised and up-dated version of the book *How To Live With Schizophrenia*, previously written in collaboration with Dr Humphry Osmond and edited by Fannie Kahan. The book went through several editions, first published in 1966 in England by Johnson Publications with a foreword written by The Right Honorable Christopher Mayhew, M.P., then in America by University Books, and later by Citadel Press, with a foreword by Professor Nolan D.C. Lewis, Emeritus Professor and Chair, Department of Psychiatry, Columbia University. Over 100,000 copies were sold.

"This is a brave book on many counts," Christopher Mayhew wrote in his foreword to the first edition. "It is addressed directly and intimately to schizophrenic patients as a group, which will shock some people. It strongly attacks the traditional approach to schizophrenia. It also commits itself to a specific form of treatment which, as the authors themselves acknowledge, is not yet completely accepted." As Dr Nolan D.C. Lewis recognized in his foreword to the third edition, "This is a unique book in two ways. It is the first book written for the schizophrenic patients, instructing them in what attitude they should take to live with the disorder. Secondly,

the authors have accomplished the difficult task of presenting a picture of the whole problem that is longitudinal in perspective, utilizing only those terms that can be readily understood by the general reader."

We wrote the first edition of the book upon the invitation of the publisher of Johnson Publications, Dr D. Johnson, a Member of Parliament in England, who had himself suffered from an undiagnosed psychosis and who coined the term 'hallucinogen' when he began to research the cause of his illness. Our motivation was to write a book for schizophrenic patients and their families that would explain in simple terms the nature of schizophrenia and recommend an effective treatment. Families of schizophrenics had no place to turn for information except for the old psychiatry textbooks that gave frightening descriptions of chronic patients and offered no or little hope for recovery. Compounding this problem of lack of information was the practice of many psychiatrists of not telling patients and their families anything about the disease because they believed the diagnosis of schizophrenia in itself would be harmful.

Despite the promise of *How to Live with Schizophrenia* for educating the public about this disease and for providing patients with the hope for recovery, there is still a need to continue the effort 40 years later. Hundreds of other books have been published about this disease, schizophrenia societies have been formed as support groups in many communities, the internet has made vast amounts of research available, and the disease has received sympathetic presentation in the Oscar Award winning movie *A Beautiful Mind*. Despite this attention, even the most optimistic psychiatrists claim that only 10 percent of patients treated will recover. The prognosis today is not much better than it was 40 years ago. While many patients in the 1960s could look forward only to a life in a mental hospital, locked up for public safety, today they are being tossed from the hospitals onto the streets, their symptoms heavily medicated. *Healing Schizophrenia* offers the promise of not only the successful treatment of most cases of schizophrenia, but also the possible prevention of the disease.

In writing and now revising this book, I wanted to provide schizophrenic patients and their families with clear information and, just as importantly, hope. Neither of these comforts was available when we first wrote *How to Live with Schizophrenia*, and, unfortunately, they are still

lacking today. Psychiatry was a closed book then, a sort of secret society. Psychiatrists did not provide the public or their patients with information about this disease. Psychiatry followed the declaration of eminent psychoanalyst Dr Karl Menninger, that any psychiatrist who told his patients they had schizophrenia was doing them a major disservice, since this knowledge would undoubtedly aggravate their condition and make it harder to treat them. Psychiatrists would not discuss diagnoses with their patients and would not talk to their relatives, since they considered the families a source of the problem and therefore enemies of the patient and the doctor. Psychiatrists did not see the family as a source of support for their patients in the treatment process. There were no schizophrenia societies equivalent to cancer or mental health societies. And because patients with schizophrenia seldom recovered under psychiatric treatment, telling them they had this disease was equivalent to telling them they had something as dreadful as syphilis. No one believed that there was any hope for recovery.

In the early 1960s, I was asked to look after a young boy with schizophrenia who had shot himself, missing his heart by about one inch. He told me that he had been treated in the Royal University Hospital in Saskatoon, Saskatchewan, on several occasions, but that no one had ever told him what was wrong. After being discharged, he saw his family physician a few weeks later. While the patient was in the office, his doctor was called to another examination room, and he did what every intelligent patient should do: he read his chart. There he learned that he had been diagnosed with schizophrenia. This was a surprise, but not a shock, since he did not know what schizophrenia was. When we got home he looked up the word in an old dictionary, which defined it as "a hopelessly incurable disease." He promptly shot himself. During my interview with him, I dispelled this myth, explained to him the nature of schizophrenia, and told him how we would treat it. He lost his fear and did indeed recover.

I decided that patients with schizophrenia should be told what they had in the same way that patients with appendicitis would be given their diagnosis. Because I had been trained in the "Do Not Tell" school of psychiatry, I approached my first patients with some trepidation when I decided I would tell all. The responses of the first two patients I told assured me I was doing the right thing. The first case was a young boy who was accompanied by his mother. After I had diagnosed him, I told his mother he was

suffering from schizophrenia, and then I added, "You did not make him sick." She began to cry. When I asked her why she was crying, she replied that I was the first psychiatrist who had not blamed her for her son's illness. The second patient was a teenaged boy who was both alcoholic and schizophrenic. His priest accompanied him to my office. I told the young man that he had schizophrenia, explained his illness to him as a biochemical disease, and explained how I would treat it. Later, his priest told me that he had asked the young man what I had said to him when he returned to the waiting room. "Dr Hoffer said I have schizophrenia," he replied. "I don't know for sure what it is, but I sure feel better after talking with him."

"Not knowing" is one of the most dreadful feelings any patient can experience. But simply informing patients that they have schizophrenia – without an explanation and without any hope of treatment – would be futile. In every case I have since treated (now at least 4,000 patients), I have advised my patients of the diagnosis, followed that up with a description of this condition (as a biochemical disease), then I have offered the hope that if they follow the recommended treatment, they will have a high probability of recovery.

The structure of *Healing Schizophrenia* follows this pattern. First, we remove the stigma from schizophrenia, letting everyone know this disease is not only common, but also understandable. Next, we describe the symptoms and analyze the various causes of schizophrenia, providing a comprehensive biomedical explanation. Then, we outline a program for treatment based on this biomedical model, finally providing recommendations for preventing this disease.

The primary treatment we recommend is founded on the principles of orthomolecular or nutritional medicine, which Dr Osmond and I developed in the 1950s and which Nobel laureate Dr Linus Pauling championed soon after he read the first edition of *How to Live with Schizophrenia* in the 1960s.

Trends in Treating Schizophrenia

Enthusiasm for treating schizophrenia has waxed and waned over the past 50 years, and depends entirely upon the expectations of the psychiatrists. Until 1950, their expectations were nil; the previous 50 years had convinced them that nothing could be done. For this reason, they were content to warehouse patients in large institutions far from home. These were generally out of sight but were usually surrounded by grounds that were beautifully

maintained. There was a deliberate attempt to conceal from the public what was going on inside these institutions.

I still recall vividly an episode that occurred when I was about 15. My parents were visiting a cousin of mine who had been a long-time resident at the Saskatchewan Hospital at Weyburn. My brother, sister, and I went along with them. At the hospital, we entered a very imposing front hall, with a wide, graceful staircase leading to the second floor. On the right was a private dining room for the superintendent's personal use, where he entertained friends and visiting politicians. On the left was the superintendent's large office with its private bathroom. We were all very impressed. We were ushered into a small waiting room while the staff went to fetch our cousin. We waited and waited; I think it was at least an hour or more. Eventually, our cousin arrived and we had our visit. But the long wait puzzled me, and continued to puzzle me until I began to visit Dr Osmond at the same hospital. He told me that the previous policy had been that no visitors were allowed to visit on the wards, since they were too awful to be seen by the public. When the nurses went to bring our cousin, they first had to give him a bath and then clothes, so that we would not see him in his usual hospital garb, which was dirty and torn. After our visit, he would have been returned to the ward and given back his rags – the better clothing removed, presumably, for the next visitor. The first major step forward in reforming the Saskatchewan hospital system was to throw those wards open to the public, who afterwards would no longer tolerate that kind of patient care.

Attitudes changed around 1950. Psychiatry became more optimistic about treating schizophrenia. There was an influx of physicians into psychiatry and psychoanalysis, and dynamic psychotherapy became very influential, eventually spreading throughout the field. Also, insulin coma and ECT (electroconvulsive therapy) had proven that patients could get well, even if their improvement only lasted months rather than years.

But the main factor in the change of attitude was the introduction of tranquilizers. This began when a French surgeon showed that anti-histamines were remarkable sedatives. Tranquilizers, for the first time, provided a method for calming schizophrenic patients by cooling their hot symptoms. Suddenly, all of the psychosocial theorists came into their element. It is impossible to do psychotherapy with an agitated, paranoid patient who is concentrating more on voices only he can hear than on the voice of

the therapist, or to discuss problems with a patient so depressed she cannot even talk or listen. The same patient, on tranquilizers or anti-depressants, was now cool and could participate in psychotherapy. Soon, armies of psychiatrists, psychologists, and social workers were happily giving psychotherapy to tranquilized patients. Drug companies quickly promoted these drugs as aids to psychotherapy, and a wave of enthusiasm swept through the field.

In reality, however, it was a wave of over-enthusiasm, which was not warranted by the facts, and which led to a mass migration of patients from institutions to other places, including the streets. Today, perhaps half of the homeless in North American cities are former mental patients, most of them having been discharged from the hospitals. On tranquilizers, with or without psychotherapy, patients are better – their symptoms cool down – but they do not recover. A revolving-door phase of therapy resulted, with patients having multiple admissions. With each admission they would be put on tranquilizers, would cool down, and would then be discharged. After discharge most would discontinue their medication, would relapse, and would then have to be re-admitted.

Now a counter-reaction has set in. Prominent psychiatrists who enthusiastically supported de-institutionalization are now equally vocal in descrying it as a bad plan. However, negativism is returning to psychiatry, and most psychiatrists today are content if their patients are getting by in the community on medication, and are not in hospital. They do not see any recoveries, nor do they expect to see them.

Orthomolecular psychiatrists such as I do see recoveries and expect many more. Our attitude is much more optimistic, and this feeling is transmitted to patients and their families. Optimism by itself will not cure, but it will ensure that patients keep on their therapeutic programs; and if the family is optimistic, they will be much more patient. It is just as important to treat patients with cancer optimistically. One of the main complaints I hear from patients about cancer clinics is that they always leave there feeling worse than before they went in. A recent patient complained to me that she left the clinic convinced they were preparing her for death. Schizophrenic patients do not complain about this, probably because they have never had any psychiatrist treat them with any hope or enthusiasm, but their families do.

Orthomolecular Psychiatry

By orthomolecular psychiatry I mean the use of optimum (often large) doses of molecules naturally present in the body to treat poor health and to promote good health – specifically mental health. In his fundamental article on "Orthomolecular Psychiatry" published in *Science* magazine in 1968, my colleague Dr Linus Pauling stated that "orthomolecular therapy, consisting of the provision for the individual person of the optimum concentration of important normal constituents of the brain, may be the preferred treatment for many mentally ill patients." Elsewhere, he has defined orthomolecular psychiatry as "the achievement and preservation of mental health by varying concentrations in the human body of substances that are normally present, such as vitamins. It is part of a broader subject, orthomolecular medicine, an important part because the functioning of the brain is probably more sensitively dependent in its molecular composition and structure than is the functioning of other organs."

As Dr Pauling explained in his study of orthomolecular nutrition in his celebrated book *Vitamin C and the Common Cold*, the human body has lost its ability during evolution to make certain nutrients. This precept is the basis of my two books on nutrition, *Orthomolecular Nutrition* and *Hoffer's Laws of Natural Nutrition*, as well as my book on children's nutrition, *Healing Children's Attention and Behavior Disorders*. About 20 million years ago, man, other primates, the guinea pig, and an Indian fruit-eating bat lost the ability to make vitamin C, Dr Pauling argues. In my opinion, man is going through a process right now where we are losing the ability to make vitamin B-3 from tryptophan. People suffering from the various schizophrenias are a group who have gone far in this direction. As diets have become less natural, more high-tech, the amount of vitamin B-3 has been lowered, and those people who no longer have the machinery for converting tryptophan into the vitamin are becoming sick. I have been convinced for a long time that if we were to add 100 mg of vitamin B-3, in niacinimide form, to our diet, there would be a major decrease in the incidences of schizophrenia, as well as many other diseases, such as hyperactivity and learning and behavioral disorders in children.

Another colleague, Dr Bernard Rimland, author of *Infantile Autism*, further explains the meaning of orthomolecular and contrasts the practice of "orthomolecular" medicine with "toximolecular" medicine: "'Ortho'

means straight, or correct, and 'molecular' refers to the chemistry of the body. 'Orthomolecular' thus means correcting the chemistry of the body. To contrast the philosophies of establishment medicine and orthomolecular medicine, I have coined the word 'toximolecular' to refer to the common practice of trying to treat disease (or at least the symptoms of disease) through the use of toxic chemicals. It doesn't make much sense to me; it is dangerous, expensive, and not very effective. But it is profitable. Most vitamins are quite safe, in contrast to the drugs in widespread use, which can be, and all too often are, lethal in large amounts. Traditional medicine consists largely of giving lethal drugs in sub-lethal amounts, it seems to me. Orthomolecular psychiatry is not only much safer, it is much more sensible. Its emphasis on the use of substances normally present in the human really makes sense."

The practice of orthomolecular medicine thus recognizes that most acute and chronic diseases are due to a metabolic fault that is correctable in most patients by good nutrition, including the use of large doses of vitamins and mineral supplements. In sharp contrast, drugs are synthetics that are not naturally present in the body and for which the body does not have ready-made mechanisms for their destruction and elimination. They are called xenobiotics – that is, foreign molecules. And unlike conventional medicine, orthomolecular medicine recognizes the principle of individuality, recommending the optimum diet of nutrients for each of us. No two patients are the same; therefore, no two treatments are the same. Orthomolecular medicine requires the application of both of these principles: individuality and the use of optimum doses (large doses if needed) of vitamins, minerals, and amino and essential fatty acids.

During the early 1950s, my colleague, Dr Humphry Osmond, and I developed a unified hypothesis of schizophrenia that united biochemical and psychosocial factors. We suggested that in schizophrenia there was an abnormal production of adrenochrome, which acts on the brain much as does the hallucinogen d-lysergic acid diethylamide (LSD). Adrenochrome is one of the more reactive derivatives of adrenaline. Noradrenochrome is the derivative from noradrenalin. Over the next 10 years, our research group in Saskatchewan established that adrenochrome is in fact an hallucinogen, that the biochemical conditions necessary for its formation in the body were all present, and that using a compound that blocked its activity on

the brain was therapeutic for schizophrenia. That compound was vitamin B-3, either nicotinic acid (niacin) or nicotinamide (niacinamide).

In the orthomolecular treatment of schizophrenia, there have been two major changes over the past 40 years. First is the evolution of orthomolecular psychiatry from a simple treatment, using one vitamin to treat the disease, into a comprehensive holistic program, which includes the use of many different nutrients in combination with standard psychiatric treatment. The only unorthodox thing about this change is the emphasis given to nutrition and the use of nutrients in optimum doses. Over the past decade, nutrition has become more popular and less unorthodox in other fields, such as cancer therapy. Such acceptance has been slow in the field of psychiatry, however.

Second, schizophrenia is not a single disease as we once thought: it is a syndrome with each syndrome caused by different factors. This concept was foreshadowed about 100 years ago. Psychotic patients admitted into U.S. hospitals were either suffering from pellagra, general paresis of the insane, or dementia praecox. Often they were indistinguishable from each other. After the cause of pellagra was proven to be a nutritional deficiency, pellagrins were no longer called dementia praecox (later schizophrenia). The same thing happened to scorbutic schizophrenia and to G.P.I. schizophrenia. Eventually, pellagra almost vanished, as did scurvy, and penicillin destroyed the spirochaete causing G.P.I. As each syndrome's cause was identified, it was removed from the schizophrenias, leaving psychiatry with a hard core of mysterious, untreatable, schizophrenic patients.

Over the past 40 years, we have identified other schizophrenic syndromes. Our work with malvaria and kryptopyrrole was elaborated by Dr Carl Pfeiffer, when he gave the first clear clinical description of pyrroluria or malvaria. In time, every schizophrenic with kryptopyrrole in their urine will be called pyrolluriac, not schizophrenic, and treatment will be taken over by internists who are interested in metabolic treatments. Some of the other syndromes are cerebral allergies, vitamin deficiencies and dependencies, mineral deficiencies and toxicities, and a few rarer ones caused by drugs such as the hallucinogens. Each syndrome is caused by different factors, but as the clinical disease is the same, there is a final common pathway – a pathology that affects those parts of the brain which control perception and thinking. Each syndrome will require its own particular

treatment. There may be an overlap of several syndromes, for example, a combination of dairy allergy and a deficiency of vitamin B-6 and zinc.

Modern orthomolecular psychiatry is the product of the research and experiences of many clinicians, chiefly in Canada and the United States. Dr Osmond and I contributed the concept of the syndromes and introduced the concept of using optimum (large) doses of nutrients for diseases not considered to be vitamin deficiencies. The details of treatment will vary with different practitioners. The program I will outline in this book is the one I follow. I believe most of my colleagues will agree with these broad outlines, while they may differ on the details. Fortunately, orthomolecular psychiatry has not become fossilized, as psychoanalysis did during Freud's lifetime. We have always encouraged diversity and open-mindedness.

Throughout the past 40 years, orthomolecular treatment of schizophrenia has remained controversial, when not ignored. During the early 1950s, Dr Osmond and I were the first psychiatrists to use large doses of vitamins systematically to treat any disease, in this case vitamin B-3 for schizophrenia. Dr Irwin Stone, in his book *The Healing Factor: Vitamin C against Disease* (1972), later described large doses of vitamin C as "mega" doses. The term soon became popular. It played both a positive and a negative role in furthering the use of vitamins. On the positive side, it captured people's imagination, like the buzz words "megatrends" or "megabucks." The word was never scientific, nor was it ever defined. On the negative side, it created some confusion. Many people thought there was something called a "megavitamin." I have had patients come to me asking to be treated with these megavitamins, when they were already taking large doses. "Mega" meant large dose, but did not specify how large. A few critics, ignorant of the field, defined a megadose as a dose 10 times as large as those recommended daily allowances (RDAs) so beloved by government agencies and others. Some physicians were fearful of the term, which to them suggested the danger of mega toxicity. The result was a refusal by many health professionals to accept or even consider the validity of our research, and the effectiveness of orthomolecular therapy, for almost a whole generation. The ongoing attacks on Dr Linus Pauling following the publication of *Vitamin C and the Common Cold* were only the most celebrated examples of a concerted attempt by the medical establishment to

discredit orthomolecular medicine, despite the demonstrable success of our treatment of disease.

Since 1952, when we first used vitamin B-3 as a main component for treating the schizophrenias, I have supervised, as Director of Psychiatric Research, Psychiatric Services Branch, Department of Public Health, Saskatchewan, four double-blind controlled studies and many continuing clinical studies. We discovered that (1) the addition of vitamin B-3 to the treatment of schizophrenic patients doubled the natural or spontaneous recovery rate, but (2) it had no immediate effect on chronic patients, though we later discovered that vitamin B-3 treatment, in combination with other orthomolecular therapy, was effective for chronic schizophrenics. Since then, there has been massive corroboration by orthomolecular physicians, especially in the United States, Canada, and Australia; my colleagues and I have treated well over 100,000 patients since 1960. The clinical evidence of the effectiveness of orthomolecular treatment has been published in various medical journals, notably in the *Journal of Orthomolecular Medicine,* but seldom in the standard medical journals, because they have been consistently hostile to our ideas. This treatment is considered of no value by many psychiatrists. It is mistakenly judged as pernicious by some, and is unknown to most. "The American Psychiatric Association Task Force 7 on Megavitamins and Orthomolecular Therapy in Psychiatry" in 1973 effectively quashed any interest in the use of vitamins. Furthermore, because no drug companies own patents on the use of vitamins, they have no vested interest in promoting their use; the drug companies' main efforts go into promoting and nurturing their profits from the use of a variety of tranquilizers and anti-depressants. Contrary to traditional medical beliefs, orthomolecular psychiatry does not discount the use of drugs – especially anti-depressants – in the treatment of the schizophrenias; rather, we sometimes use tranquilizers to cool down hot symptoms, or anti-depressants to address allergies, while introducing vitamins and minerals and other nutrients that will eventually make such drug treatment unnecessary.

Case Study

Orthomolecular psychiatrists have reason to be hopeful in their treatment of schizophrenia. First, the treatment does work, despite the harping of

medical bodies and pharmaceutical companies. And second, an increasing number of health professionals and families are turning to orthomolecular medicine when faced with the failings of conventional pharmaceutical and psychotherapeutic treatments.

This sense of hope shines through the case history of two schizophrenic patients I treated in the 1980s, Faye and John, who suffered alone for many years, met each other, married, and now get on very well together. They each received the holistic, orthomolecular therapy I advocate in this book: every treatment component was important, but only after vitamin therapy did their lives start to come together again.

Faye came to see me in June 1984, complaining that she was run down and nervous. She was 50 years old. She had not been well from birth, but she told me she first broke down when she was six years old. Her mother told me there had been no breakdown at that time, but Faye could not get along with her teacher and was taken out of school. Two years earlier she had fallen on her face, smashing her nose. This was repaired, but she required more surgery when she was 15, and she remained sensitive about her appearance.

In 1962, she became very nervous after the birth of her son. She thought she was given a series of ECT. Following treatment, her parents took her back to Alberta to convalesce, but she did not recover and was admitted to an Alberta mental hospital for six weeks. In the following years, she had five more admissions, the last one for two months in 1981. In the meantime, her daughter was placed in a foster home because Faye was unable to care for her. Her general practitioner, in referring her to me, wrote that she was having evil thoughts: she was afraid she might hurt someone inadvertently, perhaps her mother.

A mental status examination revealed she had heard voices in the past, still heard herself think, and had been suffering from hallucinations. She was more concerned about her appearance and about people, whom she believed were very critical of her. Her memory was poor and her concentration faulty. She was bothered by depression, but she was not considering suicide. She weighed 161 pounds, having come down from 220 by watching her diet. She drank three glasses of milk daily, suffered many colds and sinus discharge, and coughed a lot.

I advised her to eliminate sugar and dairy products from her diet, and

added niacin (vitamin B-3) 1 gram three times per day, ascorbic acid (vitamin C) 500 mg three times a day, vitamin B-6 100 mg per day, and zinc sulfate 220 mg a day to the drugs she was already taking. Her medications included chlorpromazine 200 mg daily, imap 2 mg i.m. every week, and parnate 20 mg a day.

I saw her again in September 1984, by which time she had shown some improvement. Her skin was healthier, her sinuses were clear, her weight was now 150, her fears were gone, she was no longer paranoid, and her memory was better. The parnate was making her nauseous, so I asked her to discontinue it.

In mid-November, she was given a vaccination against the flu, and soon after began to suffer headaches. She became paranoid again, but had no hallucinations. She was admitted to hospital from December 24, 1984, to January 5, 1985. She remained on niacin and ascorbic acid, in addition to chlorpromazine 250 mg daily and imap. For the next three months, she was very disturbed. I stopped her imap and replaced it with another tranquilizer, fluanxol 40 mg i.m. every seven days.

In July 1985, she complained about how lonely she was, even in a group home. Her son and daughter visited her regularly. She was now convinced that milk made her sick, because whenever she had some she became nauseated. I started her on anafranil 50 mg before bed, but it made her worse, and was therefore discontinued. By August 1985, she was at last completely dairy-free. She was now receiving 500 mg per day of chlorpromazine.

On November 25, 1985, she told me she had missed two injections. She was confused and very paranoid. I admitted her to hospital until December 7, 1985. The fluanxol was stopped and she was started on madecate 25 mg i.m. weekly.

On May 14, 1986, her situation was much better. She was free of hallucinations, was not paranoid, and her mood was good. She was down to 150 mg of chlorpromazine a day. However, by August 1986, she was worse again, and had begun to see faces in the rug. October 30, 1986, I stopped her modecate and started haldol injections, 300 mg once a month. We switched her vitamin B-3 from niacin to niacinamide.

In July 1987, she remained nervous and restless, but she was much better. She had started to read about schizophrenia because she was worried about her son. She was also doing volunteer work, which she enjoyed. For

the rest of 1987 and 1988 she fluctuated, now and then being depressed or nervous, and sometimes having more hallucinations.

In January 1989, she was cheerful, and two months later, in March, she married Jim, a 48-year-old unemployed schizophrenic. They had met at the group home where they both lived. After they married, they began to look for an apartment of their own. Faye's chlorpromazine was now 250 mg per day. By August 1989, she still hallucinated occasionally.

At the end of 1989, I discontinued her parenteral haldol and gave her 10 mg per day of the oral haldol tablets. She learned to adjust the dose to control her nervousness, and by the end of 1990 was feeling stable. This patient had called my office at least three times a week for several years, but in December 1990, there were no calls until around Christmas, when she called to report she was getting on well.

Faye and Jim's marriage has worked out well. They support each other, and because they understand the illness, they are very tolerant of each other's symptoms. They remind each other about their medication and vitamins. I consider Faye much improved. That is, she is getting on well in the community, gets on well with her family, and is mostly free of symptoms. She is unable to work because her life has been disrupted too much, for too long, and she will require medical help for the rest of her life; but, she is content, often cheerful, and has established a new life with a man with whom she is compatible.

Jim first came to see me in June 1989, after he and Faye were married. Since then, I have seen them together about every two or three months. Jim had become sick during his teens. He had been in hospital at age 14 for eight months, again in 1973, and for the last time in 1977, when he was 36 years old. Since then, he had taken his drugs carefully. He was on parenteral modecate 25 mg every 10 days, xanax, chlorpromazine, and medication for high blood pressure. I added niacin and ascorbic acid, 3 grams of each per day, to his program. In December 1989, I decreased the niacin to 500 mg three times a day and added the same amount of niacinamide. In November 1990, he told me he felt like a "million bucks." He remained on his parenteral tranquilizer and vitamins. Their marriage was working out well.

No one expected them ever to marry, much less to enter into a happy, successful marriage. Schizophrenic patients, when sick, find it impossible

to have successful relationships. The fact that Faye and Jim's marriage is working out so well is another measure of how much they have improved.

Despite their remarkable improvement in health, Faye and Jim will be permanent charges of society, and rightly so, for they are victims of a psychiatric care system that seems incapable of accepting new ideas. Faye had been ill 22 years before I saw her; Jim had been ill since age 14. It is highly improbable either one was going to improve spontaneously. Both were expected to remain dependent and ill, with the occasional re-admission to hospital to adjust their medication. Ideally, Jim and Faye should not have had to wait so long before they were started on effective treatment, for Faye could have been started on vitamin B-3 when she first became ill. Jim, too, could have been started on treatment when he was 14. At the beginning of their illnesses, they would have responded much more quickly; they would have been spared an enormous amount of ill health, pain and suffering, and disruption of their lives. Society would have been spared the cost of looking after them for the rest of their lives.

Still, there is hope these ideas can be properly disseminated, which is the reason I wrote *Vitamin B-3 & Schizophrenia: Discovery, Recovery, Controversy* several years ago, and is why I am now releasing this book, *Healing Schizophrenia*. Schizophrenia is not a "dread" disease; schizophrenia can be understood; and schizophrenia can be treated, successfully. Schizophrenics, their families, and their friends have good reason to hope for recovery.

① SO YOU HAVE SCHIZOPHRENIA...

So you have schizophrenia ... Or you have a relative who has it. Schizophrenia is a long name for a disease that attacks many people all over the world. Babies may be born with it. Small children may get it. Adults of all walks of life and of all ages may have it.

You may find people with schizophrenia in your school. Or in your lawyer's office. Or in the barbershop. You may have coffee with a person suffering from schizophrenia every morning. You are rubbing elbows with them every day.

You may have heard of schizophrenia as a frightful mental illness with mysterious effects, which must be spoken about in whispers. In fact, years ago, schizophrenia was such a bad word that psychiatrists preferred to diagnose a person with schizophrenia as an immature personality – a depressive or a neurotic – to spare the family the terrors that the word evoked. Even today, many psychiatrists hesitate to use the word in diagnosis for fear of "labeling patients for the rest of their lives."

Schizophrenia actually is a very common disease that affects the whole body. The only mystery is that many people are still unable to recognize it as such. It is a disease like any other disease, with causes and treatments.

When you have certain symptoms, you go to a doctor expecting that he will examine you and make a diagnosis on the basis of his findings. It is the same thing with schizophrenia.

Common Symptoms

Perhaps you have been depressed for the past few months. For no good reason that you can think of you suddenly burst into tears, or you have moments of panic you can't explain. Your work no longer interests you. You are fatigued and miserable.

At the same time, you may be having frightening experiences, such as seeing flashing lights, noticing changes in people's faces, or feeling peculiar changes in your body. Something is happening to you and no one has been able or willing to tell you what it is.

Perhaps you are now taking tranquilizers and occupational therapy at a clinic? You are possibly making regular visits to your psychiatrist for deep therapy to "root out the source of your troubles buried in your psyche." Although you are willing to cooperate with your doctor to the best of your ability, you are frightened because you are not feeling any better, and you are convinced that you never will.

Or perhaps you have a close relative – a parent, or a child, or a sister or brother – who has, unaccountably, become very difficult to live with? Perhaps they have frequent outbursts of temper and moments of unreasonable suspiciousness? They sometimes say things that frighten you and do peculiar things that seem quite irrational to you. They may be receiving treatment for some vague 'nervous' or 'emotional' disorder, but you have noticed little – if any – improvement.

You or your family member may be suffering from schizophrenia. What can you do now? Where can you go for help?

Millions of people all over the world are faced with the same dilemma you face today. There is nowhere they can go for information. No one can tell you why you feel the way you do, or what you can do about it. Mental health associations in England, Canada, and the United States do not provide sufficient useful information to help schizophrenic patients achieve recovery. They are shy about providing this information because they believe that these patients cannot recover and they do not want to raise

'false hope'. Schizophrenia associations may provide information about schizophrenia and modern treatments, primarily the use of powerful tranquilizers, but they carefully avoid any reference to the use of natural methods, with nutrition and nutrients.

For you, for your relative, and for those with similar problems, we have written this book, full of information about the symptoms, causes, and treatments for schizophrenia.

When you have schizophrenia you are actually physically ill, but the symptoms are both physical and mental, for the disease has a specific affect on the brain. You may be fatigued, listless, or depressed. Your skin may change to a darker hue, and your skin and muscle tone may not be as good as they once were. Your eyes may have a glazed unnatural look.

You will find the chief changes occurring in the way you see, think, feel, and act. You may find that you have trouble judging time or distance. People and objects may change into many different shapes and do strange things; for example, you may see beds moving up the walls. Things may even feel different to the touch because your nerve endings are so much more sensitive than before.

Sounds may seem louder, and what may be ordinary noise to others may be deafening to you. The disease may have the effect of producing voices in your head or in your ears, telling you what to do. Because of these changes in seeing, hearing, and feeling, you begin to think and act differently.

Some people with schizophrenia feel that others are plotting against them and take steps to protect themselves. Some believe that they are in positions of high authority and act accordingly. Some feel brittle and believe they will break like glass, and so stay in one position for hours at a time.

These are some of the symptoms of schizophrenia, although every patient has degrees and variations of these, depending to some extent upon his or her own personality.

Schizophrenia has been with us from the beginning of mankind and the symptoms have not changed noticeably over time. In 1849, Dr John Conolly, a physician at Middlesex Lunatic Asylum at Hanwell, England, described a schizophrenic patient in his care during a lecture at the Royal College of Physicians in London:

> *He thinks every familiar countenance changed; he believes that sermons are especially addressed to him; he imagines that he hears voices warning him, or threatening him, or urging him to specific actions. He is sure that the popular authors of the day know all about him and write at him. His senses become disturbed, he sees lights shining in the sky, or appearances in the heavens. Sentences are written there, condemning him forever. He feels heated, and thinks the air is on fire, or that some magnetic influences are exercised over him; what he touches seems impure, and what he eats or drinks tastes of poison. He arms himself, or barricades his room; he cherishes secret plans of escape and distant travel; he suspects that his friends will intercept him, and, full of revenge, meditates their destruction.... . The countenance grows haggard; the eyes have an unnatural brightness and prominence, and the pupil is dilated or contracted.... .*

Until contrary evidence is produced, we must conclude that the disease is the same in every part of the world. The Italian schizophrenic has the same illness as the Russian schizophrenic. The schizophrenic in northern Europe has a counterpart in the schizophrenic in the United States. A Canadian psychiatrist walking into a Greek mental hospital will have no trouble picking out the schizophrenics at first sight. Of course, there will be some differences in the psychological mixture of the illness, depending upon the customs of the area the patient comes from – his tradition and religion – for the schizophrenic incorporates the attitudes and beliefs of his society into his psychological systems. The content of the delusion may be different, but the delusion of the schizophrenic everywhere may be of the same basic nature.

Dr Conolly noted that about 50 percent of his patients recovered naturally. The same recovery rate was published in the early mental hospital annual reports for Dorothea Lynd Dix hospitals in New York State at about the same time in the 19th century. These hospitals provided good food, shelter, care, respect for the patients, and time for them to recover.

However, we no longer see this natural recovery rate, except in primitive cultures that have not been in contact with modern high-tech societies. A recent study showed that while the disease appeared to be universal

in its distribution, schizophrenia was much more benign in less developed countries. When I started to treat schizophrenia in 1950, the generally accepted recovery rate was 35 percent. Despite the extensive use of drugs, the recovery rate today is less than 10 percent. Dr Ralph Aquila, at the Annual Meeting of the American Psychiatric Association held in Chicago during May 2000, found that in patients taking olanzapine, one of the most modern drugs, 11 percent were able to get back to work after an acute bout of schizophrenia, compared to 9.4 percent of patients treated with one of the oldest drugs, haloperidol. In other words, over the past 150 years we have 'improved' the recovery rate from 50 percent to the present 10 percent. Contemporary treatments for schizophrenia would seem to inhibit the natural processes of recovery.

Myths

Before we can begin to understand the causes of these symptoms of schizophrenia, we need to dispel some popular myths that have been fostered by the medical community over the years, obscuring the nature of the disease and compounding its tragedies.

Nameless Disease

One myth is the refusal to name schizophrenia as a disease, with causes that can be treated. Some psychiatrists have in fact maintained that diagnosis of schizophrenia is not important. Patients are given no information about their illness. While it may seem unimportant to know the name of one's illness, in our culture what is unnamed is usually feared. Tuberculosis was once feared for the same illogical reasons we now fear schizophrenia.

When patients are denied a name for their illness, they are denied the 'right to be sick'. The right to be ill is one of man's most humane inventions, for it allows people their deviant behavior because of illness. Society will not tolerate 'badness,' but it will tolerate the eccentricities of the sick, because someone has said they are sick and has given their illness a name. The medical profession may have indeed originated from the primitive practice of deciding whether deviant behavior in members of the tribe was due to sickness or to some other cause – for example, badness (to be punished) or possession (to be exorcised). Now imagine the position of the

mental patient when his doctors refuse to diagnose him with schizophrenia and thus refuse his right to be sick. One of the most therapeutic measures known to mankind is denied, for if he has an unnamed disease, he has no disease.

Another common practice is to conceal the illness in a prettier package, calling schizophrenia a 'nervous breakdown' or an 'emotional problem', but false naming is even worse, for these euphemisms fill the patient with guilt. The patient begins to believe that his problems derive from some defect in personality – which he is completely helpless to alter. In effect, the patient is being blamed for his own illness.

Personality Flaw

A second myth is that schizophrenia is caused by a flaw in the patient's personality or moral character. The history of general paresis of the insane, a fatal disease resulting from the progressive effect of syphilis, resembles that of schizophrenia in that at one time it was thought to be due to moral, rather than physical, causes.

In his lectures, Dr Conolly referred to 146 cases of general paresis in men, all of which ended in death. The causes, he stated, were "ascertained with tolerable certainty in 96 cases." In 60 out of the 96, the disease was ascribed to moral causes, such as "losses, anxiety, grief, domestic unhappiness, disappointments, poverty, reverses, etc." Intemperance, singly, was assigned as a cause in 20 cases; but in 15 other cases of the 60 just mentioned, as a cause in combination with losses, grief, etc. The other causes mentioned, each in one or two cases only, were "fever, injury of the head, hot climate, exposure to wet and cold, hereditary disposition, abuse of mercury, sensual excesses, foul air." Dr Conolly ascribed a large majority of his schizophrenic cases to "moral causes, to some over-exertion, or to some mental shock." He even thought some cases might be due to a severe fall followed by a temporary loss of consciousness. While this notion of the 'moral' cause of schizophrenia may no longer be current among medical professionals, vestiges remain in the public mind.

Bad Parenting

A third myth is that schizophrenia is due to bad parenting or a disturbed family. It is remarkable how well-established this notion is in spite of the

fact there is nothing to prove it. Many mothers today are suffering needless feelings of guilt because their children's illnesses are explained as being caused by too early or too harsh toilet training, quarreling at the breakfast table, inconsistent discipline, or other irrelevant factors in their histories. If the mother is not to blame, the myth goes on, then it must be the father. Husbands and wives can also shoulder the blame. There are many instances of couples advised to divorce because the wife is said to be bad for her husband's schizophrenia or vice versa. So far, no one has blamed a child for a parent's schizophrenia, but since some parents do have senile psychoses, the day may come when their sons and daughters are cited as the cause. It is dangerous these days to be the relative of a mentally ill person, for you will probably be blamed for driving them mad. This scapegoat principle as used by psychiatrists may work well in circumventing the necessity for therapists to blame themselves, but it harms not only one individual – the patient whose disease goes untreated – but two or more individuals, the patient and his loved ones.

The psychoanalytic explanation of this bad parenting myth goes like this. The child suffers trauma as an infant because of something the mother or father has done and the ego is damaged. For years nothing happens, but then one day, the trauma suddenly exerts its malicious effect and the child becomes mentally ill. The disease illogically occurs 'x' years after the seeds have been planted, and repair, we are told, occurs only with psychoanalysis, since the trouble lies in a personality defect. This is a pessimistic myth for, if one is ill as a result of something that happened at the age of two, one is doomed forever, because it is impossible to change the past. It is a destructive myth, for it assumes weakness, in the patient or his family, and society has its own inimitable ways of punishing weakness, with prejudice, contempt, indifference, perhaps even imprisonment and execution.

Psychiatrists can point at any one of a number of persons as the cause of their patients' illnesses and failure to respond to treatment, but the schizophrenic remains maltreated, maligned, and misrepresented to the point where his chances of improvement are no better today than they were 100 years ago. In other words, if the patient does not improve in the natural course of the disease, as 50 percent of the schizophrenics do, he does not improve at all.

This myth is pernicious, for it hinders any attempt to view one of our most serious and damaging illnesses realistically and control it adequately.

Split Personality

Even the name "schizophrenia" is wrong for the disease, at least as it is now popularly used. The term schizophrenia implies that something is divided or split. But the personality of a schizophrenic is not split into two or three separate personalities, as we have been led to believe in books like *The Three Faces of Eve*. There is, in fact, no split whatsoever. The originator of the term 'split personality', Eugen Bleuler, referred to a lack of connection between the thinking and the feeling of the patient. Many patients who have been sick for a long time appear to others to have a feeling, tone, or mood that is not appropriate to what they are talking about. For example, a patient may be crying while relating a humorous incident. Even this sort of splitting, however, is quite rare and will become rarer still as early treatment becomes generally available.

Nevertheless, the adjective "schizophrenic" has become a part of our language, implying separateness, as in "schizophrenic nation," "schizophrenic attitudes," or "schizophrenic politics." Used in this way, it may impart some vague meaning to the reader, but it actually has no meaning in relation to the disease from which it comes.

The word "schizophrenia," therefore, serves no useful purpose either in referring accurately to a symptom or a disease and will some day be replaced by more suitable diagnostic terms, just as the older term, *dementia praecox*, precocious or parboiled madness, was replaced by schizophrenia, just as "fevers" was replaced with the diagnosis of definite diseases.

Poverty

Schizophrenia does not, as some claim, have a special affinity for the poor. It is a disease that is prevalent in all cultures and societies, and is, as far as we can tell, fairly evenly distributed among all races, no matter where they are. It is found as often among Africans and Europeans as among Eskimos and Asians.

Even the most enthusiastic supporters of the theory that schizophrenia is related to poverty have been able to produce only one study to support their claim, where it was found that there were twice as many schizophrenics

among the poor. But since about one percent of a population will have schizophrenia in their lifetime, this is not a particularly remarkable finding and was probably due to many other factors that were not adequately studied.

Other investigators have not found any evidence to show that poverty breeds schizophrenia. The evidence instead is fairly clear that patients who do not recover from schizophrenia tend to drift downward to a standard of living below that of their parents, who do not have the disease. The reason for this is simply that the patients are unable to continue in their work or function effectively in their society. In striking contrast, neurotic patients may remain the same, drift below, or climb above their parents' social station.

Stress

Schizophrenia, in spite of popular belief, seems to have hardly anything to do with stress. Just as it occurs uniformly among all classes of men, so has it remained unchanged throughout the years, as unconcerned about people's varying fortunes as about the color of their skin and their religion.

In contrast, other diseases show remarkable fluctuations through history. Before sanitation was widely practiced, diseases would sweep across the population and decimate communities. Malnutrition followed the seasons. During wars, starvation and disease were rampant. Diseases due to bacteria and nutritional deficiencies have shown major swings in prevalence and incidence. Once this was understood, simple measures were employed to reduce them drastically. Chlorinating water destroyed typhoid and other diseases. Immunization eradicated smallpox and diphtheria, and polio vaccine promises to do the same for polio. Adding vitamin B-3 (nicotinamide) to flour in North America has practically eradicated pellagra.

In fact, the first large-scale program of preventive psychiatry was begun not by psychiatrists or by psychologists, but by nutritionists. At one time, nearly 10 percent of the patients admitted to mental hospitals in the Southern states in America had a disease called pellagra, caused by a lack of a vitamin. The psychological symptoms of this disease resemble schizophrenia so closely that it is likely that many more patients admitted as schizophrenics actually had pellagra. When nutritionists persuaded the

United States government to add vitamin B-3 (nicotinamide) to the flour consumed by its citizens, there was a major decrease in this disease.

Schizophrenia has remained remarkably unchanged over the ages. During war or peace, in periods of poverty or prosperity, it has continued to take its toll in a steady, relentless manner. Its constancy through good times and bad strongly suggests that stress has no relation to schizophrenia. But even this is not conclusive, for no one seems to know for sure what stress really is. Many articles in popular journals picture modern society as being particularly stressful due to its complexities. There is remarkably little evidence, however, that communities today are suffering more stress than those of 100 or even 1,000 years ago.

Primitive man, fondly believed to have been healthy, contented, and wise, was actually, according to medical history, diseased, discontented, and ignorant. Perhaps that is why he had to seek refuge in religion and philosophy. One needs only to read the novels of the mid-19th century to learn that our ancestors lived constantly with death, filth, privation, fear, and pain. A large proportion of women died miserably in childbirth and a large proportion of men, worn out by struggle, died by the time they were 50. No family was free of death. In fact, if pain and discomfort are factors that cause stress, then our century, by all standards, must enjoy less stress than any other. Few can deny that modern societies are characterized by less pain, less illness, and greater comfort than ever before. All we can say for sure, then, is that if stress, whatever it is, does play a role in causing schizophrenia, it is not an important one.

Stress, however, does play a role in schizophrenia, as it does with any disease. The normal stresses, which usually cause little difficulty, are very real problems to the schizophrenic. In the same way that walking is not stressful to a normal person, to one with a broken leg, it is very stressful indeed. One should expect a schizophrenic to have difficulty. The schizophrenic should therefore be shielded from severe stress when ill and convalescing, and should be supported as much as possible. However, there is no recovery until any and every stress is dealt with in a normal way.

Stress also fails to explain the sex factor in this disease. It is estimated that its incidence among boys below the age of 13 is three to seven times higher than among girls the same age. If the stress theory is correct, one

would have to assume that little boys are given three to seven times as much stress as little girls. Dr F. Kallman has challenged psychodynamic psychiatrists to lower the incidence of schizophrenia in children by persuading parents to be as kind to their sons as they are to their daughters.

Between puberty and the mid-thirties, the rate of incidence is about the same for both boys and girls. Stress theorists would now have to assume that stress on females had increased remarkably after the age of puberty to raise their incidence to equal that of boys.

Death is one of the best ways of assessing stress, and Hans Selye has defined stress in animals as a proportional death rate. Yet from the menopause onward, and at a time in life when men die more frequently than women, more women become schizophrenic than men. So, during a life period when stress is apparently greater in men, as indicated by the higher death rate, they develop schizophrenia less frequently than women.

Inheritance

The first death blow to stress theories, however, was dealt by studies of twins. There are two kinds of twins, fraternal twins who come from two separate eggs separately conceived by different sperms, and identical twins who come from one fertilized egg that by chance divides, each part producing one whole individual. Fraternal twins are no more related than if they were ordinary brothers and sisters. One may be a boy and the other a girl. Identical twins are so much alike in form and structure that it is often difficult to tell one from the other. They must be of the same sex. They have nearly identical genetic factors.

If inheritance plays a major role in schizophrenia, then the chances of one identical twin developing schizophrenia, if the other has it, should be much higher than among fraternal twins. This has, in fact, been shown to be the case in excellent studies in the United States and in Europe. If one member of a set of identical twins becomes a schizophrenic, the other has an 85 percent chance of becoming schizophrenic, even though the twins may have been separated at birth and raised in different homes by different parents. The concordance drops among fraternal twins to the level of brothers and sisters who are not twins, which is about 15 percent. These facts have been established beyond doubt, although some psychiatrists who use a double standard of reasoning (a very rigid criterion for biological

factors and a very loose set of criteria for psychological factors) seem strangely unaware of these striking differences.

Although schizophrenia can be determined genetically, there is no simple or direct inheritance, as for eye color. There are a number of genes involved and one can only say what could probably occur in a family. The majority of schizophrenic patients come from normal parents, but for schizophrenics and their families who may wonder what their chances are of passing on schizophrenia-bearing genes, the following are reasonable estimates of the probabilities. One-sixth of the children who have a schizophrenic mother or father will have enough genes to make them schizophrenic. That is, out of 100 children who each have one schizophrenic parent, 17 will get it. If both parents are schizophrenic, the proportion is increased to 60 out of 100. If a brother or sister is schizophrenic, another brother or sister has a 15 percent chance of having it also.

This does not mean that patients with schizophrenia should not have children, as has been advocated by some psychiatrists in the past. On March 1, 1964, *The New York Times* ran the following headline:

Births Widening Type of Insanity
Rise in Schizophrenic Rate Called Alarming in State

The author of the article, Professor Franz Kallman, reported that "a large-scale study in New York State mental hospitals has shown that within two decades the reproductive rates of schizophrenic women increased 86 percent, compared with an increase of 25 percent by the general population." Dr Kallman warned that this rise, reflecting the difference between early handling of schizophrenic patients and modern treatment methods, might result in a steady increase of the serious mental disorder. He predicted that the birthrate among schizophrenics might eventually surpass that of the general population. Many inferred wrongly from this report the eugenic notion that schizophrenics should be sterilized because their reproduction is not desirable.

Sterilizing all schizophrenics would have very little effect in reducing the number of patients, however, even if for some strange reason society deemed this practice morally acceptable. Schizophrenia may even be a desirable trait in our evolution. People who have been cured of schizophrenia

are in many ways healthier, physically and mentally, than their non-schizophrenic brethren. Schizophrenics appear more youthful, their skin does not crinkle as quickly, their hair retains its pigment longer, and the fat under their skin seems to last better. They have fewer allergies, can stand pain much better, and do not get medical shock as easily.

Still, parents who have schizophrenia should learn as much as they can about the disease, and if it should occur in one of their children, seek immediate help. Families with more than the expected number of schizophrenics should seek help early whenever a member shows any sign of illness or peculiar behavior.

Case Studies

I have treated many patients and their families over the years who were victims of these various myths about schizophrenia. Take the case of Harvey, for example.

Harvey, an 11-year-old son of wealthy parents, was considered to be the neighborhood bad boy. He failed in school, threw temper tantrums in the classroom, bullied smaller children, broke neighbors' windows, and generally was looked upon as a disturbing factor in the community. Harvey became associated with 'badness' and just the sight of him was enough to arouse tension in his teachers, classmates, and other parents.

Harvey was also probably the most punished pupil in school. By the time he was in grade four, his teachers had stopped even trying to "understand" him. Sarcasm, humiliation, and corporal punishment dogged his footsteps. But Harvey seemed to rise above all that with even more daring adventures, even more temper tantrums accompanied by violent destructive activity, and uncontrollable crying fits in class.

Everyone kept a wary eye on him and no one had a pleasant word for him until he was finally taken to a psychiatrist who explained that Harvey was acting in response to an illness, which had a name, schizophrenia.

Immediately, the attitude toward Harvey in school, at home, and in the neighborhood changed. When he cried in furious frustration over his inability to solve an arithmetic problem, the teacher, instead of resorting to sarcasm, now spent an extra few minutes with him until he understood it. When he misbehaved, she no longer reacted as though he were just "trying to get attention," but helped him over his difficult periods, which

gradually became less and less frequent. The neighbors were still wary of him, but substituted friendliness for cold rejection.

Harvey, when given a name for his illness, assumed a new and important role in his society. He is sick and is allowed his bizarre actions because it is known that he is sick.

The reverse process is familiar to most mothers. When your child has a high fever, you allow him his crankiness, his insatiable demands, and his peevishness. You can tolerate this because you know it is only temporary and that there is a reason for it. You know the doctor is on his way and that he will leave a prescription, which, in a matter of days, will have the disease under control. This tolerance of the child's difficult behavior disappears when the doctor has pronounced him well. Instead of being a "sick, poor thing," he is suddenly "spoiled or bad."

What must parents of schizophrenic children feel when they have no such assurance of competent help or early termination of the disease, or when too often they are not told what causes their children to behave as they do? We have seen the look of relief on many of our patients when we gave them the name of their illness. There was an immediate sense of relaxation. Their parents became relaxed, lost their hostility, and were able to tolerate behavior in their children that was previously unacceptable to them.

Or take the case of Mr Williams, a businessman, and his son Peter. At the age of four or five, Peter began having violent rages and would remain in his room for hours, refusing to talk to anyone. He preferred to play by himself most of the time. The alarmed father took him to a clinic where, he was told, it would be necessary to "break through the barriers" to discover what Peter's underlying conflicts were before treatment could begin.

Peter's violent behavior continued, and with no treatment prescribed, his father took him in desperation to another clinic where play therapy was attempted "to find out why Peter reacted as he did to reality." A third clinic attempted hours of interviews with Peter and his parents, with no noticeable effect on Peter. Mr Williams was finally told that Peter's illness was caused by bad parenting and that he could not recover because of the father's own poor attitude.

Grief and guilt began to prey on Mr Williams. He had been put on trial and pronounced guilty by the medical professionals he had approached

for help. In his own defense, he reminded himself that he had raised five normal children, but he couldn't stop thinking that he had played a major role in the illness of his sixth child, condemning him by his own attitudes to a lifetime of insanity. He brooded about this until he went into serious depression, which might have ended in suicide had not an understanding friend interceded and exposed this myth.

These myths have caused untold misery and harm and need to be countered by a scientific understanding of the causes of schizophrenia that will lead to effective treatment and even prevention of this disease. Our purpose is to correct popular misconceptions planted by some psychiatrists and nurtured by some journalists in order that we can take logical and practical steps to eliminate schizophrenia as a dread disease, as we once tackled tuberculosis.

② | WHAT ARE THE SYMPTOMS OF SCHIZOPHRENIA?

What, then, is schizophrenia? How can we tell when it is present? There are a number of changes in physical, psychological, and social behavior that indicate the onset of schizophrenia. These changes in behavior are the basis for diagnosing the disease. Once we have discussed these symptoms, we can turn to an analysis of their causes in the next chapter, leading to a full answer to the question, "What is schizophrenia?"

Physical Changes

There are physical as well as psychological changes in schizophrenia, some of which are not desirable, some of which are desirable. In general, the earlier the disease strikes, the more severely it affects the body. If children become ill before their sensory organs reach full functional maturity, they may never develop normally. The organs themselves may be physically healthy, but their function and coordination may be distorted.

It is possible for skilled child psychiatrists to diagnose schizophrenia at the age of one month by observing the complete lack of muscle tone. Mothers who have had normal babies notice the queer feeling that, when picked up, their schizophrenic infants sag like limp dolls.

When schizophrenia occurs before puberty, the patients may be smaller in stature than non-schizophrenics, and often are narrow in the chest from front to back. When the left side is compared with the right side, there is found to be a deformity in shape.

When the disease strikes adults, many things can happen. Both men and women are then more susceptible to tuberculosis and are more likely to develop an infection if exposed to this disease. Tubercular lesions also heal more slowly in schizophrenics. This was an important cause of death in mental hospitals before they introduced modern methods of tuberculosis control. However, when modern control measures and proper treatments were used, the incidence of tuberculosis among schizophrenics was reduced, though not to normal levels. It is not true, however, that tuberculosis patients are more susceptible to schizophrenia.

Another important change is a pronounced fatigue and listlessness that descends upon the patient. This is common in all physical illnesses, not just schizophrenia. The patient usually feels less tired in the morning after sleep, but becomes progressively more and more tired as the day goes on. Toward evening he is often much more psychotic.

Schizophrenic men may become impotent and show atrophy of the male gonads. Women may suffer changes in the menstrual cycle, but this returns to normal if the disease vanishes. Both men and women tend to suffer a decrease in sex drive. Schizophrenic men occasionally become confused in their sexual identity.

Schizophrenics may also have desirable physical attributes that non-schizophrenics may envy. Schizophrenics are frequently very attractive physically. They tend to age and lose their hair color more slowly, and generally appear more youthful than their chronological age. They are free of many common physical complaints and seem to be able to survive misfortunes that would kill other people.

There are a number of tests which show that schizophrenic body fluids differ from those of normal people and those with other psychiatric illnesses. Dr John Lucy found that schizophrenics can take enormous quantities of histamines, the chemical substance that is responsible for allergies in some people. This resistance to histamine explains why allergies are rare among them. In another study, A.J. Lea found one allergic condition in 500 schizophrenics. Other investigations have made similar findings. This is a

characteristic of the disease itself, not the patient, for patients can and do develop allergies when they are free of schizophrenia. D.H. Funkenstein reported in 1960 on a group of psychotic patients who had asthma when they were not suffering from schizophrenia, but who never had the two together.

Rheumatoid arthritis is also very rare in schizophrenia. Dr D. Gregg reported in *The American Journal of Psychiatry* in 1939 that out of 3,000 autopsies on patients with psychosis who died for other reasons, not one patient had any evidence of arthritis in their joints or bones. Dr Nissen and Dr Spencer found no cases of arthritis among 2,200 psychotic subjects, and in 1954, Dr Trevethen and Dr Tatum, in examining 9,000 admissions to a general hospital, discovered that 80 had arthritis, but not one had schizophrenia.

Among schizophrenic patients in mental hospitals, diabetes mellitus is an unusual occurrence. Both mental hospitals in Saskatchewan, with a total population of over 3,000, had fewer than five diabetics while I worked there. Dynamic psychiatrists have explained this by saying that patients who have one "defense mechanism," schizophrenia, have no need for another, diabetes. They have not yet explained in what way diabetes is a defense mechanism any more than they have explained schizophrenia as having a stress basis. It is interesting to note, however, that doctors continue to treat diabetes with insulin, and not with psychotherapy.

Schizophrenics can suffer extensive burns, severe injuries, fractures, heart attacks, acute appendicitis, and even self-mutilation with abnormal stoicism and detachment. While some people faint when blood is drawn, one schizophrenic patient cut his throat and bled so much that he required five pints of blood, with little sign of shock. Some have cut off fingers and hands without collapsing or appearing to be affected in any other way. They have been known to escape shock symptoms usually suffered at the beginning of a perforated ulcer.

Some, of course, do go into deep shock and die, but others seem to benefit from shock when it does occur. One patient, a chronic schizophrenic with bizarre ideas and behavior, suffered very severe burns over a large portion of her body in a kitchen accident. She went into deep traumatic shock, and after a lengthy period of recovery, emerged completely clear mentally and was able to return to her family.

This resistance to pain can be dangerous, however, for acute illnesses are often ignored until too late. Psychotic patients die more often from ruptured hearts than normal people do, without complaining of pain or giving other signs of severe difficulty.

In 1964, Sir Julian Huxley, Professor E. Mayr, Dr Osmond, and I suggested that the biological advantages present in some schizophrenics accounted for the constant rate of prevalence, even though there should have been a gradual decrease in the incidence of the disease. The usual incarceration in hospitals, combined with the decreased fertility of schizophrenic women and decreased sexual drive of many male schizophrenics, should have had this outcome. We suggested that schizophrenia is part of a genetic polymorphism. This means that some non-schizophrenic relatives of schizophrenics have biological advantages over the normal population. In 1971, as reported in the *British Journal of Psychiatry,* Dr Michael Carter and Dr C.A.H. Watts examined this idea by comparing relatives of schizophrenics with relatives of carefully matched controls. They found a decreased incidence of viral infections among relatives of schizophrenics (but not of bacterial infections), a decrease in accidents, a decrease in allergies, and a decrease in fertility. This is evidence that the genes do impart some biological advantage. It is an advantage to have these genes – to have some of the biochemistry of a schizophrenic – but not, of course, to be ill from schizophrenia.

Several years ago I examined the relationship between schizophrenia and cancer, based on the two basic properties of adrenochrome. Adrenochrome is an hallucinogen and, according to our theory, is one of the main factors in causing schizophrenia. But adrenochrome is also a potent mitotic poison, so it ought to inhibit the growth of cancer. If a person has schizophrenia, he has too much adrenochrome and, therefore, should not get cancer. But if a person has too little adrenochrome, he may get cancer but should not become schizophrenic. I have seen over 5,000 schizophrenic patients since 1955, and of these, as far as I know, only six have developed cancer. They all recovered when treated by a combination of orthomolecular and standard treatment. I have not seen a single schizophrenic patient die from cancer. I have also seen nearly 1,100 cancer patients since 1977, including only the same six patients who also had schizophrenia. The same relationship exists in the first order relatives of schizophrenic patients.

These first order relatives have a much lower frequency of cancer, but the first order relatives of cancer patients have a much lower incidence of schizophrenia.

Psychological Changes

There is no personality type that is peculiar to schizophrenia. There is no particular type of personality preceding it, and it does not impose a uniform type of personality on all patients. People with schizophrenia represent all personality types. Opponents of biological theories of schizophrenia have used this as an argument, on the assumption that any biological disease would have the effect of making all patients act the same way. This is a novel idea, since it is not true of any disease thus far discovered. Diabetes mellitus does not produce uniform personalities any more than schizophrenia does, but no one argues that it is not a physical disease.

Only one personality type is believed to precede the disease, and it has found its way into literature as the 'schizoid' personality. A schizoid personality is supposed to resemble schizophrenia and is usually applied to a person who is ingoing, introverted, quiet, and who enjoys seclusion. It was once believed that children who were shy and quiet by nature were pre-schizophrenic, and parents of such children were advised by physicians to be concerned about them. So strong was this assumption that much research money was spent trying to establish that people with schizophrenia would come largely from that group known as schizoid personalities.

One such study was completed in Toronto, where an examination was made of a large number of school children from an upper-class section of society. A small number of schizoid children were selected, but over the course of the study, it was found that childhood schizophrenia occurred more frequently in children who had *not* been selected as schizoid. A study at the University of Texas yielded similar results. A large group of children seen in a mental health clinic were classed into extroverted, introverted, and ambiverted groups. Of these, the introverted ones would most closely resemble the schizoid people. Over a long follow-up period, it was found that the introverted group produced less than the expected share of schizophrenic patients. In fact, out of 10 subjects found to have been diagnosed schizophrenic, only one was classified as introverted. On the other hand,

three were extroverted, and six were ambiverted. It thus appears that many introverted and retiring people have been needlessly annoyed by this error.

Since it has not been shown that schizoid subjects produce more schizophrenics than any other personality types, where did this idea originate? It seems likely that the idea came from the necessity of taking histories, and the habit of mistaking the first signs of the disease for a special personality preceding it. This is another example of putting symptoms before causes and drawing the wrong conclusions because of it. It is as scientific as the procedures adopted by the wise men called upon by the king to determine why the wind blows. The wise men studied the problem for a long time without coming up with any satisfactory answers. It was observed, however, that whenever the wind blew the trees waved. It was therefore concluded that the waving of the trees produced the wind.

Although there is no personality type related directly to schizophrenia, the basic personality is altered by the disease. This is not unique to schizophrenia, since it has been known for centuries that any illness alters personality. A subject with a painful headache may exhibit an irritable, withdrawn, reclusive personality that becomes relaxed, friendly, tolerant, and outgoing again when the headache disappears.

The confusion on this point may be due to the characteristic way in which the disease begins. Most diseases give definite and unmistakable warning of their presence fairly early in their history. They have obvious physical manifestations that make it relatively simple for others to accept the fact that the patient has now become sick. If there is a personality change with cancer, for instance, it is understood that this is the result of pain and suffering, and allowances are made.

But schizophrenia is often treacherous. It may come on so slowly and insidiously that, like watching the hourly hand of a clock, one sees no beginning or end of the movement. There is nothing definable that one can see, like a sudden loss of weight, unusual pallor, or a sharp pain in the abdomen. It makes its changes gradually where they are least noticeable, resulting in a slowly increasing personality deformation without any obvious explanation.

If one examines the clinical histories of many patients, it becomes obvious that there were personality changes that included withdrawal and shyness, for example, long before schizophrenia was fully developed or

recognized. Perhaps this is why personality theorists have fallen into the trap of believing there is a personality that is predisposed toward schizophrenia. In these cases, however, the so-called schizoid personality was the first sign that schizophrenia was present, and was a symptom – not a predisposing factor. The term "schizoid," then, has no clinical value, and might well be dropped from usage.

Changes in Personality

Since the personalities of patients with schizophrenia differ as widely as the personalities of subjects who do not have this disease, the psychological tests used to measure personality in diagnosis of schizophrenia have no value. Still, there is one important, unchanging characteristic of the disease to look for – alteration in personality. Whenever there is a change in character, without an accompanying clear change in the environment, and in the absence of physical illness, one might suspect schizophrenia. This change is marked by a turning into oneself and an intensification or exaggeration of abnormal and asocial traits. For example, if a normal outgoing adolescent over a period of years becomes shy, reclusive, lonely, and irritable, this is a serious personality change and parents should look for the cause. In a proportion of cases, they will find schizophrenia.

Change in personality, then, is a hallmark of schizophrenia. In order to evaluate the change, we must know the pre-existing personality and must consider the age at which the change occurred. The easiest patients to diagnose on the basis of change are those who have reached the end of the developing years and have achieved stable personalities.

Schizophrenia is very difficult to diagnose in the first 10 years of life. In fact, several decades ago, it was believed that schizophrenia did not occur at all under the age of 10. Of course it does, but its diagnosis requires skill. Trained and skillful psychiatrists can even diagnose it at the age of one month, but these experts are extremely rare.

Several years ago Professor R. Rabinovitch, who was in Saskatoon, Saskatchewan, for a conference, remarked on the extremely low incidence of childhood schizophrenia in this province. It occurred, he noted, only one-twentieth as often as in his home state of Michigan – an interesting phenomenon in view of the fact that the disease in adulthood occurred so uniformly across all regions. He concluded that its low incidence in

Saskatchewan children was due to the fact that there were too few psychiatrists there able to diagnose it. Undoubtedly, the majority of schizophrenic children in Saskatchewan were cited for behavioral problems or were considered mentally retarded.

One reason for confusing schizophrenia with retardation in the young is again due to our habit of diagnosing symptoms instead of the disease. Human beings, animals, and birds all have critical learning periods in their development. The song-learning period in birds, for example, is about a year. If a young male chaffinch is isolated from others of his kind at the age of three or four days, he doesn't learn the complete chaffinch song. But if he hears an adult bird singing before he learns to sing himself, he will in a year produce the song of his species, whether he is isolated or not. Similarly, there is a 10-day period just after weaning when mice learn to fight. If mice are kept by themselves at 20 days of age, they do not fight as readily in adulthood as those brought up in groups. There is a critical period in human development when children learn to speak, and in other ways prepare themselves for the learning that lies ahead. If, for some reason, they are unable to learn during this period, they may not learn at all.

If schizophrenia occurs under the age of 10, it will interfere with the learning process, and the child's learning may be permanently impaired. Since we cannot distinguish a clear personality change, we take note of failing school grades or inability to keep up with others of the same age. The inevitable 'wrong' diagnosis is often retardation, and the child is forced into the special place reserved in our society for that group of people, from which there seems to be no escape.

Personality in the next 10 years of life is better established, but still unsettled. Therefore, schizophrenia becomes easier to diagnose, but there is a great danger that the adolescent's illness will take a form that many will confuse with simply "adolescent behavior." A large proportion of adolescent schizophrenic cases are called anxiety neuroses, adolescent turmoil, or other such terms.

When the disease first strikes during the second 10 years of life, the patient has a better chance of recovery. The main difficulty here is that education is interrupted for several years as the disease develops and during treatment and convalescence.

During maturity, schizophrenia is most readily diagnosed, for at this

period of life, personality has more or less stabilized and change in personality can be determined more readily.

The only periods during maturity when the diagnosis is easily missed are during the period after women have had their babies, when the illness is frequently mistaken for depression, and during menopause, when most illnesses are called involutional depressions. The final period of life when diagnosis is difficult is when old age or senility develops, for then many mental illnesses are confused with senile psychosis.

Changes in Perception

Some schizophrenics realize their normal powers of perception have gone awry, while others don't. Thus, some may see the changes as being real, and some as unreal. If the changes are accepted as not being real, they may produce anxiety, doubt, and a turning inward, but they will not alter character and personality as much as if they are assumed to be true. If these strange experiences are frequent or persist a long time, they are likely to be accepted as real because man has always trusted his senses. It would be extremely doubtful if any one of us who saw a man standing in front of us for a long time would doubt someone was there.

Changes may come about in any of the senses. It is obvious that changes in some senses will not be as dangerous as changes in others. A perceptual change that interferes with a person's occupation will tend to be more harmful than those that attack other aspects of perception.

One of our patients, a stenographer, found that whenever she transcribed from one page to another, she could not keep her eyes on the line because it would jump to the line above or below. She tried to prevent this by placing a ruler under each line, but this did not help. She had other symptoms, but this is the one that made it impossible for her to do her job and forced her into hospital.

In general, vision and sound are distance senses that chiefly determine our relations to our fellow men. Smell, taste, and touch are intimate senses and are used to control relations with lovers, close friends, and relatives. Thus, it is likely that sight and sound are going to produce hostile reactions more often. Schizophrenia is usually not diagnosed until vision and hearing are altered and patients have responded with fear or anger, or in some other way that draws attention to them.

Any perceptual change will be reacted to in a common sense way. We mean by this that anyone with imagination can place himself in a similar situation and predict fairly accurately what the expected reaction would be. Here are some common situations and reactions.

Changes	Results
People are watching	Suspicion, uncertainty (paranoid behavior)
Faces are distorted	Fear, suspicion
Faces are funny	Inappropriate giggling
Inability to distinguish faces	Confusion, suspicion
Colors too bright	Euphoria
Colors dull	Depression
Unable to judge distance	Fear, anxiety when driving
Hallucinations	Depends on kind

Subtle changes can be just as injurious as gross ones, although the subject may be unaware of them. For example, when two people are talking to one another, they use a tone of voice just loud enough for clear transmission of words. But sound waves follow the inverse square law. When the distance between people is doubled, the voice must be raised four times for the same intensity of sound to be transmitted. The speaker must be able to judge how far away he is before he can adjust his voice properly. This is not a conscious decision (except with speaking on a public platform, when the speaker knows he must make an effort to get his voice to the back of the hall).

Suppose, due to a defect in judging distance, the patient doesn't know how far away he is from the person to whom he is talking. Then he may speak too softly, thinking the other person is close, or too loudly, thinking the other person is too far. But the one to whom he is talking is unaware of this. What he notices is that he is being shouted at or whispered to, and this can easily result in difficulties in communication.

Some patients have a defect in estimating distance on the road. This makes driving an anxious business, and our patients are often reluctant or

unable to drive. If the patient is a truck driver, he will lose his job. But it could be much worse if he had not been aware of something being wrong.

Some people respond quite appropriately to their hallucinations. One young woman saw Christ, who told her she was destined to be his bride. She thereupon gave up her job, went home to her parents, and spent her days studying the Bible and telling her parents about the hallucinations. This led to her admission to hospital.

Patients often feel that both their eyes and ears may be playing tricks on them, especially as the illness comes on or as they begin to recover. Many people with schizophrenia have described their doubts that what they were seeing was real. One of these was Perceval, the son of a British Prime Minister in the 19th century, who became schizophrenic, recovered, and then wrote his own account of his illness in *Perceval's Narrative*.

Perceval expressed some anger and resentment toward his brother because, when he experienced hallucinations and asked his brother about them, his brother did not tell him they were hallucinations. For many months, Perceval believed the voices he heard were real and prophetic. Later on in his illness, as he began to recover, he used several ingenious psychological experiments to help him decide whether they were real or not. For example, at the height of his illness, he was convinced that every prophecy made by his voices was true. But later he kept track of the prophecies and soon observed that most of the time they did not occur. He decided the voices were fallible and, later, that they were not real.

Psychological changes that occur so frequently in schizophrenics can be categorized under four main headings: perception, thought, mood, and behavior. Inside every human being is a finely woven network of nerves that take messages from ear, eye, nose, skin, and taste buds to the brain. Here they are worked upon by a vastly complicated system of chemicals, each with certain duties to perform, and various departments charged with the heavy job of advising different parts of the body what to do. There is an instant interpretation, which is telegraphed back to the parts directly concerned, whereupon individuals get angry, excited, frightened, pleased, or in other ways act appropriately in response, depending a great deal on their own personality.

This is perception. The five senses provide us with information we must have about our own bodies and the world around us, if we are to survive.

They pick up cues from other people – the tone of voice, the facial expression, the gestures – and these play an important part in how we get along with them.

In addition to the five senses, there are other important perceptions. One of these is the sense of passing of time. Another is a sense of space – knowing where your hand is, for example, or relying on your feet to carry you up stairs, without any special prodding.

In normal individuals, perception is spontaneous, automatic, and perfectly coordinated. Suppose, however, that something interferes with the way messages are taken to the brain and the individual receives a distorted picture. Still acting appropriately to the information received by the brain, an individual is now acting inappropriately to the situation. Judgment may then be impaired; the individual cannot think clearly.

Or suppose because of interference with messages in the brain that one has to stop and think about what one's feet are doing. Suppose, when you are reading, the words jump up and down you are so interested in what the words are doing that you forget to think about what they mean. Suppose you can no longer remember what your mother looks like, unless you piece an image of her together, feature by feature, and then have to concentrate to hang on to it. Suppose you hear a voice telling you to go hang yourself. Suppose, because sounds are too loud, you are distracted and can no longer concentrate on the simplest things, like watching television.

All these things can and do happen in people, and they happen when the person has schizophrenia. The world and people in it have changed.

Dr Andrew McGhie and Dr James Chapman in England have collected descriptions from various schizophrenic patients on how the disease has affected them, and found that disturbance in areas of perception and attention is primary in this disease. Normal conversation is disrupted. "When people are talking," said one patient, "I just get scraps of it. If it is just one person who is speaking that's not so bad, but if others join in, then I can't pick it up at all. I just can't get into tune with that conversation. It makes me feel open, as if things are closing in on me, and I have lost control. Movements become slower because each one must be thought out."

"People go about, completely unthinking," said another. "They do things automatically. A man can walk down the street and not bother. If he stops to think about it, he might look at his legs and just wonder where he is

going to get the energy to move his legs. His legs will start to wobble. How does he know that his legs are going to move when he wants them to?"

Or as another patient put it, "If I do something, like going for a drink of water, I have to go over each detail. Find cup, walk over, turn tap, fill cup, turn tap off, drink it. I keep building up a picture. I have to change the picture each time. I have to make the old picture move. I can't concentrate. I can't hold things. Something else comes in. Various things. It's easier if I stay still."

Schizophrenia can change one or all of our sensory modes, and this produces the bizarre thinking and behavior characteristic of the disease. For anyone to function normally, each sense has to be linked smoothly and easily to all the others. We make judgments on the basis of what our senses tell us. If anything goes wrong with any one of our senses, our lives at home, at work, and in the community can be seriously disrupted.

Changes in Vision

One of the primary senses, vision is trusted more than most of the others. The statement "seeing is believing" expresses a profound truth.

Changes in visual perception that can occur in schizophrenia are as follows:

Changes in Color: Colors may become very brilliant or, more frequently, lose their brilliance. Sometimes the whole world becomes a uniform, monotonous gray. When this happens, it is not clear whether patients see all colors, but have lost their normal emotional reaction to them, or whether they see all colors the same. The patient during this period may be unaware that the world is different. One patient realized her world had been dull and gray only after she suddenly regained normal color vision.

The opposite may also occur – colors become brighter. "Colors seem to be brighter now, almost as if they are luminous," one patient told Dr Chapman and Dr McGhie. "When I look around me, it's like a luminous painting. I'm not sure if things are solid until I touch them." Another patient said, "I am noticing colors more than before, although I am not artistically minded. The colors of things seem much clearer, and yet, at the same time, there is something missing. The things I look at seem to be flatter, as if I were looking just at a surface. Maybe it's because I notice so much

more about things and find myself looking at them for a longer time. Not only the color of things fascinates me, but all sorts of little things, like markings in the surface pick up my attention, too."

Changes in Form: Objects remain recognizable but look different. This may lead patients to believe the objects are unreal – that is, that they have a new, unexpected and, therefore, unreal quality. Sometimes pictures are seen as having real three-dimensional quality. A house in a picture may appear to have the depth and perspective of a house on the street. On the other hand, three-dimensional objects may appear flat.

Angles may become distorted. Instead of lines going up and down or straight across, they may seem to be leaning over. Sometimes objects develop life-like qualities and pulsate, as though they were breathing. Words on paper may move up and down or sideways, and lines may appear to crowd together. Parallel lines or patterns on wooden objects or in floors may flow in and out as if alive.

Misidentification: The ability to distinguish one face from another depends upon being able to see properly. The slightest change in a face is enough to make it seem strange or different.

One male patient in the study said people's shapes did strange things. Sometimes their faces were triangular or square. Sometimes their heads got larger or smaller. Sometimes one shoulder went up and the other went down. For this reason, he couldn't look at people for very long, but had to look away.

"But you're looking at me now," said the social worker.

"Yes, but you don't bother me," he said. "I'm used to you. In fact, you look rather funny."

If visual perception is disturbed, the subject may lose his ability to recognize people. *The New York Herald Tribune*, February 12, 1964, carried the following story under the heading, "Killer Says Voices Told Me To Shoot":

> *"When he came down the stairs he had unnatural feet, iridescent eyes and his fangs were showing. My voices told me to shoot him." Police said 'A' had suffered a nervous breakdown after his father's death.*

Clearly what happened was that 'A' was very psychotic, and suffering from visual and auditory hallucinations.

Another patient had a similar misidentification with serious consequences. During a period of deep depression and anxiety, he looked up to see a young girl coming down the stairs. She seemed to be surrounded by a halo and looked like an angel. This psychotic man immediately fell in love with her. This eventually led to his divorce and to a prolonged period of extreme tension and unhappiness. An elderly schizophrenic, who had been sick for 10 years, knew she was married to Mr Jones, but when asked if Mr Jones was sitting beside her, she was unable to recognize him and denied it. A male patient lost his ability to tell one face from another. All faces seemed the same to him, leading him to believe he was being followed.

Some patients notice changes in themselves when they look in the mirror and find these disturbing. One patient's chief symptom was that she saw bags and lines under her eyes. None of these were present, but she could see them and this had a profound effect upon her. She became quiet and reclusive.

Some patients may also see themselves as being much younger or older than they really are, which can lead to problems.

Changes in Far Vision Perspective: A common complaint of schizophrenic patients deals with the inability to orient themselves. Subjects who ride in cars become insecure and feel either that passing cars are coming toward them too closely, even when they are not, or that they themselves are too close to the ditch. Because of this, several of our patients stopped driving cars as their illness developed. These visual changes also make it difficult for patients to estimate correctly the size of people and objects far from them. Some see other people much smaller than they really are.

These changes send patients to oculists or ophthalmologists, from whom they demand glasses. Most often the new glasses do not solve the problem. A frequent symptom of schizophrenia is a frequent change of glasses with no relief.

A common problem among sufferers from the disease concerns the ability to judge whether people are looking directly at them or not. The

ability to decide whether one is being looked at depends upon a proper binocular vision and a very exact coordination of a variety of cues. If the area of the brain that judges convergence is not functioning properly, subjects would be inclined to see people as looking at them when they are not. In a study involving schizophrenic and non-schizophrenic patients, we found that 25 schizophrenic patients were less able to decide whether an investigator was looking into their eyes than a group of 30 non-schizophrenic patients.

A person with schizophrenia is liable to feel that he is being looked at for an unusually long period of time and more often than usual, when this is not so. The earliest symptom of schizophrenia may be the inability to lose the feeling of being watched. Recently, a professor of biology sought a psychiatric consultation because he was continually and painfully aware that his students were watching him as he lectured to them. He was disturbed that, after many years of lecturing, this feeling was still present and was much stronger than it had been. A urine test showed he was very ill with malvaria, a precursor to schizophrenia. Whether people are looking at us or not, and how they look at us, produces an emotional reaction in most people and would, therefore, have a profound effect on the schizophrenic.

Edward T. Hall, Department of Political and Social Science, Illinois Institute of Technology in Chicago, wrote, "I think that the point about the schizophrenic not being able to tell when people are looking at him is very important. Its importance, as a matter of fact, has undoubtedly been overlooked. Recently, I have had my students doing experiments on eye behavior.... One of the first things I discovered was that my own feelings – about being looked at in certain ways that often caused me to be quite anxious – were actually shared by a great many people. I had thought that my own discomfort was due to a failure on my part in working through some old dynamism that was buried in my past experience. This may also be so, but the data indicate that the reaction is a normal one, and can be exceedingly painful." He went on to point out that "dominant baboons can cause a younger baboon to scream with pain at a distance of around 30 feet simply by looking at him." He concluded that if schizophrenics' capacity to tell when people were looking at them was seriously disturbed, they could be in deep difficulties. He also observed that "they use their eyes in very improper ways, creating hostility or anxiety in those around them."

In ordinary life, there is a kind of visual exchange between one person and the other such that the eyes facilitate social relations. When people talk, they look at each other and look away again. They may look at a person's mouth, shoulder, or at the top of the head. They rarely look directly into each other's eyes, except for very short intervals. Being stared at makes many people uncomfortable. In fact, small children are often told not to stare. Many animals are disturbed when they are stared at. A boar can be temporarily halted or completely silenced by gazing straight into his eyes. Freud placed his patients on a couch because he disliked being looked at for hours on end. The feeling of being watched or stared at, then, would be reason enough for a person to remain in seclusion.

Illusions and Hallucinations: Schizophrenics do not, as we are told, "imagine" they hear or see things that are not there. They actually hear and see them. They have illusions because something has gone wrong with the way they receive things and, therefore, they misinterpret what they are looking at. The coat hanging in a cupboard may momentarily look like a man or a bear.

Hallucinations are things, scenes, people, etc. that patients see but which other people do not see. Visual hallucinations can be anything familiar to everyone in everyday life, or may be fantastic visions of the kind seen during transcendental states or during experiences induced by psychotomimetic drugs, like mescaline and LSD-25.

Visual changes may range in intensity from very slight to very severe, and may endure from an hallucination of a single moment to hallucinations lasting many decades. The response or reaction of the subject to his visual changes depends upon many things. Some psychiatrists try to distinguish between so-called true and pseudo (not true) hallucinations. They accept hallucinations to be true when the patient sees any familiar object that no one else can see, and believes it to be real. Pseudo-hallucinations are said to be the same visions, but when the patient realizes them to be phantasms or visions.

If this were the only matter at issue, there would be no quarrel with these arbitrary definitions. But psychiatrists have used these distinctions to make diagnosis even more unclear and difficult, for it is now said that schizophrenics have true hallucinations and hysterics have pseudo-hallucinations.

If the psychiatrist wishes to give the patient psychotherapy, he will be tempted to call them pseudo-hallucinations. In this case, diagnosis depends not upon the patient and his hallucinations, but upon the psychiatrist. If the psychiatrist thinks the patient has hysteria, he terms the hallucinations "pseudo," and if he believes the patient has schizophrenia, his hallucinations are said to be true. The definition is wrongly tied to the idea of the diagnosis. It would be scientifically better to drop these terms "true" and "pseudo" and merely say instead that the patient has hallucinations.

Changes in Hearing

There may be fewer changes in hearing than in seeing. Sounds may be louder or not as loud. "It's as if someone had turned up the volume," one patient said. "I notice it most with background noises – you know what I mean, noises that are always around but you don't usually notice them. Now they seem to be just as loud, and sometimes louder, than the main noises that are going on.... . It's a bit alarming at times because it makes it difficult to keep your mind on something when there's so much going on that you can't help listening to."

Sounds may become less intelligible and harder to locate. One patient, for instance, said that though he knew the sounds were coming from the radio in front of him, they seemed to be coming from behind his back. One schizophrenic tried to get admitted to a psychiatric ward because he thought others were talking about him, yet knew this was not so. At the same time, he had visual disturbances, and he decided he must be getting sick again.

Very few schizophrenic patients are free from auditory changes. Auditory hallucinations occur after schizophrenia is well established. The changes appear to occur in order as follows:

1. Patients become aware of their own thoughts.
2. They hear them in their head.
3. They hear them as if outside their head.
4. They hear voices.

The hallucinations can be anything from voices giving orders and conversations with God, to music, unearthly sounds, and buzzing noises.

There is no way of predicting in advance what the patient will hear. This will probably depend upon his personality, the part of the brain that is affected by the chemical producing these changes, and other factors. The voices may belong to people known to the patient, alive or dead. They may teach the subject or hold conversations with him. They may make fun of him or give him orders, such as, "Do not eat any more." Religious communications have been very common, but in recent years, sexual comments seem to have become more frequent.

The nature of the communication is not as important as the ability of the patient to act, or refrain from acting, on the advice given him. A person may have the most vivid auditory hallucinations, yet appear normal as long as he can refrain from doing what the voices tell him to do, and telling others about them. One patient, a physically and mentally rugged individual, heard voices telling him as he shaved every morning, "Cut your throat, cut your throat." But he knew this was nonsense and carried on as if these voices did not exist. This man had lost both legs in action in 1917 during the First World War and had made a splendid adjustment to this disaster. His schizophrenia did not develop until 1947, 30 years later.

One of the stages in treatment, therefore, is to convince patients not to tell others about their hallucinations.

Changes in Smell
Patients may become either more or less sensitive to odors. Since smell is an important factor in taste, any change in the former may lead to a change in the latter. The patient may become acutely aware of odors not normally noticed before. Body odors may become exaggerated and unpleasant. Other people may smell strange. Consequently, patients may wash themselves excessively or insist that others do so.

Hallucinations of the sense of smell can occur such that patients will be aware of odors not present. These hallucinations seem rare in schizophrenia, but as questions about smell are not commonly asked, we really do not know. Patients will complain about them only when the changes are pronounced.

Normal human beings are as loath to accept the fact that things smell differently to different people as they are to believe they taste differently. Yet it is well known that some people find a perfume most attractive when

others will consider the same perfume to be vile. Generally, children are better smellers than adults. There are cases reported of children who were able to identify the owners of clothes by the unique odor, even after the clothes had been cleaned.

Many physicians can diagnose certain diseases by the odor. We can smell schizophrenia when it is present in some patients, while other physicians cannot. The smell of schizophrenia is a peculiar, aromatic, slightly musty odor. Many schizophrenics can smell their own sick odor and find it very troublesome. One of our female patients diagnosed the condition in three out of her seven children by this odor. As they recovered, the odor vanished.

Changes in smell perception can result in a variety of bizarre delusions. Several patients have smelled strange odors and assumed they were being gassed. Others have assumed food was poisoned, because of the smell, and refused to eat it. This recalls the work of Professor Kurt Richter with rats. When given poisoned food, they had a choice of eating it or starving. Instead, they became catatonic.

One patient complained someone was pulling his seminal fluid from him since he could smell it all over himself. Another of our patients made desperate attempts to deodorize his barn because his sense of smell had become too keen. One patient claimed to smell dust and insisted on a thorough housecleaning every day. When her family objected, she became violently angry. A whole family can be subjected to elaborate bathing and washing rituals by a sick member.

Changes in Touch

These changes seem to occur less frequently than in any of the senses. Patients may become more or less sensitive to touch. Usually they become less sensitive to pain. Decrease in touch sensitivity is generally not troublesome unless the patient's job depends upon a keenness of touch.

But an increased sensitivity can be very troublesome. The feel of a fabric can be exaggerated until it feels like harsh animal hair. There might be bizarre sensations, like the feeling that worms are crawling under one's skin. Unusual touch sensations may be interpreted as having electricity applied to one's person, being stuck with needles, and so on. There may be increased or decreased sensitivity in the genital organs, resulting in sexual delusions.

Normal subjects commonly experience the feeling of being out of the body when they take LSD-25. This usually occurs when the subject is so relaxed he is unaware of his own body. The medical explanation for this may be that messages from the outside of the body to the brain are temporarily suspended, and that the patient's "perceived body" is distorted. "Perceived body" is the awareness of the limits of one's own body. This is undeveloped in babies, but well-defined in adults.

If the body image is diffuse, patients can invade other people's "personal" space. In their research at Weyburn Hospital, Dr Osmond and Dr R. Sommer found that there is a space surrounding each person, which, if invaded by another, makes the person very anxious. You have seen some people talking face-to-face, while others are at least a yard away. The extent of personal space around each individual is determined psychologically and by the customs of the society in which the subject lives.

If a young female schizophrenic loses the ability to judge body image, she may unwittingly get too close to men and so appear to them to be forward or seductive, with many undesirable results. Staring at another is a violation of personal space and makes one feel anxious. We may feel threatened or "dominated" if an individual we dislike gets too close to us in conversation.

In another disturbance of "perceived body" induced from taking LSD-25, the subject may see his own body from the outside as though he were on the ceiling looking down on himself. This also occurs with some schizophrenic patients. One patient was placed in a jail cell because of his asocial behavior. During this incarceration, he woke up one day and, hearing footsteps in the corridor, went to his cell door to look out. In the corridor, he saw himself pacing restlessly up and down.

Changes in Taste

In schizophrenia, the proper balance of flavors is altered. Patients may become less sensitive to taste so that foods taste unusual. New tastes may occur.

It has been known for many years that people's taste sensations differ. The same tea may have a different taste to each person who drinks it. The ability to taste a compound called phenylthiocarbamide is inherited. To some people, it tastes bitter, and to others, it is tasteless.

It is remarkable how often people will not believe that this difference in taste is possible. Tasters do not believe there are non-tasters, and non-tasters believe tasters are lying or are mentally sick. Husband and wife have been observed to have furious arguments over this. This is due to the nearly universal belief that every person senses the common world like every other person, and all things are seen, felt, tasted, and smelled the same way by all people.

It is also believed that if there are changes in taste, this must be due to a clearly recognizable condition, such as having a cold, being tired, and so on. When, therefore, changes in taste sensation do come on in the absence of a cold or other such reason upon which to blame them, it is assumed to be due to a change in the food that is being eaten. Coffee may suddenly taste bitter, or the subject may feel that something has been put in the meat to make it taste strange. One of the most distressing things that can happen is for food to taste bitter, metallic, or tainted, for this can easily lead to the belief it has been poisoned. Many patients will, as a result, refuse to eat, and will suffer malnutrition. Dr John Conolly in 1849 believed that many of his patients' delusions arose from disorders in taste perception. He reported many patients would not eat because foods had a coppery taste.

The poisoning delusion leads some people to prepare their own food in elaborate and peculiar ways, and has led some patients to take drastic action in self-defense against the alleged poisoner. Other taste changes may puzzle and bewilder, but they need not lead to any great inconvenience unless, of course, the patient is a taster, whose livelihood depends upon the sense of taste. However, if this happens to the primary cook in the family, it might account for some peculiar taste in the food of which he or she would be unaware, but which might lead to bitter arguments with the rest of the family.

The only dangerous changes are those leading the patient to believe someone has tampered with the food. In our culture, bitter things are often associated with medicines or poisons, and it is very likely that the common delusion of people with schizophrenia that they are being poisoned stems from the hallucinations that the food tastes bitter.

Changes in Time

Time is one of the important senses, even though there seems to be no

definite organ that deals with it. It is likely time perception is a function of the entire brain, which acts like a computer, integrating all sources of information from the senses to estimate the passing of time. For example, the eye sees day and night, sun, stars, and shadow. The ear hears different noises at different times of the day, while the body feels hunger and other sensations from bladder, bowel, fatigued muscles, and heartbeats. All these impulses, taken together, help us to tell whether it is morning, noon, or night. This skill has to be learned, and time- or clock-conscious societies force their members to learn it more thoroughly than others, although no human is ever free of the need to know that time is passing.

Few people realize how important the sense of time passing is to them until they are deprived of external aids, such as wristwatches, or unless they find themselves in a world where time has lost its normal qualities, such as in the world of LSD-25. Today, when so many new demands are being made on our ability to perceive the passing of time, we can imagine the havoc that would result in our daily lives if we suddenly found ourselves unable to judge, or be aware of, time passing normally. Yet schizophrenics are continually living with a distorted time sense.

Time may appear to pass very slowly, as in the hour spent listening to a dull lecture. Time may pass very quickly, as in the three hours spent in an interesting chess game or in hours of love, which fly by in minutes. Time may stop altogether when there is no sensation of time passing at all. Patients in mental hospitals are frequently disoriented for time, possibly due to the lack of external aids that other people depend upon. The sense of days and weeks passing is normally diminished when one is removed from one's daily occupation. People on vacation and patients in hospital are more disoriented at home. In general, calendars, daily newspapers, and daily visitors help maintain orientation. But mental hospitals are not so well blessed. One of our chronic schizophrenic patients was completely disoriented in time until the nurses were instructed to show her the calendar and daily newspaper and to ask her frequently the day of the week and the date. With these aids, she soon became normally oriented.

In schizophrenia, there can be very few changes in the sense of timing, but their effects are very profound. In our research, we found that schizophrenics are more confused and muddled about time than any other patients – except those in confusional states, for example, in senility or toxic

states of other illnesses. They seem to be in long, slow delirium, resembling the state normal subjects find themselves in when they take LSD-25.

Some catatonic patients seem to be suspended in time. When they recover from their catatonia (the state suffered by some schizophrenics when they do not move or speak), they can remember things that happened around them but not the order in which they happened. Time is normally sequential. That is, "today" follows "yesterday" and is behind "tomorrow." It would be very disturbing if this normal flow of time were reversed. This happened to one of our subjects who, when given LSD, found himself drinking his coffee before the cup was lifted to his lips. We have not yet seen this in patients, but we have not made a particular point of inquiring about it. We do not doubt it does occur, but it is rare. The order of events in schizophrenia, however, can be confused.

The changes may be of short or long duration and one may follow the other. A patient may sit down for a few moments, stay there several hours, and "come to," thinking only moments have passed. Schizophrenics alternate between periods of time passing slowly and time passing quickly. When it is passing slowly, they may be depressed. When it is passing quickly, they may be excited and elated. It is usually believed the mood sets the time sense, but there is no reason why the time sense cannot set the mood.

In fact, in our hypnotic experiments, the mood was exactly correlated with the change in time passing. The slowing down of time movement produced depressed emotions. The speeding up of time produced euphoria, cheerfulness, and even mania. When time was stopped, catatonia was produced.

It is surprising that so little attention has been paid to time perception in schizophrenia and its relationship to mood, even though this has long been a matter of general knowledge. It is also surprising that so little use has been made of this knowledge to develop diagnostic tests for schizophrenia.

Synesthesia

Some people experience a phenomenon called "synesthesia," which may be normal for them, but surprising and frightening for others. In synesthesia, some people see a flash of light at the same time they hear a musical note. This commonly happens when one has taken LSD-25 or its related compound, mescaline. It also occurs in schizophrenia. One may feel a pain in

the chest at the same time one sees a flash of light. This can be very disturbing to patients and can easily lead them to believe they are being controlled by magic or by the influence of others. One patient kept getting messages from the planets. Some patients have a feeling of omnipotence and power.

Changes in Thought

Although we will not attempt to list all the varieties of changes in thought that can occur in schizophrenia, they may all be classified into two main categories: change in thought process and change in thought content.

Thought Process

By the process of thinking we refer to the act of putting thoughts into words in a logical manner. Ideas follow one another simply and logically and are appropriate to the time and situation. Random and stray thoughts do occur, but they are under control and do not interfere with the normal flow of thinking. Memory for recent and remote events is adequate and the timing of one's thoughts is in tune with, and appropriate to, the group engaged in the conversation.

Any major change in brain function may disturb or disrupt this normal flow of thinking. The following changes in thinking have been found in schizophrenia.

There are no ideas whatever: the mind is blank. This happens momentarily now and then to all of us. Repeated momentary blocks of this kind are called blocking. But when there are minutes or hours of blankness, it is highly pathological. One patient was mute. After many hours of trying to get him to talk, he blurted out that he could not talk, for his mind was blank. When he was given a book to read, he was able to read it aloud perfectly correctly. The words on the page were properly registered in his brain and properly reproduced as words, but he had no thoughts of his own to put into words.

The process of thinking may be slowed down. This is found more frequently in patients who are severely depressed, whether or not schizophrenia is present, and may be related to a slowing down of the sense of time passing.

One schizophrenic patient spoke extremely slowly and answered questions only after prolonged pauses. When her sense of time passing was speeded up by hypnotic suggestion, she was able to respond much more quickly and speak more rapidly for several weeks.

The opposite of this, a marked acceleration of thought and speech, is also found in schizophrenia, although it is more typical of manic states. This may account for the increased brilliance of many young schizophrenic patients when their schizophrenia is just beginning.

Thought processes may be so disturbed that one thought is followed by another that has no direct connection with it. Thoughts may jump about at random. Bizarre thoughts may intrude and interfere with normal thought.

Memory and recall may become so disturbed that clear thinking becomes impossible. Patients have described some of these changes to Dr Andrew McGhie and Dr James Chapman. On patient explained, "Sometimes I can't concentrate because my brain is going too fast, and at other times, it is either going too slow or has stopped altogether. I don't mean that my mind becomes a blank, it just gets stuck in a rut when I am thinking over and over again about one thing. It's just as if there was a crack in the record." Another patient explained, "I may be thinking quite clearly and telling someone something and suddenly I get stuck. What happens is that I suddenly stick on a word or an idea in my head and I just can't move past it. It seems to fill my mind and there's no room for anything else. This might go on for a while and suddenly it's over. Afterwards I get a feeling that I have been thinking very deeply about whatever it was, but often I can't remember what it was that has filled my mind so completely."

"My trouble," another patient commented, "is that I've got too many thoughts. You might think about something – let's say that ashtray – and just think, oh! Yes, that's for putting my cigarette in, but I would think of it, and then I would think of a dozen different things connected with it at the same time." As another commented, "My mind's away. I have lost control. There are too many things coming into my head at once and I can't sort them out." These are some of the changes that can occur in thought process in schizophrenia. They are invariably present in well-established cases, but they may not be present very early in the illness.

Because the patient cannot control ideas or thoughts, or perceive normally, his speech is disturbed, leading some professionals to believe there is a "schizophrenic language." There are some writers in psychiatric literature who even give the impression that they know and can even hold conversations in a schizophrenic language. This is another myth.

Dr Osmond and Dr Sommer tested patients in the Weyburn Mental Hospital, Saskatchewan, with the Word Association Test, which was originally used by Sir Francis Galton in 1879. The test is completely objective and can be given and scored by an untrained technician. Dr Osmond and Dr Sommer became interested in this question while studying autobiographies of mental patients. When they compared these to books by former prisoners, they found that they could hardly read some prison books without a glossary because of the special language of prisoners. But there was no special language among mental patients. They felt this could explain the lack of organized social activity among schizophrenics and the fact that schizophrenic patients did not organize mutinies, riots, or protests.

In their studies with patients, they found that schizophrenics not only had less in common in word associations than non-schizophrenic patients and normal subjects, but that they did not understand one another's speech any better than anyone else did. In fact, they found that patients were intolerant of the delusional and incoherent speech of other patients, and only paid attention when their fellow patients talked more or less normally. Patients sometimes complained about "crazy talk" by other patients and even walked out of meetings and group therapy sessions if there was too much of it.

They found that though the speech of schizophrenics may appear bizarre to us, they were actually responding to information received through their senses. Thus, rather than having a language of their own, they associate with their own associations to the words given them. Furthermore, as additional proof, a schizophrenic's associations to the same word may vary.

This leads us to believe there is no schizophrenic language, but that the schizophrenic's disjointed, rambling, and often incoherent speech is another symptom of the schizophrenic process that has broken every line of contact with the world.

Thought Content

Everyone has wrong ideas. Superstitions, beliefs in certain 'miracle' foods, prejudices against groups, and extraordinary belief in one's own abilities are examples of commonly held wrong ideas. We may go along quite contentedly with these ideas for most of our lives, particularly if most people in our society share them with us. When our wrong ideas conform to ideas generally accepted in the community, we are not sick, even though other societies believe they are abnormal. For example, enormous numbers of men believe in racial superiority, while enormous numbers of other men believe this is a delusion. Yet the individuals who share this widely held belief are normal in their own society.

But at some time or another we may have to ask ourselves, is this idea true? Does it make sense? Is it normal to think that way?

We can decide for ourselves whether our ideas are true or normal by testing them. We can search for supporting evidence. We can compare them with the consensus of ideas in the community. We may then find that our ideas are indeed wrong or different, but that we cannot help believing them. In that case, we have to decide whether we want to keep our ideas, even though they are wrong, or whether we want to change them. If our ideas interfere with our jobs, with our relationships with relatives and friends, and with our general effectiveness in our community, then we must examine them closely and decide either to take the consequences or to reject the ideas.

Many schizophrenics at one time or another in the course of their illness also have wrong ideas, but these are more extreme and may fluctuate. They may believe that someone has poisoned them or that they are victims of some community plot. This, of course, is not so, yet they may develop a long line of logical reasoning to explain why they believe this is so.

When she is well, the schizophrenic is able to judge whether her observations are true or not. But when she is sick, her judgment is impaired. This, together with the changes in perception that characterize the illness, can lead to an infinite number of bizarre and unusual changes in thought.

Again, we must emphasize that thought can be considered abnormal only if it differs markedly from the culture one is in. We do not mean the kind of culture that refers to art or literature, nor do we mean a "cultured"

person who is well versed in these matters. By culture we mean the total number of factors in which a person has grown and lived, which have molded or shaped that person. Westerners grow up in a Western culture of competition, judging status and prestige by wealth and accomplishment. North American Indians had varying cultures, where status meant different things in different tribes. Thus, a paranoid whose thoughts may be bizarre in our culture is normal in a community where everyone else's ideas are also more or less paranoid.

It is relatively unimportant to know all the kinds of content changes that can occur in schizophrenia. There is hardly any idea that cannot be imagined, and undoubtedly, these have been found among schizophrenics. But if the ideas become extreme and unusually different from the thinking of people around them, they may be a symptom of schizophrenia.

Changes in Mood

One may be normal in mood, depressed, too happy, or completely lacking in feeling – that is, flat or uninterested. But among schizophrenics, mood may not be consistent with the thought content expressed by the subject in his speech and, in this case, may seem inappropriate to the observer.

Depression is the most common change in mood. Everyone at times is depressed, especially when one is sick, or frustrated, or has failed in some endeavor. In fact, it is so common that most people are convinced that every depression must be the result of some failure, some reverse, or some clear physical disease. It is very difficult to convince many patients that the depression is primary and may occur in the absence of a precipitating event. Nearly all patients, and most psychiatrists, search ceaselessly for a reason, and this search, which is so often fruitless and degrading, is aided and abetted by careless professional probing.

Depression is often the earliest symptom of schizophrenia, just as it is the first symptom of many other illnesses. Whenever depression occurs in a young person where there is no physical illness or other clear reason for it, schizophrenia should be suspected. The depression (sadness) may come on slowly, endure for several days or weeks, and then vanish until the next episode. The subjects are then hounded by inexplicable moods of despair

and irritability. When this is witnessed together with clear perceptual changes, the diagnosis can be made early. The period of depression may be followed by a feeling of euphoria, when the patient feels much too happy when all circumstances are taken into account. But these periods of elation are few. The usual story is to have periods of depression followed by periods of normality. If the moods are too short and follow each other rapidly, especially in young people, schizophrenia is very likely the reason.

But when depression occurs alone as the first symptom, the patient is not so fortunate. It is likely he will then be diagnosed with depression or an anxiety neurosis for many years. The unfortunate schizophrenic will then fall into the group of depressions who within 10 years are clearly schizophrenic, or in the group who respond to ECT (electric shock treatment) or to anti-depressant drugs with a gratifying change of mood, but, to the horror of their doctor, now appear schizophrenic. Meanwhile, many valuable years have been lost, during which the patient could have been given specific treatment and spared useless therapies.

If mood swings are present, they are often diagnosed as bipolar or manic depressive psychosis. Perceptual changes are minimized by ascribing them to a type of delirium induced by the manic state, and thought disorder is now considered a symptom characteristic of this affective disease. This belief is reinforced by the fact that a few patients do show features of both diseases and that their moods are stabilized by lithium. Many equate recovery by lithium as the definitive diagnosis of manic depressive psychosis.

During the early stages of the illness, the depression is always appropriate to the patient's circumstances. This, too, makes diagnosis difficult, since many psychiatrists wait for the depression to become inappropriate before they will entertain the diagnosis of schizophrenia. But this delay is very dangerous, for the disease becomes well entrenched and chronic before the mood becomes inappropriate enough to satisfy the psychiatrist. No research has come to our attention that shows how long it takes for a schizophrenic's depression to become inappropriate, but it must be several years.

Still, the most common inappropriateness in mood is flatness, in which the patient feels neither depression nor happiness. He feels no emotion at all and is completely apathetic. This can be a disturbing symptom for subjects who once did feel appropriately, but if it occurs very early in life and

has been present many years, they get used to it and eventually find it quite tolerable. It is probably easier to endure than the severe tension and depression that usually precede it.

Upon recovering, however, the ability to feel emotion often returns, and this, too, can be disturbing to patients. We have often seen this happen in patients who were receiving adequate treatment with nicotinic acid. It is a mistake in this case to assume that the occurrence of anxiety and tension indicates the disease has recurred. It is, on the contrary, a heartening sign. The patient's tension can be easily controlled with anti-tension compounds, which can be slowly withdrawn usually after a month or so.

This flatness of moods is puzzling. It is very characteristic of schizophrenia, but there is no adequate explanation for it. It is possible it is responsible for the inappropriateness of mood – for, if a person can feel no mood, in time he will lose the ability to judge what his mood should be. Many schizophrenics compensate intellectually for the inability to feel emotions by observing others in social and group situations, and by role-playing the appropriate mood. If the others are sad or gay, they feel they must also be sad or gay, and act accordingly. This is very hard on them and may lead them to avoid group situations.

One beneficial effect of this flatness of mood is that it probably keeps many schizophrenics from killing themselves. It is well known that many severely depressed people do kill themselves, but it is generally known that schizophrenics do not have a very high suicide rate – but it might even be higher if they did not have some flatness of mood. Research in Saskatchewan and elsewhere shows that out of any group of schizophrenics, about 0.2 percent will kill themselves each year. If one started with one thousand fresh cases of schizophrenia, one would expect that two would die each year from suicide, whether they have or have not received psychiatric treatment. The only exception we know of is the treatment program that includes nicotinic acid. Out of over 300 schizophrenic patients treated adequately with nicotinic acid who have been followed up in Saskatchewan for nearly 10 years, there were no suicides.

With the flatness of mood, therefore, it appears as if the disease itself acts as a poor tranquilizer. This will be discussed in a subsequent chapter. The only hallucinogens (drugs capable of producing hallucinations as in

schizophrenia) that reproduce this peculiar flat mood are adrenochrome and adrenaline, which are probably present in the body, and which we think are somehow responsible for the disease process called schizophrenia. This hypothesis will also be discussed in the next chapter.

Changes in Sleep Patterns

One of the most common changes in schizophrenia is fatigue. Very often it is the first symptom to appear. It comes on slowly and insidiously and is very disabling. It becomes difficult to perform one's job, and this produces great anxiety. Eventually, fatigue may become so great that the patient is immobilized by it. Others, not realizing how ill they are, find this difficult to understand, and patients, as a result, are often accused of being lazy and indifferent. They naturally resent this, and so further misunderstanding and resentment is generated.

One of our male patients, aged 26, recalled the great difficulty he had had because of fatigue. He had been ill many years, with several admissions to a mental hospital. After recovering, he remarked that he clearly recalled the excessive fatigue he first felt when he was eight years old. This feeling remained with him from then until after he had been treated. During those 17 intervening years, he was chronically fatigued and considered to be lazy, stupid, and indifferent. With some bitterness, he recounted the great difficulty he had had in school, and said that he had always considered himself to be stupid. But now he found he was able to grasp the course of studies with little difficulty, and realized he was not stupid at all, but had experienced trouble learning because he had been ill.

Lack of sleep itself will produce hallucinations and other symptoms commonly present in patients who have schizophrenia. In one of the first experiments in 1947, Dr Tyler kept normal subjects awake up to 72 hours. After 30 to 60 hours of being awake, many symptoms of schizophrenia appeared. They included increased irritability, lack of attention, loss of memory, illusions, and hallucinations. If lack of sleep can cause normal people to suffer these changes, it is not surprising that lack of sleep, even though it is not as severe, can make mental patients worse. This is a common observation made by psychiatrists who work closely with their patients.

In fact, patients are so sensitive to lack of sleep that many become worse

has been present many years, they get used to it and eventually find it quite tolerable. It is probably easier to endure than the severe tension and depression that usually precede it.

Upon recovering, however, the ability to feel emotion often returns, and this, too, can be disturbing to patients. We have often seen this happen in patients who were receiving adequate treatment with nicotinic acid. It is a mistake in this case to assume that the occurrence of anxiety and tension indicates the disease has recurred. It is, on the contrary, a heartening sign. The patient's tension can be easily controlled with anti-tension compounds, which can be slowly withdrawn usually after a month or so.

This flatness of moods is puzzling. It is very characteristic of schizophrenia, but there is no adequate explanation for it. It is possible it is responsible for the inappropriateness of mood – for, if a person can feel no mood, in time he will lose the ability to judge what his mood should be. Many schizophrenics compensate intellectually for the inability to feel emotions by observing others in social and group situations, and by role-playing the appropriate mood. If the others are sad or gay, they feel they must also be sad or gay, and act accordingly. This is very hard on them and may lead them to avoid group situations.

One beneficial effect of this flatness of mood is that it probably keeps many schizophrenics from killing themselves. It is well known that many severely depressed people do kill themselves, but it is generally known that schizophrenics do not have a very high suicide rate – but it might even be higher if they did not have some flatness of mood. Research in Saskatchewan and elsewhere shows that out of any group of schizophrenics, about 0.2 percent will kill themselves each year. If one started with one thousand fresh cases of schizophrenia, one would expect that two would die each year from suicide, whether they have or have not received psychiatric treatment. The only exception we know of is the treatment program that includes nicotinic acid. Out of over 300 schizophrenic patients treated adequately with nicotinic acid who have been followed up in Saskatchewan for nearly 10 years, there were no suicides.

With the flatness of mood, therefore, it appears as if the disease itself acts as a poor tranquilizer. This will be discussed in a subsequent chapter. The only hallucinogens (drugs capable of producing hallucinations as in

schizophrenia) that reproduce this peculiar flat mood are adrenochrome and adrenaline, which are probably present in the body, and which we think are somehow responsible for the disease process called schizophrenia. This hypothesis will also be discussed in the next chapter.

Changes in Sleep Patterns

One of the most common changes in schizophrenia is fatigue. Very often it is the first symptom to appear. It comes on slowly and insidiously and is very disabling. It becomes difficult to perform one's job, and this produces great anxiety. Eventually, fatigue may become so great that the patient is immobilized by it. Others, not realizing how ill they are, find this difficult to understand, and patients, as a result, are often accused of being lazy and indifferent. They naturally resent this, and so further misunderstanding and resentment is generated.

One of our male patients, aged 26, recalled the great difficulty he had had because of fatigue. He had been ill many years, with several admissions to a mental hospital. After recovering, he remarked that he clearly recalled the excessive fatigue he first felt when he was eight years old. This feeling remained with him from then until after he had been treated. During those 17 intervening years, he was chronically fatigued and considered to be lazy, stupid, and indifferent. With some bitterness, he recounted the great difficulty he had had in school, and said that he had always considered himself to be stupid. But now he found he was able to grasp the course of studies with little difficulty, and realized he was not stupid at all, but had experienced trouble learning because he had been ill.

Lack of sleep itself will produce hallucinations and other symptoms commonly present in patients who have schizophrenia. In one of the first experiments in 1947, Dr Tyler kept normal subjects awake up to 72 hours. After 30 to 60 hours of being awake, many symptoms of schizophrenia appeared. They included increased irritability, lack of attention, loss of memory, illusions, and hallucinations. If lack of sleep can cause normal people to suffer these changes, it is not surprising that lack of sleep, even though it is not as severe, can make mental patients worse. This is a common observation made by psychiatrists who work closely with their patients.

In fact, patients are so sensitive to lack of sleep that many become worse

from morning to evening. It is well known that physically ill people feel better in the morning after having slept. As the day progresses, they become more and more fatigued until, in the evening, they may be very miserable. A substantial number of schizophrenic patients feel quite well in the morning, but in the evening their symptoms can be most troublesome.

Some years ago we examined the nursing records of patients in the morning and in the evening. The nurses were not aware the study was being made. We were surprised how different the same patient appeared when the morning and evening periods were compared. In several cases, a colleague examining patients in the morning could not believe they were suffering from schizophrenia, but a re-examination late in the afternoon dispelled his doubts.

Patients should be aware that lack of sleep can change them so markedly. This may have a profound influence on their reactions to their relatives and friends. Schizophrenic patients often are not able to attend to the conversation of more than one other person. If they are engaged in conversation with two or more people, a powerful effort to listen and to understand what is going on is needed. This is easier for them in the morning. As a result, they may drift away from groups late in the day when they will not do so in the morning. We once had a meeting with a recovered patient that required much discussion of important matters for several hours. After two hours, it was obvious he was fatigued, much less talkative, and had great difficulty following the conversation. This is not peculiar to schizophrenia. Other brain disorders produce similar changes.

Changes in Social Behavior

It should not be surprising that changes in perception, thought, and mood should lead to changes in social behavior. The social consequences of schizophrenia follow naturally from the perceptual and other disturbances that accompany the illness. Yet, as far as we know, they have never been linked together in an understandable way. Perhaps by examining some of the simplest interactions between two people, we can become aware of a few of the many problems that assail not only patients with schizophrenia but also the people they contact.

As Professor Edward T. Hall has shown, the presence of a person who

does nothing and says nothing will alter the behavior of someone who has previously been alone. Let us suppose, then, that two people are walking towards each other. At first, they are too far away for recognition to be possible. As they get closer, it might seem at this point nothing much could possibly go wrong. Yet we know from the work of our old friends, Professors Sommer and T. Weckowicz, that much could, and very often, does go wrong.

As people walk toward us, we see them getting closer. But they also get bigger and bigger. We learn to interpret this enlarging of the image on the eye retina as meaning the individual is getting closer, although it might equally well mean that the object from which the light was being reflected was getting larger. This is a subtle distinction that schizophrenic patients are sometimes unable to make, and many of them have reported the eerie and frightening experience of a tiny dwarf becoming a huge and menacing giant as it looms forward.

In normal people, by some complex and not yet understood mechanism of the brain, the approaching figure remains roughly the same size, but for many schizophrenics, we now know, this reassuring mechanism goes wrong. A very common problem these patients face, for instance, occurs when they are driving on the highway and oncoming cars seem to rush by too quickly. In addition, they are uncertain of their position in their own car lane, and many feel they are too close to the center line or too close to the edge of the road. For this reason, it is not unusual for patients who are developing schizophrenia to stop driving many months before they seek help. Others, however, continue to drive, and we suspect the accident rate for schizophrenics is rather high.

We know one patient who was an excellent pilot of small planes and made a living dusting crops. He was normal as long as he took nicotinic acid regularly. For unknown reasons, he stopped taking the medication, and a few months later, his symptoms began to reappear. While motoring back to Saskatoon for help, he drove his car into a concrete pier alongside the road and was killed. A second patient was a physician who became schizophrenic. He also died in a similar car accident. Finally, we have recently come upon a schizophrenic patient who has a long record of automobile accidents.

What the sick person does about this strange experience must depend on his previous life experiences. He may simply be interested, observe it, and learn how to live with it. His stoic calm is perhaps more frequent than we suppose. Another patient may well become panic stricken, freeze with fear, run away, or lash out with his fists. When he sees someone coming toward him as being frighteningly large, whatever he does is likely to surprise and even distress the other person. If the latter is genial and expansive, he may be holding out a hand in welcome, but the sick one will see an enlarged and quickly growing hand coming at him in an uncanny or menacing way. As fear and terror grows, this hand could lose all connection with his friend's body, and as it seemingly pounces on him, it might turn into a huge disembodied talon clawing forward.

A schizophrenic person can easily confuse his wishes and hopes about a relationship that might develop in the future with one that actually exists in the present. Actions taken on the basis of these unrealistic hopes may well confuse and dismay the other person. The person with schizophrenia would then feel that he had been rudely and inexplicably rebuffed by someone whom he had deeply trusted.

Schizophrenic patients sometimes fail to recognize those who are familiar to them. This is not surprising if one considers how extraordinary it is that we can pick out people we know from hundreds – or even thousands – of people who are roughly the same size and shape. Orientals often complain that all Occidentals look alike, and *vice versa*. This suggests that we commonly use rather small clues to distinguish one face from another. The schizophrenic who doesn't recognize his friend will suppose that he is being addressed in a familiar way by a stranger, and may refuse to acknowledge his greeting and turn away, suggesting that he has made a mistake. The patient may also respond in a reserved or perfunctory manner. This may hurt the friend's feelings enough for the sick person to lose contact with someone who, if he had understood what was happening, would have made allowances for such behavior in the very same way that one excuses shortsightedness or deafness.

It may happen that the sick person mistakes a total stranger for a relative, friend, or an enemy, often due to some real resemblance. Anyone who has waited those long minutes that seem like hours for a girlfriend or

boyfriend at some assigned spot knows how frequently figures seen in the distance can resemble each other in size. As the figure comes closer, hopes rise – only to be dispelled when you are about to greet the wrong person.

Expectations are great deceivers. The schizophrenic person can easily mistake a similarity for an identity and refuse to believe that a total stranger is not a relative or a close friend. This person will then address the stranger in an unexpectedly warm and friendly way. The greeting is often reciprocated, for most of us are usually delighted with such spontaneous friendliness. This, however, only confirms the sick person's belief, and disillusionment follows sooner or later, making the schizophrenic person timid and uncertain about initiating such relationships in the future. This person may easily come to believe that doubles of his relatives and friends are being kept nearby to annoy or spy upon him. Schizophrenic patients need constant warmth and encouragement, which they respond to positively, albeit slowly. Unluckily, they are easily put off by what they construe to be rejection and take it very much to heart.

Time perception plays a big part in social relationships. Speech that is either too fast or too slow becomes unintelligible. Speech depends upon loudness, pitch, and a variety of emphasis and inflection, all of which are influenced by timing and which can greatly alter the meaning of what is spoken. The simplest phrase can be said in many different ways with many different meanings. A skilled actor can make a sentence like "To be or not to be? That is the question," carry all kinds of unexpected possibilities.

But timing affects much simpler matters than speech – the handshake, for instance. Few of us know exactly how long a handshake ought to take. Most of us, however, do know when a handshake takes too short or too long a time. A person who drops one's hand without clasping it, or holds on to it indefinitely, gives one a sense of discomfort and uneasiness which is quite hard to put into words. Try it on an old friend and see what he makes of it, but be sure to explain what you have done afterwards.

Yet this ability to shake hands at the 'right' speed is something we learn during childhood from those around us, and must be closely connected with our sense of time and with an awareness that the person whose hand we are shaking feels that the ceremony is completed. Again, just how close should one stand to another person? Professor Hall, in his brilliant series of studies, has shown that this differs greatly from country to country. Arabs, South

Americans, and Russians like to be close to a person with whom they are talking. North Americans and the British prefer being farther away and are 'stand-offish'. Different peoples have different ideas about what these distances should be, but one usually learns the distances that one's neighbors, friends, and relatives prefer, and most of us maintain them.

The schizophrenic person often loses his ability to judge the volume of his envelope of space around others and around himself. This person either comes too close and seems intrusive, or stands too far away and appears unfriendly. The consequence of either of these actions can be graver than one might expect. If people intrude on our personal space, we tend to move away involuntarily, and if they keep coming towards us, we become tense and anxious. The sick person may easily interpret this to mean a distaste for him personally and either withdraw, hurt and mortified, or become quarrelsome to seek revenge for the slight.

If it is the schizophrenic person whose need for space has been increased, he may become afraid and angry at what seems to him to be an aggressive and unjustified intrusion upon his very being. Unless one knows what may be wrong, such behavior seems inexplicable, and indeed, it usually is, for nearly all of us take these everyday matters for granted because they are outside our awareness.

These, then, are simple and straightforward examples of the way in which schizophrenia affects everyday life situations. Let us now look at something a little more complicated. In many – perhaps most – situations involving two or more people, one is seen as being older, wiser, richer, more powerful, more important, or higher-ranking than the others. This is known as a status relationship, and similar relationships occur among many gregarious animals and birds.

Examples among humans are employer and employee, teacher and pupil, mother and daughter, bishop and curate, officer and soldier, older brother and younger brother. The person of higher status is expected to behave in ways that show he is aware of his higher station, and the lower status person to acquiesce with good grace. Most of us learn to accept a higher or lower status in a variety of rapidly altering situations. Indeed, in everyday life, every one of us has to be a quick-change artist in these matters. We are parents one moment, and could be children the next; pupil in one situation, teacher in another; telling people what to do in the morning,

and having our licenses scrutinized by the police in the afternoon. However, we can only succeed in such changes if we can perceive both ourselves and other people accurately. If we cannot do this, we are likely to behave strangely and make those with whom we are trying to interact behave less normally, too. A lower-status person is as uncomfortable with a higher-status person who behaves in a manner below his station as if the reverse occurred. A general who behaves towards a colonel as if the colonel were his superior would make the latter unhappy.

People with schizophrenia can and do make both kinds of mistakes due to their misperceptions, and this leads to endless trouble. The tension and uncertainty is compounded because people are seldom aware of what is happening and can take no adequate counter-measures. Consequently, social relations become eroded or may break down completely. Due to perceptual difficulties and lack of energy, the schizophrenic person cannot respond to his fellows either as quickly or as consistently as normals can. Unless healthy people know what is wrong, and are taught how to help this person and make allowances for his deficiencies, he will probably drift, and be driven further and further out of touch.

Although there are many other behaviorial changes that people with schizophrenia undergo, the most common misperception of their behavior by society is that they are dangerous. They are, indeed, somewhat more dangerous to themselves than they would be if they were not schizophrenic, but they are not more dangerous to other people.

The risk of homicide among people with schizophrenia is no greater than it is for non-schizophrenics. Nevertheless, this belief is so well engrained that it has until recently been an article of faith for mental hospital architects, society, and even nursing staff. This is one reason mental hospitals have been built like fortresses and jails. The best evidence that this is false is the fact that one or two rather small female nurses can herd as many as 40 to 60 or more chronic schizophrenics.

There are, of course, isolated incidents of homicide. These result from certain delusions, especially when the hospital staff do not treat the patient appropriately. It is a general rule that a violently aggressive patient is a sign of poor psychiatric treatment. Most modern mental hospitals have done away with physical restraints, cuffs, guards, etc., with great success.

The behavior of schizophrenic patients is predictable when one takes the trouble to find out, not only what they think, but what they perceive.

Diagnosis

The first responsibility, when changes in perception, thought, mood, and behavior do occur, is to diagnose the presence of schizophrenia. In order to do this accurately, the simple fact that perceptual changes are absent or present is most important, and when they are present, a diligent inquiry must be made before schizophrenia is ruled out. It is important to know the kind of perceptual changes that are present in order to treat the subject intelligently. Very often a proper explanation to the patient will weaken the emotional effects of the perceptual change and make life simpler for him.

These changes in perception, thought process, mood, and behavior are the highlights of the changes that can occur in schizophrenia. No one patient has them all, nor do they remain the same from month to month. We do not advise subjects to diagnose themselves, but we do advise them to familiarize themselves with the symptoms and, if they in any way have similar ones, to seek help. This is the subject's responsibility, just as much as it is the responsibility of a woman to be aware of lumps in her breast that could be cancerous, or of anyone to know that excess consumption of liquids, too much urine, loss of weight, and weakness could indicate diabetes mellitus.

A second way of diagnosing oneself is to become familiar with self-accounts written by schizophrenic patients who have recovered. For this purpose, a bibliography is included at the end of this book. Alcoholics Anonymous has discovered it is good for alcoholics to hear from other alcoholics about their problems. AA literature also follows this principle. *The Grapevine*, the official monthly publication of AA, contains many interesting accounts written by alcoholics who have recovered. These serve two purposes: (1) they provide security by consensus – that is, patients realize there are many others with similar problems; and (2) they are given examples of people equally sick who have recovered. It is quite likely a similar compilation of case histories would be equally useful for schizophrenic patients, who would be encouraged to read them.

A third way is to complete the HOD test (Hoffer-Osmond Diagnostic test), which is included in Appendix A at the back of this book. This is a simple card sort test that helps to differentiate schizophrenia patients from others. This test is based to a large degree on the presence of perceptual changes. It includes 145 cards, and the patient is asked to sort these into two piles, true and false. If the subject has a significant number of true answers, he is usually considered to be ill. Dr Osmond and I developed the test in 1961 on the basis of differences we had observed between people who had schizophrenia and those who did not. It is so designed that high scores indicate schizophrenia is present. Any person who scores very high on this test should decide, not that he is suffering from schizophrenia, but that, if he has symptoms that lead him to believe he is ill, he should be examined by a psychiatrist. A normal person who has no symptoms will not score highly. Young people under 16 tend to score much higher than older people and should not be given the test. The test and its interpretation should be left to a psychiatrist.

The HOD test is the only test that we know of which will not only help tell what your diagnosis is, but will let us know what is going on in your inner life in a direct and straightforward way. Even though we feel it can be much improved and amplified, we find it useful in uncovering changes in sight, hearing, taste, and smell, and indicating what the patient feels about himself and others. Without this simple yet essential information, we cannot begin to guess the kinds of troubles you will have, both at home and at work, because of your illness, and cannot help you understand and live with it until you get well.

The test will furthermore tell when you are getting better and when you are getting worse. If we feel that you are best treated in hospital, the HOD test is a valuable tool for measuring your progress while you are there, will help us decide when you are ready for discharge, and will show us during follow-up studies after discharge, if and when the disease is coming back.

A serious mistake commonly made is the failure to diagnose. Prompt and proper diagnosis is the first important step in the treatment of any disease. Without it, your doctor will not know what the trouble is, how to explain it to you, and what to do about it. As well, it is not unusual to see patients who are sinking into chronic schizophrenia while being zealously treated for a severe anxiety state. Instead of questioning the diagnosis, the

usual explanation is that the therapist has in some way failed in his treatment or, more frequently, that the patient (or his family) is in some mysterious manner to blame. But what has actually happened is that the doctor has not been able, or willing, to diagnose such a grave illness as schizophrenia. We cannot overemphasize, therefore, that when schizophrenia is present, it must be diagnosed for the very practical reason that we are advocating here: if proper treatment is started early enough, the majority of the patients will be cured. Failure to diagnose schizophrenia correctly, in our opinion, is as serious, for example, as failure to diagnose cancer of the breast.

Assuming then that you have found a doctor who has examined you for schizophrenia and has satisfied herself or himself that you are suffering from this disease, what is the next step?

If you are sick, you must be told the nature of your illness and be given its name. You must be told, straightforwardly, "You have schizophrenia."

We find that the patient's response to the word "schizophrenia" will vary all the way from fear and denial to marked relief. We have had a few patients who denied they were ill until they began to recover and realized they had been ill. We have seen many who experienced a marked sense of relief when told what they were suffering from, for now they and their families had an explanation for their difficulties. This same sense of relief has been reported by patients diagnosed with other very serious diseases, like tuberculosis, cancer, or even leprosy. Almost anything is better than an unknown and unnamed ailment. One patient told us that his psychiatrist's refusal to answer his questions frightened him more than his symptoms. "I used to keep my white gloves clean all the time," one patient said. "I know they need to be washed now, but I just haven't the same interest, and no one understands. They seem to think I am lazy, or that I am pretending to be sick, or that it's all in my head."

There will be some who maintain that no one should even be allowed to suspect that he or she might have schizophrenia. This is incompatible with modern scientific principles. There should be no secrecy in medicine. The days of guilds, Latin prescriptions, and other secret devices are long past. In fact, in our experience, patients do appreciate having their suspicions about themselves either denied or confirmed. With the knowledge that you are sick comes a return of self-respect and a new status in the community,

for it is perfectly acceptable to be ill. You can now accept yourself as suffering from an illness, without harmful feelings of guilt and self-recrimination. Others are now allowed by society to show sympathy, understanding, and tolerance. You are able to cooperate in your recovery.

It is very rare for patients to be disturbed when given the diagnosis if the psychiatrist is not frightened. But the diagnosis must be followed by a description of schizophrenia as an illness with causes that will respond to treatment.

3 | WHAT CAUSES SCHIZOPHRENIA?

There are few things in life that have one cause, and there are no diseases where single causes operate. There is, in fact, no limit to the number and diversity of causes that may work together in producing any disease. However, we can approach the analysis of causes by dividing them into two main groups: primary or immediate causes (often the most readily modifiable causes); and secondary or contributing factors. We can divide the causes or factors that lead to schizophrenia in the same way. The most readily treated factors are biochemical. The secondary or contributing factors are psychological and sociological.

The human body is a biochemical organism that is in normal good health when these chemicals are "balanced." The body consumes chemical substances and produces chemical substances. Before anyone can get schizophrenia, the body must lose this balance, and stop consuming or producing chemicals in the normal way. And the body must have the capacity to go out of order for some reason, perhaps genetic or environmental, and start aberrant biochemical changes in motion to cause the disease. This is an immediate cause of schizophrenia. Without it, the disease cannot occur. With it, schizophrenia may occur, but not necessarily so, just as everyone susceptible to tuberculosis does not develop tuberculosis.

Once this 'disease' process is established, the patient has schizophrenia. How patients act and what they think will be decided by the secondary or contributing factors – the kind of perceptual, thought, mood, and behavior changes depend upon the patient's culture and personality. While it is important to know what these changes are if one is to treat the patient adequately, for they mold the disease process and determine the content of the illness, there is very little evidence to support the claim that they can trigger the disease.

Toward a Comprehensive Theory of Schizophrenia

A scientific theory can be compared to a building. A building must have a foundation. Similarly, a scientific theory is built upon a foundation of facts available from all the research that has been completed at the time it is created. It then grows and develops with further research, as new facts are accumulated and old ones expanded.

A theory has two important functions. The first is to provide a logical and intellectually satisfying explanation for the facts that make up the problem. If this is not done, we will have a problem that is not related to the theory. And facts divorced of their proper theory are as incomplete as the pile of bricks from which the house will be built.

The second function is to provide a guide for further exploration and research. If this is done, it will have led the research into previously unexplored territories, yielding valuable and sometimes undreamed of information. These new facts will mold the theory as research progresses, until in its final form, it is unrecognizable. Thus, theories, when research is completed, often have as little resemblance to the original supposition as houses have to the foundations on which they are built.

For theories live only to be altered, and any theory that survives too long unchanged will become fossilized by the veneration of dogma or the scientific incompetence of its disciples. This is what has happened to the psychoanalytic theory.

The theory we will present of schizophrenia is, like most living theories, incomplete, and more work must and will be done on it. It is based upon the best evidence reported in scientific journals and books, as well as our own

experience in treating schizophrenia. It remains to this day the only theory that has attempted – and in our opinion has succeeded – to account for most of the biological, psychological, and sociological factors involved in this illness. Other theories have either ignored biochemical peculiarities found in schizophrenia, or else have made little or no attempt to relate these peculiarities to the psychological and sociological disturbances, considering them to be no more important than the waving of blades of grass in the wind.

Nevertheless, we hope that our theories will go out of date very quickly as evidence about schizophrenia continues to accumulate. In our own ongoing research, we will indeed do our best to make them obsolete. We do not claim that our theory is the only true one, and we invite other doctors and scientists to question our theory, objectively, on the basis of facts.

Summary

Our comprehensive theory of schizophrenia may be summarized as follows:

1. Due to chromosomes (which contain genes) derived from parents, the person uses normal chemicals in an abnormal way.
2. As a result, at a certain time in life, toxic chemicals are produced in the body that interfere with the normal operations of the body, including the brain.
3. Now, the world and the body as experienced by all the senses appear to be altered, strange, different, unreal.
4. However, the person has learned to accept the evidence of the senses as real or true and continues to do so. This person is not aware that these changes are due to changes in his body and believes it is the external world that has altered.
5. Based on these changes, the person reacts in a way considered appropriate, but as the perceptions are inappropriate, so must be these actions, as judged by others. If other people lived in similar worlds, they would react in similar ways.
6. As a result, the person's total behavior and personality becomes different, bringing into play a host of social consequences in relationships with family, friends, and society.
7. Society may react by placing the person in the care of health professionals, in hospital, or even in jail.

Genetic Inheritance

The many notable studies of Professor Franz Kallman, Professor Eliot Slater, Professor Erik Stromgren, and many others have shown that a tendency towards schizophrenia is inherited. Their conclusions have survived 25 years of harsh criticisms and are now well-enough established to have been publicly endorsed by Professor Paul Meehl, President of the American Psychological Association.

There are still those who doubt that schizophrenia is a genetically inherited disease, and most of these seem to have failed to recognize the significance of a well-known fact: that the disease occurs in about one percent of the human race. It has never been explained by these skeptics why an illness, often thought to be due to the sufferers being unfit for the full rigors of life, should occur in so many people.

Two publications firmly establish the genetic basis of schizophrenia. Kety, Rosenthal, Wender, and Schulsinger conducted a general review of the nature-nurture debate and came out positive for the biological nature, while Gottesman and Shields, using twins as a basis, conclude that specific genetic factors clearly underlie schizophrenia, whereas environmental factors are nonspecific and idiosyncratic. They describe schizophrenia as the "outcome of a genetically determined developmental predisposition."

It is also generally not admitted, although it is well known, that the illness itself confers physical advantages on its victims. Dr J. Lucy showed that schizophrenics have an extraordinary tolerance for injected histamine. Dr Lea demonstrated that schizophrenic soldiers have a very low incidence of allergies compared with similar young soldiers who have had head injuries. Rheumatoid arthritis is a very infrequent occurrence among schizophrenics. Professor Ehrentheil's studies suggest that they are not as likely to suffer shock after such catastrophes as the perforation of an internal organ or a coronary thrombosis. Our own inquiry shows that they are highly resistant to wounds and surgical shocks following grave injuries and burns.

The tendency toward a disease like schizophrenia may seem a high price to pay for this superiority, but for some people, it may be of vital importance to survival. To hunters and food gatherers, for example, allergy could be a matter of life or death. A hunter who is allergic to pollens might not be able to hunt and so would expose himself and his family to the danger

of starvation. If he became partly blinded and deafened by hay fever, he might himself become the victim of another predator.

If injured, the schizophrenic hunter would have a higher resistance to wound shock. If lost, he would be able to stand cold and privation better than others. Like many schizophrenics, he might well survive misfortunes that would kill his fellows. His perceptual difficulties, or even frank hallucinations, might cause him little or no distress. Like most hunters and food gatherers, he would be living in a very small, tightly knit society, isolated from settled areas. Here, communication would be lacking, mutual support would be essential, and tolerance would be high. For his counterpart in a more populated farm or city area, the same psychological changes might be far more disruptive and have serious social consequences.

In fact, these changes may work to the hunter's advantage, for the ability to see visions and endure various hardships is highly esteemed among many hunting peoples. Not only does this bind the group together, but it also enhances the prestige of those who are favored in this manner. Far from being despised, outcast, or persecuted, they can become valued members of society whose gifts are highly regarded and used for the common good. They are likely to have special duties that might not only reduce their chances of being killed while hunting but increase their chances of breeding. A close look at history shows that those whose perceptions ranged from the unusual to the bizarre have, from time to time, had great influence on art, politics, philosophy, religion, and science, greatly altering not only the viewpoint, but also the actions of our entire species.

Schizophrenia, then, appears to be beneficial as well as harmful to the individual and to the species, and can be useful to man if properly understood. A careful study of the genetics and biochemical nature of the disease will help us obtain not only an increased knowledge of a great illness, but a better understanding of those life-saving qualities with which it seems to be associated.

Even if we wish to ignore these facts, the remarkable twin studies of Kallman and Slater are absolutely convincing in themselves. Their work was confirmed in a most unlikely way when four girls, quadruplets, developed schizophrenia within a few years of each other, as described by David Rosenthal. The quadruplets were studied in extraordinary detail by a team of over 24 investigators supported by the National Institute of Mental

Health of the U.S. government in Washington, D.C. It was found that all four girls and their father had the same kind of brain-wave electrical patterns. All four developed a similar kind of schizophrenia, and it unfolded in the same manner. All four were underactive and had difficulty talking, were depressed, and socially isolated. Furthermore, their grandmother was psychotic and their father had unreasonable, out-of-place rages and a lifelong pattern of secrecy and lying. The investigators, therefore, concluded that the girls' illnesses were understandable in terms of a combination of inherited and environmental factors.

The inheritance factor helps us to explain why some members of a family are schizophrenic and some are not. The person likely to become schizophrenic inherits from his parents a number of genes for schizophrenia that make possible the biochemical processes we will describe. He may obtain equal numbers from both parents, or more from one or the other. Most likely, the parent whose family has the greatest loading of schizophrenia provides the greatest number of genes. It is, of course, possible that anxiety or stress acting in some way on the biochemistry of the body can help trigger the process, but if this is a factor, it seems of little importance.

Biochemical Causes

The nerve cell, or neuron, is one of the main cells of the nervous system. It starts electrical impulses and transmits them to other neurons. This is essential to the working of the brain. A neuron burns foodstuff to provide it with the energy it needs, and releases heat and waste chemicals. Neurons are surrounded by, and bathed in, body fluids. They control secretion of hormones and other chemicals about them. The brain has an extraordinary need for energy. Just over two pounds of brain in a 150-pound man uses one quarter of the amount of energy used by the whole man at rest.

The point of connection – or bridge – between the neurons is called the synapse. Messages are carried across this bridge in an unusual way. When a neuron is stimulated, an impulse races down the nerve cell to the end of the nerve. There, it releases a chemical messenger, which may be acetylcholine, serotonin, or noradrenaline. This chemical slowly moves across the bridge, and when it arrives at the other end, it stimulates the next nerve

cell. By this means, messages from our eyes, ears, and other organs are carried from cell to cell.

The brain depends for its normal functioning upon a proper formation, release, and removal of these chemicals. Too little or too much of any of the chemical messengers can prevent the brain from working properly. In addition to the enzymes that make them, there must be enzymes (protein substances) that destroy them when their work is done. The brain has both kinds of enzymes available to maintain proper quantities of these chemical messengers.

When poisons are formed in the brain, or penetrate into it from the blood, they can interfere with the work of these enzymes and prevent the removal of the messengers. They continue to stimulate neurons when they should not and can produce many abnormalities in brain operation, including convulsions. For example, many insect poisons block the action of the enzyme that destroys acetylcholine. This is why they are so poisonous to us if we should breathe them in or get them on our skin.

When anything happens to interfere with the way messages are normally transmitted across the synapse from one neuron to another, many other parts of the brain are thrown out of order. We can see the disturbances that result when the electrical brain waves are measured by the electroencephalogram. This is what happens in schizophrenia. Patients with schizophrenia have many abnormalities on their brain wave patterns. This has been established beyond doubt by the work of Professors Robert Heath, Stephen Sherwood, C. Shagass, L.A. Hurst, F.A. Gibbs, L. Goldstein, and many others.

We believe that in schizophrenia, poisons made in the body interfere with the carrying of messages, and as a result, those parts of the brain that keep the world around us steady, or, to use a technical term, maintain constancy of perception, are disturbed. We think these poisons include increased quantities of adrenochrome and adrenolutin, taraxein, and perhaps other substances.

Although we shall, for simplicity's sake, write as if adrenochrome can only come from adrenaline, it is quite possible that other chemicals in the body might also be changed into adrenochrome. Professor Mark Altschule believes adrenochrome might come from substances made in the body from the amino acid, tyrosine. It is even possible that adrenochrome-like

chemicals can be made in the body from serotonin, but much more work is needed to settle this matter.

Adrenaline itself is very poisonous and too much of it can lead to serious changes. Physicians know this and rarely inject more than one milligram in one dose. There is enough stored in the body to, if released suddenly, kill the subject. If it is secreted in the body in excessive quantities, it produces most of the symptoms of severe anxiety, panic, and fear, and increases blood pressure, causes headaches, and may cause hemorrhages in the body and brain.

Because adrenaline is so toxic, it must be removed as quickly as possible before it can do any damage. This is done naturally in the body where it is quickly changed into a large number of other compounds. Most of these are neither dangerous nor toxic, and, in fact, they may serve a useful role in the operation of the brain and body.

It has been discovered that blood contains an enzyme called "adrenaline oxidase," which combines adrenaline with hydrogen peroxide to form new compounds. Adrenaline oxidase is an adaptive enzyme. In other words, the more adrenaline there is secreted into blood, the more enzymes that are formed, presumably to protect the body from the toxic adrenaline.

Some of the adrenaline, however, is converted into another poisonous chemical, probably within the cells of the tissues and not outside them, in the fluids that bathe them. This chemical, adrenochrome, has no effect on blood pressure and fortunately is very reactive, changing quickly in the body to less active chemicals. It is, however, poisonous to nerve cells, and even trace quantifies of pure adrenochrome, as Professor Ruth Geiger has shown, will kill them. It must, therefore, be removed as quickly as possible, and this can be done in two ways.

Protective or buffer substances in the body fluids quickly bind adrenochrome and keep it from coming in contact with the neuron. Adrenochrome can also be changed quickly into other non-toxic chemicals. We are not certain we know all the substances that are needed to change adrenochrome into these non-toxic substances. This change requires enzymes, or catalysts. It is known to occur more easily when vitamin C, the interesting amino-acid derivative, glutathione, and cysteine are present in sufficient amounts.

The non-toxic substance is formed when adrenochrome is changed in this way is called 5,6,dihydroxy-N-methyl-indole (or leuco-adrenochrome). It has helped many subjects with its definite anti-tension properties. We consider the conversion of adrenochrome into leuco-adrenochrome a normal reaction in the body. We also believe there must be a balance between adrenaline and this substance. If there is a lot of adrenaline and not enough leuco-adrenochrome, the subject will be anxious and tense. If there is enough leuco-adrenochrome, the balance is adequate and any anxiety in the person will be normal.

Leuco-adrenochrome is broken down further into a type of chemical called pyrolles, or built up into the brown or black pigments in the skin or in the brain.

Adrenochrome is very unstable and is rapidly converted into other indoles, including adrenolutin. The schizophrenic patient would then have too much of both these oxidized derivatives of adrenaline. Like adrenochrome, adrenolutin is also psychotomimetic. Physiologists and biochemists have studied adrenochrome since it was first identified in 1937, and a good deal is known about its actions in the body. Schizophrenic patients who have too much adrenochrome (and adrenolutin) will have certain biochemical abnormalities.

The following changes are, therefore, most likely to occur in people with schizophrenia. There will be a lowering of energy production in the brain. Foodstuff will be converted into energy less efficiently. This might account for the profound fatigue present in the majority of patients who have schizophrenia.

There is a chemical in the brain called gamma amino butyric acid (GABA) that is considered to be a regulator of transmissions across the synapses. It prevents too many stimuli from jumping across the synapse. If too little is present, the brain will be too excitable and may even develop electrical storms that result in convulsions. GABA is made from the amino acid glutamic acid by the loss of one molecule of carbon dioxide. The enzyme that makes it is prevented from doing so by adrenochrome.

Thus, when adrenochrome is present, there will not be enough GABA available. As a result, the brain, agitated by an over abundance of stimuli, will be too excitable or irritable. In fact, the majority of schizophrenic patients are irritable and have abnormal brain-wave charges.

Adrenochrome also blocks the action of the enzyme that destroys acetylcholine. This is one of the messenger chemicals that cross the synapse from the nerve cell to the neuron. There will then be too much acetylcholine in the synapse, and this will add to the irritability or excitability of the brain.

Schizophrenics have diabetes much less frequently than one would expect, and this can be attributed to the presence of adrenochrome and adrenolutin in their bodies, which act in the same way as the compounds used to treat diabetes. Insulinase (the enzyme that destroys insulin) is too active in some forms of diabetes mellitus. These diabetic conditions are treatable by giving patients compounds that block the action of insulinase. Adrenochrome and adrenolutin act in the same way as these compounds and so might prevent diabetes from developing. However, it is possible for people who get diabetes first to develop schizophrenia later.

It was observed some time ago that when schizophrenia comes on early in life, it prevents normal growth and development. The victims tend to be slender, slight, and too narrow in the chest from front to back. There are also changes in each half of the body so that they develop what is called asymmetry (the shape of one half of the body does not conform to the shape of the other). If the disease comes on after physical growth is complete, no such malformation is possible.

Adrenochrome is a very powerful inhibitor of cell division and is known as a cell mitosis poison. In fact, this was one of the first properties of adrenochrome to be discovered, long before we began to suspect it was related to schizophrenia. It is not surprising that cancer is very rare in schizophrenic patients. It should also interfere with all those processes in the body that depend upon the rapid growth of tissues. For example, when a tissue is injured, it is normally repaired by a rapid growth of fibrous tissue. Tuberculosis lesions in the lung in normal people are walled in by this growth of fibrous tissue, and so do not spread through the lung.

But schizophrenic patients may be less resistant to tuberculosis, probably because of too much adrenochrome in their bodies. Fortunately, modern sanitation, better hospitals, and antibiotic treatment have markedly reduced tuberculosis infection cases, and modern mental hospitals have tuberculosis in their schizophrenics nearly under normal control.

Other effects of reduced growth that we have observed in some patients include a slower rate of hair and nail growth, and a defective formation of sperms.

Adrenochrome should render schizophrenic patients more prone to developing scurvy. Scurvy was once one of the most dreaded scourges of man, especially after a late winter, when no fresh vegetables were available. It develops in the absence of vitamin C, one of the essential chemicals found in foods. Vitamin C is essential for normal body function, and since it cannot be made in the body, it must be taken in the food. Adrenochrome, however, combines with vitamin C and so uses it up more quickly, resulting in a deficiency in the schizophrenic. Professor M.H. Briggs has shown that when scurvy is artificially induced in guinea pigs, they excrete certain unusual compounds in their urine. He has also shown that patients who have schizophrenia excrete the same substances.

The dark pigments in skin come from the amino-acid tyrosine, from dopamine, and possibly from adrenochrome. Pigmented areas in the brain more than likely come from adrenochrome. By contrast, albinos who have little or no color in the skin (because they cannot form melanin from tyrosine) have normal melanin-like pigment in the brain. Albinos do not have any deficiency in the formation of adrenaline pigments.

Schizophrenics who have too much adrenochrome should, therefore, have darker skin than when they are not ill. We have found that elderly schizophrenic patients do not turn gray nearly as quickly as do other psychiatric patients. Dr Lea has found that young patients with schizophrenia experience earlier darkening of hair color than do subjects in the control group. The excess of dark pigment probably accounts for the extraordinary youthful appearance of many middle-aged and elderly patients.

The rare occurrence of allergic diseases or arthritis in schizophrenic patients is an observation that has been made frequently and has never been denied, but this observation is ignored by most psychiatrists. The reason for this favorable condition may be due to the presence of adrenochrome, which is an anti-histamine nearly as powerful as the weaker of the commercially-made anti-histamines. Small quantities of adrenochrome constantly present in the body could protect schizophrenics against allergies more effectively than larger doses taken by non-schizophrenics a few times a day

by mouth. While the physical allergic reactions are very rare, psychological reactions are very common. This has been called "cerebral allergies." Many studies have shown that up to 50 percent of schizophrenic patients are allergic to common foods, such as the grains, dairy products, and so on. Any food may be involved. Every patient must be examined for the presence of these allergic reactions since the treatment will depend upon whether these are present.

Schizophrenics also have a remarkable resistance to histamine. Histamine is a powerful substance found in small quantities in the body. When it is injected under the skin or into a vein, it produces a marked facial flush and a rapid drop in blood pressure. For this reason, only small quantities can be given without danger to the subject. In 1952, early in our research program, one of our colleagues, Dr John Lucy, found that chronic schizophrenic patients could tolerate remarkable quantities of histamine before their blood pressure went down. We were not trying to discover how much they could take. We were studying the effect of histamine injections as a treatment.

The procedure called for giving increased quantities of histamine until the blood pressure went down to a given degree. But when we began our studies with schizophrenia, we found that so much histamine was needed to lower blood pressure, we quickly used up all our research supply. We asked a drug firm to make us solutions of histamine 10 times as concentrated as before. This request was so unusual the firm was reluctant to do so unless we gave them a special release, since they had not previously known these large quantities could be given to subjects. Schizophrenic patients are also more resistant to small quantities of histamine placed in the skin. Normally, this produces a welt or a reddish raised area. But in schizophrenia, the area of the welt is smaller and comes on more slowly.

The ability of schizophrenics to resist histamine is probably due to the presence of adrenochrome in increased concentrations. The greater supply of adrenochrome may also account for the remarkable resistance of schizophrenics to medical and surgical shock.

We will refer to only one more finding. Until recently, serious studies were made of schizophrenics' brains, which were compared to the normal. Only the outer layers were studied, and although some changes were found in them, so many other factors could have been the cause that these find-

ings are no longer taken seriously. In fact, the majority of psychiatrists now assume there are no changes in the brain in schizophrenia at all.

But very few studies have been made of the deeper areas of the brain, which are particularly concerned with emotion. We believe no changes in the brain are found unless the disease has been present many years. But there is a good deal of evidence that, after 10 years of illness, there are changes in the brain that lead to the enlargement of the brain ventricles. This is one of the important reasons for preventing early schizophrenia from becoming chronic schizophrenia by the best possible chemical treatment. For when neurons are destroyed, they can never be replaced, and when too many are gone, they set a permanent pattern of activity in the brain that may be irreversible, much the same way that cloth permanently weakens when too many fibers are removed from it.

There is one known way the body has of protecting its vital tissues against the poisonous chemical, adrenolutin, which comes from adrenochrome. In normal men and women, the blood contains a protein called ceruloplasmin. It is a blue copper-containing substance that can change adrenaline to other substances, and that can also alter serotonin. One can easily measure, biochemically, how much is present in the blood. Ceruloplasmin has the remarkable property of being able to hold or bind adrenolutin so firmly that it does not come off. If a small quantity of adrenolutin was released in the body, the ceruloplasmin would immediately soak or mop it up, and no harm could be done.

During stress, more adrenaline is secreted, and so it makes sense to suspect that a small quantity might then be converted into adrenochrome and adrenolutin. But during stress and physical disease, there is also more ceruloplasmin in the blood, ready to mop up these harmful chemicals before they can do any damage, much as though the body has prepared itself to cope with such an eventuality.

Ceruloplasmin, because of its ability to remove adrenolutin, plays an important role in the recovery of schizophrenics. It is made in the placenta, and during the last three months of pregnancy, more is secreted from the placenta into the mother's blood. The mother is thereby protected against toxic substances like adrenolutin or histamine. On the other hand, after the baby is born, the amount of ceruloplasmin in the blood very quickly decreases and reaches normal levels in about two weeks.

This increased quantity of ceruloplasmin in pregnancy would be of great benefit in absorbing any abnormal quantities of adrenolutin present in the body. Once pregnancy is over, however, the woman is deprived of the extra ceruloplasmin, which means that the adrenolutin is free to exert its toxic effects. In fact, nearly two-thirds of all serious psychoses that occur after the baby is born do come on within this short period after birth. Men also have ceruloplasmin in small quantities.

Professor Heath found that some schizophrenic patients had more ceruloplasmin than others and that these were the ones who more often recovered. This suggests they were able to recover because they had better biochemical defenses against the disease, including the ability to make more ceruloplasmin. Dr B. Melander has shown that ceruloplasmin injections will cure the majority of acute schizophrenics to whom it is given.

These early experiments have not been reproduced, perhaps because as the ceruloplasmin preparations became more refined, the active therapeutic principle was removed. It is not likely these results were due to a placebo reaction. These early positive experiments will remain a mystery.

Taraxein, a toxic protein, plays an important role in the formation of schizophrenia, as Dr Heath has shown. Dr Melander, on the basis of his research, suggested that taraxein might sensitize the brain to substances like adrenolutin. Over their evolutionary history, mammals have developed mechanisms for keeping most undesirable chemicals away from the brain. There is a barrier called the blood-brain barrier that keeps these toxic substances out. But Dr Melander believes taraxein lowers the barrier, and so substances like adrenolutin are able to penetrate into the brain more easily.

Both Dr Melander and Dr Heath have shown that, in animals, taraxein appears to increase the effect of even small quantities of adrenolutin. When animals are first given taraxein in small amounts, which do not produce changes in behavior, and then given small quantities of adrenolutin, there is a very marked change in behavior. The presence of taraxein would make subjects peculiarly sensitive to quantities of adrenolutin, which might otherwise not be dangerous. Schizophrenic patients having both are, therefore, vulnerable for two main reasons.

We have also suggested that taraxein might act by increasing the conversion of adrenochrome into adrenolutin, or it might combine with ceruloplasmin and so prevent it from functioning as an absorber for adrenolutin.

These are conjectures that may or may not be supported by data in years to come. Nevertheless, it is certain taraxein does play an important role in producing schizophrenia.

Adrenochrome-Adrenolutin Hypotheses

The adrenochrome-adrenolutin theory was first developed publicly in 1952 and is based on, or originates from, the amino-acid called tyrosine. This is a simple amino-acid from which skin pigment and the hormones, noradrenaline and adrenaline, as well as other constituents, are made.

Body hormones are constantly changing into other hormones. Each new hormone has its own structure and role in the building of the final structure of the body and helping it function. Body hormones are carried by the blood to all parts of the body, on which they have a direct effect. Some affect growth. Some affect digestion. Some affect moods. They may be necessary to the normal function of a tissue. Chemicals may join forces with other chemicals to produce still other effects.

As long as they go about their business in a routine fashion, the individual remains well. But when, for some reason they change routine, or the normal balance of chemicals is changed, the person becomes ill. The adrenochrome-adrenolutin theory is based on the assumption that certain chemicals stop following the normal procedures, and the result is schizophrenia.

The adrenal gland, a little triangular-shaped organ weighing only one ounce, sits on top of each kidney. The adrenal gland is made up of an inner part called the medulla and an outer part called the cortex. In the central area, the medulla, a hormone called noradrenaline is made, and from this comes adrenaline, a hormone important to the emotions. Adrenaline flows from the inner area through the cortex into the bloodstream.

Scattered through the body are tissues similar to the adrenal medulla, which can also make adrenaline. When the adrenal medulla is destroyed or removed, these tissues begin to grow and soon put out nearly the original supply so that the body is never without it.

In an emergency situation, adrenaline acts as a coordinator of the many mechanisms required for use. It helps to mobilize the biological resources for fight or flight. When a man is attacked by a bear or tiger, for example, he is immediately ready for action, whether or not he is afraid. A few seconds

later, adrenaline and other hormones are pouring into the bloodstream, and the body is soon flooded with them. It seems likely there is a fine balance of psychological and biochemical factors as the following changes occur.

The rate of breathing is increased. The heart rate goes up and the pulse count is faster. Blood pressure goes up. Sugar is poured into the blood. Blood is channeled from the internal organs that are not essential for the defense operations – bowel, stomach, etc. – to the aid of the muscles needed for the hard work ahead. Pain sensitivity is reduced. The blood is ready to stop bleeding more quickly, if injury occurs. There are many other changes, and the person is now ready for fight or flight. A sustained effort is needed, though, and here slower mechanisms come into play. The final result is to increase the chances of survival.

Once the drama is over, the individual is psychologically relieved or relaxed, the hormone production slows down, and the body gets rid of the extra supply of used chemicals, either by destroying them or excreting them.

Adrenaline also plays a role in the emotions in smaller quantities. There is good evidence that it helps the person feel anxious and may play a role in depression.

However, this beneficial hormone turns into a very toxic and changeable hormone called adrenochrome. Adrenochrome can be seen as part of the red pigment coloring adrenaline when this substance is allowed to stand in water solution in the open air. It has been, and is, easily made in the laboratory as a dark crystalline material. In its pure form, it manifests itself as beautiful, sharp, needle-like crystals that have a brilliant sheen. When the crystals are powdered, it appears as a bright red powder, which dissolves quickly in water to produce a blood-red solution. It is very reactive and combines quickly with many other chemicals. There is substantial evidence, both direct and indirect, that adrenochrome is also formed in the body.

Adrenochrome in the test tube and in the body can, in turn, be changed into two new compounds. One of these is harmless and is called 5,6 dihydroxy-N-methyl-indole (hereafter referred to as dihydroxyindole or leucoadrenochrome), and the other is poisonous and is called adrenolutin.

Adrenolutin is a bright yellow crystalline material with an orange tinge when pure. Impure preparations develop a greenish color. The darker the

material, the more impure it is. It is difficult to dissolve in water. When an ultra-violet lamp shines on it, it glows with a beautiful blue-white color.

The other hormone in this triangle, dihydroxyindole, consists of small flattish crystals that are slightly off-white in color. They dissolve easily in water to form a colorless solution. Large amounts of dihydroxyindole have been given to animals and men, and if any changes have occurred, they have been beneficial ones. It is possible this compound works against adrenaline to create a balance that keeps the person from becoming too tense or irritable. We have elsewhere suggested that tension or anxiety depends upon how much dihydroxyindole is present as compared to adrenaline. If there is too much adrenaline and too little dihydroxyindole, we suggest that the person will be too anxious.

This whole process, then, from adrenaline to adrenochrome to dihydroxyindole or adrenolutin is the essence of the adrenochrome-adrenolutin theory of schizophrenia, and can be sketched as follows:

$$\text{adrenaline (A)} \longrightarrow \text{adrenochrome (B)} \begin{array}{c} \nearrow \text{dihydroxyindole (C)} \\ \searrow \text{adrenolutin (D)} \end{array}$$

We suggested many years ago that the normal pathway of these changes is from A to B to C, and that if A and C are present in normally balanced quantities, the subject will be neither too tense nor too relaxed. Adrenochrome (B) reacts very quickly and probably does not remain free in the body very long.

In schizophrenics, however, for reasons still unknown, the pathway is from A to B to D. Adrenolutin provides some relaxation, but it interferes with normal chemical reactions in the brain, and the process of schizophrenia is under way.

If this theory is correct, we can expect certain things to happen. In fact, it is important to test these ideas to see if these consequences do occur. And if they do, then belief in the adrenochrome hypothesis must be strengthened and the theory more widely accepted. The three main sets of consequences of the theory are:

1. If the theory is shown to be true, then adrenochrome and adrenolutin, when injected into animals and man, will reproduce some of the essential features of schizophrenia.
2. If the theory as shown is true, then adrenochrome and adrenolutin, or their products, are present in the body. When a person has schizophrenia, they are present in greater concentrations.
3. If the theory as shown is true, then any mechanism that reduces the formation of adrenolutin or adrenochrome, or that removes them from the body altogether when they are formed, or counteracts their effects, will cure schizophrenia.

The evidence so far established supports all three suppositions. Much more evidence is needed, but there is enough now to make it impossible to prove otherwise. Following is the evidence that all these expected consequences of the adrenochrome theory do occur.

Adrenochrome and Adrenolutin Produce Changes in Animals and Man: The first human studies with adrenochrome were started in 1952 in Saskatchewan. Usually, new chemicals are first given to animals to test toxicity and determine their effects on the body. No animals were then available, but we were. The first studies were completed on ourselves.

One of our first clues to adrenochrome as a possible villain in the body came from a severe asthmatic. Before coming to Saskatchewan in 1951, Dr Osmond and a young colleague at St. George's Hospital, London, England, Dr John Smythies, had experimented with mescaline and noted that the experience resembled that of some schizophrenics. While listening to a recording of a mescaline experiment, this subject remarked that things like that sometimes happened to him. If he took very large amounts of adrenaline to treat his asthma, as he sometimes did, the world changed; he had colored visions with his eyes shut and feelings of unreality. In Regina, Dr E. Asquith later told us that during the war, pinkish adrenaline was used during anesthesia, and when the patients revived, they had disturbances, including hallucinations.

Early in 1952, we called upon Professor Duncan Hutcheon, Professor D. MacArthur, and Dr V. Woodford, of the University Medical School in Saskatoon, to ask for their help. When we mentioned pinkish adrenaline,

Professor Hutcheon suggested adrenochrome, which comes from adrenaline and resembles mescaline. Professor MacArthur showed that it could be related to every hallucinogen then known if one examined its chemical structure. Professor Hutcheon made our first small supply of good adrenochrome, and before he left Saskatchewan in early 1953, we had a model of schizophrenia from these early experiments, starting with ourselves and our wives.

I was the first to take adrenochrome and Dr Osmond the second. Ten minutes after taking it, Dr Osmond noticed that the ceiling had changed color and that the lighting had become brighter. He closed his eyes and saw a brightly-colored pattern of dots that gradually formed fish-like shapes. He felt he was at the bottom of the sea or in an aquarium with a school of brilliant fishes. At one moment, he thought he was a sea anemone in this pool. He was amazed when he was given psychological tests and asked to relate what was happening.

He was given a Van Gogh self-portrait to examine. "I have never seen a picture so plastic and alive," he later noted. "Van Gogh gazed at me from the paper, crop-headed, with hurt, mad eyes and seemed to be three-dimensional. I felt that I could stroke the cloth of his coat and that he might turn around in his frame." When he left the laboratory, he "found the corridors outside sinister and unfriendly. I wondered what the cracks in the floor meant and why there were so many of them. Once we got out of doors, the hospital buildings, which I know well, seemed sharp and unfamiliar. As we drove through the streets, the houses appeared to have some special meaning, but I couldn't tell what it was. In one window, I saw a lamp burning, and I was astonished by its grace and brilliance. I drew my friends' attention to it but they were unimpressed."

The second time Dr Osmond took adrenochrome he had no feelings for human beings. "As we drove back to Abe's house, a pedestrian walked across the road in front of us. I thought we might run him down, and watched with detached curiosity. I had no concern for the victim. We did not knock him down. I began to wonder whether I was a person any more and to think that I might be a plant or a stone. As my feeling for these inanimate objects increased, my feeling for and my interest in humans diminished. I felt indifferent towards humans and had to curb myself from making unpleasant personal remarks about them."

The next day, he attended a scientific meeting, and during it, he wrote this note: "Dear Abe, this damn stuff is still working. The odd thing is that stress brings it on, after about 15 minutes. I have this 'glass wall, other side of the barrier' feeling. It is fluctuant, almost intangible, but I know it is there. It wasn't there three-quarters of an hour ago; the stress was the minor one of getting the car. I have a feeling that I don't know anyone here; absurd but unpleasant. Also, some slight ideas of reference arising from my sensation of oddness. I have just begun to wonder if my hands are writing this; crazy, of course."

Later he found he could not relate distance and time. "We had coffee at a wayside halt and here I became disturbed by the covert glances of a sinister looking man."

The two observers later wrote, "The change in H.O. [Humphrey Osmond], marked by strong preoccupation with inanimate objects, by a marked refusal to communicate with us, and by strong resistance to our requests, was in striking contrast with H.O.'s normal social behavior."

These perceptual, thought, and mood changes were also experienced by another subject, whom we shall call Mr Kovish, leading us to believe that we were on the right track. Mr Kovish was in his middle thirties, friendly, intelligent, and with a lively sense of humor. After subsequent interviews with him, we felt we had no reason to doubt his story.

Mr Kovish occasionally suffered from asthma, for which he had taken adrenaline by inhalation regularly for at least 10 years. One night in mid-1956, he found himself without adrenaline, many miles from home. He stopped at a drug store and the druggist said that all he had was one bottle, but that it was quite discolored. He seemed hesitant to sell it, but Mr Kovish bought it anyway. While driving later that night, he felt alert and wakeful, but had some difficulty in judgment and some bizarre thoughts. His vision was distorted. The road, which was very familiar to him, looked different. He felt alert to an extreme and pulled off the road. This seemed very strange to him.

This was the beginning of an experience that thoroughly frightened him. He suspected he was becoming mentally ill, and he was ashamed of what was happening to him. He did not, however, associate these changes with the adrenaline and continued to take it for about a month at various intervals until he had finished the bottle.

"I have always felt myself to be a normal individual – unneurotic, and with a zest for living," he later wrote to us. "It was, therefore, quite a shock to me to find one day that I had suddenly become an individual who: (1) saw the world as through a distorted glass: I sought to interpret the visual distortions as being due to strange mental processes; (2) became quite anxious and depressive; (3) had compulsive thoughts; and (4) began to doubt myself and my sanity.... Had I known that I was going to have an artificially induced psychosis, I am sure the severity of the consequences would not have been felt because, not knowing the origin, I ascribed them to psychic difficulties, and this led me deeper into my feelings of unrest. I went into a tailspin, and perhaps this had something to do with the length of the effect. I also should mention that I was in a personally stressful situation, which might have been a contributing factor."

Mr Kovish described some of his symptoms as "tendency toward fixed thinking, feelings of excitement for no apparent reason, surroundings – especially people (men much more so than women) – looked peculiar, including pictures in newspapers." He remembers being bothered by groups of people. "I felt that there was something distorted or different appearing about them. This was not localized to any one person. There was a strangeness about seeing groups of people which had a somewhat frightening effect on me. I noticed distortion in many things, some animate and some inanimate ... I saw people more or less like I have seen before, except that they impressed me differently, and this was very frightening ... I could find no logical reason for this strange thing that was happening to me and I spiraled downwards to the depth of despair at having lost my mind, and I felt that that was a very disgraceful and shameful thing to do."

He was able to reconcile himself to familiar people very easily by telling himself, "Now look, you have seen these people before. They are not really changed. They haven't changed. It's got to be YOU."

He suffered anxiety, depression, compulsive thoughts that had no relation to reality. He had bizarre thoughts that seemed to be connected with the strangeness of the way people appeared to him. Internal excitement plagued him. He had never had any fear of flying, through storms or any other stressful situations. Now he was extremely anxious in airplanes.

He was "too charged up" at times to sleep at nights and experienced "uncertain visual patterns and shapes a few times" before dropping off to

sleep, which he hadn't experienced before or since. What was more, he had no asthma or wheezing at night under any circumstances, except once, when he was at the home of a friend who had dogs, and was completely without asthmatic symptoms even after heavy exercises. "It can be summed up by saying I felt like one is supposed to feel when they have had a lot of adrenaline."

He was extremely irritable, felt low, and could no longer participate in family life, such as playing with the children and talking things over with his wife. While discussing this with a friend one day, he casually mentioned the adrenaline. She immediately reminded him of R.W. Gerard's article in *Science* on the "Biological Roots of Psychiatry," in which he discussed breakdown products of adrenaline as causing temporary psychoses. In rereading Gerard's article, he found a description that seemed to fit his feelings exactly.

He wrote to the author of this article, who referred him to an article we had written. In this article, he found more specific details that helped sustain him to the end of his distressing symptoms. When the experience was over, his asthma was gone.

This story had exciting implications. Outside of a laboratory, unsuspecting and unprepared, a normal man had taken "bad" adrenaline and, as a result, had suffered all the classic symptoms of schizophrenia for several weeks. He had no advance knowledge of what the drug would do to him and was, in fact, reluctant to admit that it had been the cause of his troubles.

Those close to him, who had always seen him as a man with good reserves of humor and optimism, even when things seemed difficult, were very surprised and disturbed when he seemed so unlike himself. They had never seen him like that before. His account furthermore resembled in many ways famous accounts of schizophrenic illness and experiments with such drugs as mescaline, LSD-25, adrenochrome, adrenolutin, and others.

After hearing of the effect of inhaled discolored adrenaline on Mr Kovish, we began exploratory experiments with inhaled adrenolutin. We were the first to take adrenolutin, but under the influence of the drug, we had no insight into our own behavior. The third volunteer to take it, a normally friendly, outgoing young man, alarmed his family with violent temper outbursts, delusions, suspiciousness, and other behavior typical of schizophrenia.

Most of the subjects reacted to adrenochrome and adrenolutin. The most striking changes were changes in personality, which continued up to two weeks in several volunteers. There was no insight, and even though the subjects were aware that they had taken these chemicals and remembered having taken them, they assumed the changes in themselves had nothing to do with the drugs. Several subjects became temporarily psychotic, and one had to be admitted to a mental hospital for several months of treatment.

We found that in human volunteers adrenochrome or adrenolutin produced the following changes:

Changes in Perception: These are subtle, but no less serious, when small doses are used. With 30 mg or more placed under the tongue, visual hallucinations are produced that may be as clear and distinct as those experienced with LSD. Furthermore, all the perceptual changes found in schizophrenics as described previously may occur with adrenochrome.

Changes in Thought: These are also similar to those found in schizophrenia.

Changes in Mood: In most cases, the subjects were depressed, but sometimes they were too relaxed or flat.

Our conclusions, based upon these few original studies, have been confirmed by other research workers in the United States, Germany, and Czechoslovakia. They might not, in themselves, be adequate, but they receive very strong support from the results of experiments with animals.

Adrenochrome and adrenolutin have been given to spiders, mice, rats, cats, dogs, rabbits, and monkeys. These studies have been carried out in Sweden, Russia, Czechoslovakia, Germany, Switzerland, Canada, and the United States. These compounds have shown activity in animals in every study except one, where adrenochrome was used in quantities too small. In every other study, animal behavior, as a result of the injection of adrenochrome and adrenolutin, was altered markedly.

Russian experimenters, using sensitive methods, showed that very small amounts of the poisonous substances given to trained monkeys rendered them incapable of carrying out procedures they could easily perform before

and after. In Moscow, scientists trained monkeys to work for their food by handling an apparatus that released a banana if they did it right. They had to press a button, pull a cord, and perform other tasks in order, and if they were done accurately, the banana that came out as a result was their reward.

When given 1 mg of adrenochrome, they were no longer able to go through the routine, even if they were as hungry as before. But they knew what a banana was, and they knew they were hungry, and if a banana was placed beside their cage, they reached out and picked it up. Thus, they were able to perform at a very simple level, but had lost the ability to carry out more complicated tasks that they had been able to do well before taking adrenochrome, and which they could perform after they had recovered from it. The adrenochrome also made them bad-tempered, boorish, and lacking in social graces.

Work at the University of Saskatchewan showed that rats given adrenochrome were not able to learn as readily as normal animals, and they forgot what they had learned more quickly. One could look upon them as rats that had become retarded because of adrenochrome.

There are few now who doubt that adrenochrome is active in animals and in man. It is now included among the family of compounds known as hallucinogens – compounds like mescaline and LSD-25, capable of producing psychological changes in man.

Adrenochrome Metabolism and Schizophrenia: Adrenochrome has not been isolated from living tissue, but there are indications that it soon will be. J. Axelrod, one of the scientists who previously maintained adrenochrome was not present in tissue and that there was too little adrenaline available for its formation, recently reported he had proved its presence in saliva gland tissue. He used radioactive tracer techniques that are valuable in metabolic studies. But it will be a very difficult job to isolate adrenochrome in a pure form. This is not surprising, because it is such a reactive chemical – changing so quickly in reaction to other things – that it eludes capture. Special techniques will be required to stabilize it and to extract it. Meanwhile, several research workers have measured adrenochrome and adrenolutin in urine and blood. These were found to be present in higher concentrations in schizophrenic patients.

Professor M. Altschule at Harvard University measured adrenolutin

levels. He suggested the term "hyperaminochromia" for those mentally ill patients who had increased quantities of adrenolutin in their urine or blood. (Adrenolutin belongs to a class of chemicals called aminochromes.) Dr E. Kochava, in Paris and Prague, found adrenochrome in the urine of schizophrenic patients. Professor Altschule and his colleagues have recorded considerable evidence for the presence of adrenochrome, adrenolutin, and similar oxidized compounds in the blood. These substances are carried in the blood combined with proteins. The combination is called theomelanin. The toxic effects of oxygen under pressure (hyperaoric) is due to the excessive formation of these substances.

Other laboratories have added additional information. Dr B.C. Barrass and Dr D.B. Coult located a substance in the urine of schizophrenic patients that slowed down the destruction of serotonin and at the same time increased the formation of adrenochrome from adrenaline. They suggested that similar enzymes might be present in the brains of schizophrenics and, if they were, could cause an increase in serotonin in addition to an increase in adrenochrome. Either change would be detrimental, but both together would be highly toxic.

"The debate over the formation of adrenochrome in the body is over," Dr J. Smythies has written. "Blood can be analyzed for adrenolutin, the first reduction product from adrenochrome. The role played by adrenochrome and similar oxidized derivatives of catecholamines such as adrenalin, noradrenalin, and dopamine is well established in neuropsychiatry." Dr Smythies, who was one of our original team in Saskatchewan, summarized the most recent work in a series of valuable reports, such as the one in *Schizophrenia Research* (1997;24:357-64), entitled "Oxidative Reactions and Schizophrenia: A Review-discussion," and in *Biochimica et Biophysica Acta* (1998;1380:159-62), "The Oxidative Metabolism of Catecholamines in the Brain: A Review."

More recent evidence has finally established that adrenochrome is made in the body in substantial quantities and that most of it is synthesized in heart muscle. Myocardial muscle is very rich in an oxidizing enzyme that changes adrenaline into adrenochrome, noradrenalin into noradrenochrome, and other catecholamines into their respective aminochromes. The evidence is now so powerful that there is no longer any controversy about the ability of the body to make adrenochrome *in vivo*.

As soon as scientists discovered that adrenaline turned pink in solution, it appeared likely that what happened so easily *in vitro* could also occur in the body. Adrenaline is a member of a class of chemicals called catecholamines, which polymerize very readily – i.e., they combine with each other to form darkly pigmented compounds with new properties. These new substances are melanins. All the conditions necessary to make these melanins must be present in the body. These are (1) the substrate, the catecholamines, and (2) the enzymes, which convert these substrata and the trace minerals necessary for this conversion. The oxidation of adrenalin to adrenochrome in water is an example. This requires oxygen and is accelerated by traces of metal, such as copper ions. Ideally, the final proof would have been the isolation of adrenochrome crystals from blood or other body fluids, but because adrenochrome is so unstable, it is very difficult to do. Perhaps it could be stabilized by adding semicarbazide to fluids. Adrenochrome semicarbazide is a stable derivative and could be extracted. So far, this has not been tried. But nature has already made these stable derivatives, the melanins. The neuromelanins in the brain are derived from catecholamines and are easily seen by neuropathologists.

Adrenolutin is a derivative of adrenochrome, just as toxic, but causing different psychological changes. It is more stable in blood. Recently, a research group in Winnipeg, in the cardiology laboratory of the University of Manitoba, developed a method for measuring how much adrenolutin was present in blood. When they injected adrenalin into rats, they were able to show a several-fold increase in the amount of adrenolutin in their blood. The amounts found were surprisingly high. They examined the amount of adrenolutin in four species of animals. The values were in rats 0.11 mm/ml, in rabbits 0.08, in dogs 0.05, and in pigs 0.04. From this small series, it appears there is a relationship to body size, with the smallest animal having the greatest amount in the blood. This work was reported by Dhalla, Ken S. et al., in *Molecular and Cellular Biochemistry* (1989;87:85-92), under the title "Measurement of Adrenolutin as an Oxidation Product of Catecholamines in Plasma."

Removing Adrenochrome and Adrenolutin is Therapeutic for Schizophrenia: There are four ways of reducing the amount of adrenochrome and adrenolutin in the body, and each one ought to improve schizophrenics, if the

hypothesis is correct. These are: (1) to reduce the formation of adrenaline; (2) to reduce the formation of adrenochrome; (3) to increase the conversion of adrenochrome into the beneficial compound, dihydroxyindole; and (4) to reduce the concentrations of adrenolutin.

Treatments have been developed using each technique, and they have improved the recovery rate of schizophrenics. They will be described briefly in this chapter and in more elaborate detail in the chapter on treatment.

Reducing Production of Adrenaline: There are no effective ways of doing this. By that we mean there are no specific ways. But there are many non-specific ways. Since anxiety, conflict, cruelty, and bad psychological treatment increase the flow of adrenaline, these should be avoided. Patients should be treated humanely in such a way that adrenaline secretion is reduced, with kindness and understanding.

Certain chemicals and drugs may reduce adrenaline levels in one of two ways: by protecting the individual from the impact of external factors or conflicts – these include drugs that decrease the levels of anxiety, such as the anti-anxiety drugs; and by a direct action on the body, such as is caused by the major tranquilizers and anti-depressants.

We began to use nicotinic acid in 1951 as a treatment for schizophrenia. One of the reasons for using nicotinic acid was that theoretically it could reduce the formation of adrenaline by mopping up extra chemicals that the body requires it to build from noradrenaline. There is evidence that this is, in fact, what nicotinic acid does.

One might think that removing the adrenal glands would remove all the adrenaline and so prevent adrenochrome from forming. In fact, our early adrenochrome theory was severely condemned by several, because removal of both adrenal glands from chronic schizophrenics did not cure them. At that time, it was not known that the body could quickly regenerate the tissues that made adrenaline – not in the adrenal gland, which is gone, but in other areas of the body. Many tissues can also generate adrenaline. Thus, surgery cannot be used to prevent the formation of adrenaline. Nor would we expect chronic patients to be helped even if the adrenaline flow had been interrupted, for there would undoubtedly be permanent changes caused by the disease that would prevent any cure. They can only be improved.

Smoking substantially increases adrenaline secretion. This is due to its nicotine content. Injections of nicotine produce great increases in adrenaline secretion. For this reason, schizophrenics should be discouraged from smoking.

Decreasing Production of Adrenochrome: This can be done by using chemicals that decrease the conversion of adrenaline into adrenochrome. But even without changing the concentrations of adrenaline, one might reduce the amount of adrenochrome by taking away those substances needed by adrenaline to facilitate its oxidation, or by making it more difficult for adrenaline to be oxidized.

Substances that could increase the oxidation of adrenaline are copper ions. These are copper atoms that have lost their electrons and are able to float in water. Removing them might be helpful. We have found penicillamine to be one of the best safe compounds that can bind copper and remove it from the body, and have indeed used it to help treat schizophrenics in phase three treatment. The second way is to add safe substances such as vitamin C (ascorbic acid) and glutathione (an amino acid). Both these substances have been found to increase the number of cures in schizophrenia. We use vitamin C regularly in large doses (3-10 grams per day) to help us treat schizophrenia.

Decreasing Adrenochrome Production by Converting It into Dihydroxyindole: There would be no point in increasing the production of adrenolutin (which is as toxic as adrenochrome), but increasing the concentration of a neutral or anti-tension compound would be helpful. Such a compound is dihydroxyindole, which comes from adrenochrome when the body organism is functioning normally. If the process of converting adrenochrome into dihydroxyindole instead of adrenolutin could be achieved, the effect would be two-fold: it would remove a toxic compound (adrenochrome) and lessen adrenaline's severe affect on the person.

We know of only one way of doing this. This can be done by penicillamine. In the test tube, penicillamine combines with adrenochrome and converts most of it into dihydroxyindole. Thus, penicillamine may have two functions: to bind and remove copper and to convert more adrenochrome into the neutral indole. Penicillamine is available, but it must be used cautiously and under strict medical supervision because of its potentially toxic effects.

Removing Adrenolutin: It may be possible to remove adrenolutin by converting it more rapidly into other non-toxic chemicals, or by mopping it up. We do not know enough about adrenolutin to increase its destruction in this way. Treatments that one would expect would work if the adrenochrome hypothesis were true do indeed help patients to recover. We do not wish to imply there are no other treatments, but merely to show that these treatments do work, and that the hypothesis is supported.

Pellagra and Schizophrenia

Many psychiatrists are no longer familiar with the clinical manifestations of the vitamin deficiency disease known as pellagra, but when the older literature is examined, it is clear that the best model of schizophrenia is pellagra. Pellagra is a vitamin deficiency disease commonly found in countries where nutritional standards are low and people do not get enough nicotinic acid in their diet. It was very common in some parts of the Southern United States before 1939. This disease was said to be characterized by the three 'D's: delirium, diarrhea, and dermatitis. The delirium was very similar to schizophrenia. It has been estimated that up to 10 percent of the admissions to some Southern mental hospitals were these pellagra psychotics.

For many years, psychiatrists in mental hospitals could not distinguish between the two diseases. The only certain diagnostic test was the therapeutic one, once crystalline vitamin B-3 became available. If the psychotic patient recovered in a matter of days on 1 gram per day or less, he was labeled pellagrin; if he did not, he was retained in the diagnostic group "schizophrenia." It would appear that pellagrins suffer from a vitamin B-3 *deficiency* disease, while schizophrenics suffer from a vitamin B-3 *dependency* disease. People with schizophrenia need more vitamin B-3 to restore their biochemical balance than people with pellagra or any 'normal' person.

Both diseases are characterized by changes in perception, thought, and mood. The major difference has been in skin pigmentation. Pellagrins usually suffered symmetrical brown pigmentary changes, while this was less common in schizophrenics. It is likely, however, that this was an artifact resulting from the way the patients were cared for. Schizophrenics were generally locked up in mental hospitals and were not exposed to the sun, whereas pellagrins came in from the community and either recovered fairly quickly or died.

What is not as well known is that long before pellagrins became psychotic they suffered from tension, depression, personality problems, fatigue, and every other change commonly seen in neurosis, psychopathies, and depressions. In other words, mild forms of pellagra modeled non-psychotic forms of pellagra and severe forms of the psychotic varieties.

Malvaria and Schizophrenia

Research on the adrenochrome-adrenolutin theory has led to the recognition of a disease called "malvaria," which can be diagnosed by a chemical test. Its presence in the majority of untreated schizophrenics is a fact, not a hypothesis. The nature of malvaria adds much proof to our thesis that biochemical factors play a major role in causing schizophrenia.

The history of this research goes back to the time when we expanded the model psychosis hypothesis. Model psychoses are new and strange states of mind produced when normal subjects take such compounds as LSD-25, mescaline, psilocybin, adrenochrome, etc. This model psychosis, induced by artificial means, resembles real psychosis. The "model psychosis hypothesis" is simply the idea that, by producing states of severe mental illness in normal subjects, it is possible to learn more about the real psychoses that come on naturally.

We expanded the idea by assuming that the model was active not only in the psychological area but in the biochemical area. That is, that LSD-25 might cause the same changes in the body chemistry that were naturally present in schizophrenia.

Sometime in 1957, our biochemists developed chemical techniques for isolating and demonstrating substances in urine. You can see for yourself how this works when you drop ink on a blotter. If a big blob drops on the blotter, the ink begins to spread from the point from where it was dropped in a radial direction. If you look closely, you can see that there is a clear margin of water that moves faster than the particles of pigment making up the ink.

In the laboratory, we place a drop of the liquid we want analyzed on specially treated strips of filter paper. The paper is dried, and then the strip is dipped in a trough containing specially selected solvents. By a wick action, the liquids travel up the paper, sweeping along the chemicals that

are present in the drop originally placed on the paper. These chemicals travel more slowly than the solvent, just as the particles of ink travel slower than the water. In a certain number of hours, then, they will not have traveled as far on the paper strip as the solvent. How far they travel depends upon the structure of the molecules. Some are swept further from their origin than others and are called fast running or high Rf spots.

After the paper strip has been allowed to stand for 18 hours, the paper is removed from the trough, dried, and sprayed with a chemical that develops it in the same way that a photographic film is developed. The molecules that have moved along the paper react with the spray and produce colored spots. If conditions are ideal, the same molecules always travel to the same area in the paper and give the same color with the spray reagents.

In 1957, we collected urine from alcoholic subjects before and at the height of an LSD-25 experience. We followed the procedure outlined above in identifying the chemicals in the specimens. To our pleasure, a mauve looking spot appeared in the LSD-25 urine sample that had not been present in the sample taken before the drug was administered. We then collected a small series of urine samples from schizophrenic and normal subjects and had them analyzed in the same way. All the schizophrenics showed the same spot. None of the other subjects tested did. This began a series of extensive studies at four of our research laboratories in Saskatchewan. The spot was called any one of the following names: mauve spot, unidentified substances, or "u.s.", for short.

Since then, over one thousand patients have been examined for the absence or presence of the mauve factor. People with schizophrenia untreated and ill less than one year have the greatest incidence of mauve factor in the urine. Normal subjects have none. However, since a small proportion of schizophrenic subjects do not have the mauve factor and small proportions of the other groups do, it was not possible to use the presence of mauve factor as a definitive diagnostic test for schizophrenia. This is not surprising, for it is generally true that diagnosis in psychiatry, while as precise as diagnosis in other branches of medicine that have no laboratory tests, is not precise enough to guarantee that every patient labeled schizophrenic is in fact schizophrenic, and every person not labeled schizophrenic is not.

Furthermore, it is possible that some patients with clinical schizophrenia have other biochemical abnormalities not measured by the mauve test.

For these and other reasons, we decided to use the mauve test as the main diagnostic laboratory test, in much the same way as the Wassermann test is used for syphilis. As a result, we decided that every human who had mauve factor in the urine had a disease called malvaria, regardless of any other diagnosis given by other diagnosticians. This was an operational definition, depending entirely on the chemical test. A verbal definition is a series of statements about something. These are found in dictionaries. But the accuracy of the definition depends upon the meaning of other words, and there is much room for argument. An operational definition depends not upon other words, but upon a series of accurately described procedures that any trained person can follow and reproduce. In this case, any chemist who follows the written instructions can show when the mauve factor is present in urine. Thus, the area of disagreement about whether the mauve factor is present or not is sharply reduced.

Malvaria, then, is that disease which is present in human beings when they excrete a mauve factor. Thus, there can no longer be any argument about malvaria. It is, or is not, present, and the decision is made by the chemical test.

But does it have any use in the practice of psychiatry and in the care of the mentally ill? Malvaria would be a meaningless term unless it turned out that having malvaria leads to proper specific treatment. The only objective of diagnosis is to determine treatment and to establish prognosis – the future of the disease. In other words, is it of any help to know that a subject has malvaria? How is the patient with malvaria different than the patient who does not have it?

The problem has been examined in the following ways:

1. By giving-malvarians and non-malvarians a series of psychological tests for comparison.
2. By giving the two groups a series of physiological tests for comparison.
3. By examining the group of malvarians and non-malvarians not treated with nicotinic acid or nicotinamide for response to treatment and prognosis.

4. By examining the group of malvarians and non-malvarians that were treated with nicotinic acid for response to treatment and prognosis.
5. By comparing malvarians and non-malvarians for psychological response to LSD-25.

The results of these large-scale studies are as follows:

Are malvarians different clinically from non-malvarians? The answer is "yes." We have compared 104 malvarians with 75 subjects who did not have malvaria, drawn at random from a group of 150 non-malvarians. Whether they were diagnosed schizophrenic, neurotic, or neither of these, patients whose urine tests showed the mauve factor were more like each other than patients whose urine did not. Even non-malvarians who were schizophrenic seldom had the vivid perceptual changes of the schizophrenics who also had malvaria.

In general, malvarians have a much higher incidence of perceptual changes. They more frequently show disturbances in thought content and the process of thinking is disturbed. They show inappropriate mood changes much more frequently, as well as bizarre and unusual changes in behavior. The only symptom that was present as frequently in both groups of patients was depression, or low spirits.

Were malvarians and non-malvarians psychologically different? Yes. When examined with the HOD test, malvarians scored nearly twice as high. They scored higher on the Minnesota Multiphasic Test. When examined for certain visual tests that measure constancy of perception, they showed more rigidity. The differences were large and statistically significant.

Were malvarians and non-malvarians physiologically different? Examination of certain changes in brain-wave patterns showed malvarians had more abnormalities than non-malvarians.

What difference was there in response to treatment and prognosis of the two groups not treated with nicotinic acid or nicotinamide? Ordinary psychiatric treatment produced different results in the two groups. In general, patients

with malvaria (whether they were neurotic or psychotic) did not respond as well to treatment, had to stay in hospital longer for treatment, and needed to be re-admitted more often after discharge.

What difference was there when nicotinic acid was used in treatment? When nicotinic acid was included in the treatment program, those with malvaria began to recover much sooner, much better, and in larger numbers than non-malvarians (the methods will be described later).

This applied to all diagnostic groups: the mentally retarded, adolescents with problems, anxiety neuroses, alcoholics, and schizophrenics. For example, six malvarian alcoholics were treated with LSD-25 as a main treatment. They were not improved whatsoever and remained alcoholic. But out of eight alcoholic malvarians treated with nicotinic acid, seven were sober over the two-year course of the study.

Non-malvarians do not respond nearly as well to nicotinic acid. We have given nicotinamide treatment to seven children with malvaria and 20 without it. All were either afflicted with behavioral problems or were unable to learn in school. Of the seven with malvaria, six are nearly well and getting on well. The seventh, a child of one year of age, was treated for only one month while expecting admission to a school for mentally defective children. After admission, the vitamin was no longer given and there was no improvement. Of the 20 non-malvarian children, only one has shown any improvement of significance.

Do malvarians and non-malvarians respond differently psychologically to LSD-25? Yes. Out of any group of normal subjects given LSD-25, about one-half will have an experience that we term "psychedelic." That is, they are relaxed, at ease, and have exciting and useful experiences, many times of a mystical or visionary sort, from which they derive lasting benefit.

Alcoholics without malvaria show the same incidence: about half will have these psychedelic reactions. This type of reaction seems to be important to treatment. Several of our workers have observed that alcoholics who do have these good experiences provide the majority of recoveries. However, alcoholics who have malvaria, either before or after the LSD-25 session, are different. Less than one-fifth have relaxed and good experiences and hardly any have a deep visionary, religious, or other experience.

This evidence, collected over a two-year period, shows the usefulness of the diagnosis of malvaria. The presence of the mauve factor indicates that the patients are seriously ill and should be given nicotinic acid treatment, as well as other treatments. It allows one to predict that if they are given such treatment, the results will be much better than if they are not.

Finally, if the mauve factor vanishes from the urine, it is a hopeful sign that the patients are beginning to recover. So far, no patient who has recovered has remained malvarian. In addition, a recurrence of the malvaria is a bad prognostic sign and suggests that active treatment should be instituted right away.

Dr Irvine and his co-workers have established the structure of the mauve factor. It is kryptopyrrole (KP), a well-known chemical. This work has been confirmed by A. Sohler, R. Beck, and J.J. Noval, who first demonstrated that it produced behavioral changes in animals. This work has been expanded by Dr K. Krischer and Dr Carl C. Pfeiffer, who suggested that both KP and a nicotinic schizophrenic sweat factor came from a common precursor. Pfeiffer found that KP bound with pyridoxine (vitamin B-6) and could, therefore, produce a vitamin B-6 deficiency. He suggested that the presence of the mauve factor (KP) is an indication that increased quantities of vitamin B-6 should be given to patients.

To test for the mauve factor, Dr Pfeiffer and his research group developed a simple colorimetric test that is used to analyze urine for this substance, and he found that this factor bound both zinc and pyridoxine, producing a double deficiency. Based upon this work, Dr Pfeiffer divided schizophrenia into three different biochemical types: those positive for this factor, called pyroluriacs; those high in histamine, called histadelics; and those with too little blood histamine, called histapenics. Each type requires slightly different biochemical treatments, although they all call for megadoses of certain vitamins.

To diagnose these groups accurately, one needs a laboratory that will test for kryptopyrole and blood for histamine levels. If you cannot find a physician and laboratory facilities to do these tests, do not despair. You will still benefit enormously from this overall orthomolecular approach.

Pyroluriacs: This group excretes kryptopyrole in their urine. This group also has some unusual characteristics, including white spots in their nails,

stria on their bodies, and others. They need zinc and pyridoxine in addition to the rest of the program.

Histadelics: About 20 percent of schizophrenic patients fall into this group. The syndrome has been described by Dr Holford working with Dr Pfeiffer's research. They have the usual features of schizophrenic patients but, in addition, have a variety of psychological (chiefly depression) and physical complaints, and they have certain body characteristics. Dr Pfeiffer did not recommend niacin for this group. In this, he and I disagree. I found vitamin B-3 very effective, but the fact that there is too much histamine needs to be considered. It can be slowly reduced by building up the amount of niacin in the presence of ascorbic acid.

Dr Pfeiffer recommended a low-protein, high-complex carbohydrate diet, as well as calcium, 500 milligrams twice daily, and the amino acid methionine, 500 milligrams twice daily, in addition to the rest of the program. He recommended avoiding folic acid, which can raise histamine levels, but recently it has been found that folic acid, in doses of 25 to 50 milligrams daily, can be very helpful in treating depression.

Histapenics: This schizophrenic group also has certain unusual characteristics. For this group, Dr Pfeiffer recommends niacin, folic acid, vitamin B-12 injections, l tryptophan, zinc, manganese, and a high-protein diet.

These studies have clearly shown there are biochemical causes for the symptoms of schizophrenia.

Psychological Factors

There are numerous psychological theories of schizophrenia not based on a biochemical hypothesis, but we propose a psychological theory, which may be called the perceptual theory of schizophrenia, based on this hypothesis. Our basic assumption is that the biochemical changes somehow interfere with normal perception. As a result, the external world is perceived in an unusual or distorted way. The subject is not aware that these changes have occurred and believes they have occurred in the environment. The

patient reacts appropriately to what he perceives in the new world, but to the observer, these actions are inappropriate.

An example may illustrate what we mean. In normal use, certain figures are punched on the keyboard of an ordinary calculator in a certain order. This is data fed in from the environment. Then the machine performs certain operations, such as adding and multiplying. The final result appears as an answer on the display. As long as the correct data is punched in and the machine performs its operations accurately, the result will be satisfactory. Suppose, however, the machine begins to produce a series of random answers, some right some wrong. The error may lie in the data punched in, in the way the data was punched in, or the data fed in may have been handled incorrectly because of some defect in the machine. The answers are then bound to be wrong.

The same reasoning can apply to a human being. A human being is normal as long as the information from the environment is received in the usual stable way, is used by him in the expected manner, and is acted upon in a rational way. A failure in any one of these three facets of normality can produce irrational behavior. The three mechanisms are perception, thought, and action. In our theory, disorders of perception and disorders in thinking can account for the final disorder of action we know as schizophrenia.

Over 300 hundred years ago, the physician Thomas Willis enunciated a perceptual hypothesis when he noted that psychotic patients seemed to see the world through a distorted looking glass. John Conolly, the eminent English psychiatrist, and his colleagues, Pinel and Rush, had a well-developed perception theory over one hundred years ago.

Perceptual changes are present in the majority of schizophrenic patients, as we discussed in detail in our chapter on the symptoms of schizophrenia. To see the range of possible perceptual changes involved in schizophrenia, a useful guide is the HOD (Hoffer-Osmond Diagnostic) test. When this test was correlated with the mauve factor test, it was found that most subjects scoring high on the test also had the mauve factor. It was, therefore, found to be a diagnostic test for malvaria as well as for schizophrenia.

Objective tests have shown that schizophrenics have a rigid kind of visual perception that prevents them from stabilizing their external world.

Objects appear usually too small and perspective is altered. When a schizophrenic is looked at, he often believes people are looking directly at him when, in fact, they are looking beyond him, to his left or to his right.

Perceptual changes can be induced in normal subjects by hypnosis, bringing about symptoms resembling those of schizophrenia. This can be done during the trance or post-trance state, providing a method for giving subjects perceptual changes while they are hypnotized and allowing these changes to continue after the hypnosis. This makes it possible to study the reaction of these subjects to other people about them.

A large series of experiments of this kind were carried out by Dr S. Fogel and me in Saskatoon, on two normal subjects who were trained in becoming hypnotized. After they had achieved a deep trance state, certain changes were induced by command: "When you come out of your trance, you will find that (here the key suggestion was given). When I snap my fingers you will be normal again." The suggestions covered all the perceptual areas, including time: for example, "You will find that people are watching you," "People's faces look funny," "Everything looks blue," or "Time is moving very quickly."

During the experiments, we observed the following results:

Changes in Vision: At the command, "You will find people are watching you," the subjects developed a typical, even exaggerated clinical picture of paranoid schizophrenia. They were hostile, suspicious, irritable, and difficult. On one occasion, a subject was interviewed by a psychiatrist who did not know she was in the post-trance state. At no time during hypnosis was the subject given the suggestion to become schizophrenic or paranoid, yet, 20 minutes after the interview began, the psychiatrist was preparing to write out committal papers to send her to a mental hospital.

In this post-trance state, she vehemently denied she had been hypnotized and that people were watching her. This paranoid reaction was easily demonstrated in the presence of one or more observers, and on one occasion, it was demonstrated to the research meeting of the College of Medicine, University of Saskatchewan.

We produced emotional reactions to visual changes, which resembled the behavior of schizophrenics. In one experiment, the subject was told that all colors would be alike. She thereupon became sad and depressed,

and had visual hallucinations. Disorientation to her environment was complete. The suggestion that all colors were bright, on the other hand, produced manic behavior. She was happy, excited, spoke rapidly, and was very gay. She read and walked more quickly than usual and laughed easily. Again, she was completely disoriented.

The feeling that there was no color anywhere, suggested during hypnosis, produced hostility, suspiciousness, depression, and irritability. When told that she would not be able to recognize anyone in the room but herself and the hypnotizer, the subject became suspicious of everyone except the hypnotizer. She demanded to see my credentials before acknowledging me as a doctor. She thought a metronome was a time bomb. Had it not been for her faith in the hypnotizer, she would have run away. Upon being told that everyone present was sinister, she became suspicious, hostile, argumentative, sarcastic, insulting, and belligerent.

Changes in Hearing: The subjects' reactions to suggested changes in hearing followed the same pattern. One subject heard voices and became suspicious and hostile when told that all sounds would be louder. But when told that all sounds would be quieter, she became depressed, unhappy, quiet, and withdrawn. The suggestion that she would not be able to locate the source of any sound she heard produced another interesting response. She withdrew and became silent, refusing to answer any questions. When we insisted, she folded both arms over her face and withdrew into herself in a peculiar way, as if to shut out all sight and sound.

Changes in Smell: We were able to produce similar changes when we told the subject that all odors would be exaggerated. She said her name was Rose, which it was not, and became angry and unfriendly. She said she could smell the pond in a picture we showed her, and she believed she could actually get into the cold water. She was very argumentative and resented questioning. But when told she had no sense of smell at all, she presented a pathetic, childlike picture of bewilderment, worry, and confusion. She became withdrawn and vague.

Changes in Touch: We suggested to the subject that her sense of touch would be heightened. As a result, she became possessive about a linen

handkerchief that was handed to her and refused to give it up as she continued to feel it with her fingers. She was not interested in a dry sponge or other coarse objects, but smooth objects occupied her full attention. She was distant and not as communicative as usual. She was then told she would not be able to feel anything. She thereupon became hostile and scornful, and said her name was Susie, which it was not. She was again suspicious and argumentative, aggressive and angry, a typical paranoid schizophrenic.

Changes in Time Perception: For these experiments, we used a metronome with a loud regular beat that could be adjusted in frequency from zero to several hundred beats a minute. The subjects were hypnotized and the frequency was set at 60 beats a minute. The subjects were then given the instruction, "When you come out of your trance, you will find the clock beating 60 beats a minute." Then the subjects were ordered to come out of the trance.

At this point, they appeared little altered. When the frequency was decreased to 30 beats a minute without their knowledge, however, they were markedly slowed up. They thought slowly and acted slowly, said they were depressed, and appeared to be depressed.

When the beat was stopped, the subjects became catatonic almost immediately, literally stopped in their tracks, even if they were walking rapidly or engaged in any activity at the time. One subject developed a typical waxy flexibility. When she was placed in any position, she seemed frozen in it indefinitely. The other developed a rigid negativistic catatonia from which she could not be moved. When the beat was started again, they both resumed their activity as if there had been no pause at all. In fact, they vigorously denied they had stopped or paused or interrupted what they were doing in any way.

When the beat was set to exceed 60 a minute, the subjects became more alert, friendlier, and more active. They spoke more rapidly, stated that they felt wonderful, and appeared to be hypomaniacal.

We will not give the details of all these experiments, but they proved that when normal subjects were exposed to perceptual changes, and when they accepted them as real, their behavior was abnormal and reproduced the

varieties of schizophrenia seen clinically. It was possible, by giving the appropriate perceptual change, to demonstrate nearly every variety of schizophrenia, including hebephrenia, catatonia, paranoia, and the simple forms.

Dr B. Aaronsen, at the New Jersey Bureau of Research in Neurology and Psychiatry, has corroborated our work and expanded it into new and exciting dimensions. He has shown that profound changes in behavior are produced by these techniques, as well as major changes in response to the Minnesota Multiphasic Personality Inventory (MMPI) test.

The evidence, then, is fairly strong that perceptual changes, if accepted as true by the patients, will produce bizarre and abnormal behavior. Further research will determine how important these changes are in determining the content of the schizophrenic illness.

Sociological Factors

By sociological factors, we mean interaction of the schizophrenic person with other people. This is a vast subject, and we can illustrate only a few components. Our basic hypothesis is that changes in perception will determine the patient's interaction with other people.

Consider, for example, a baby's reaction to its mother. One of the first interactions between mother and child is the smile. It does not matter much who smiles first, mother or child. Usually the other responds, perhaps involuntarily, and a mutual interaction is developed.

Suppose, because of some perceptual difficulty, the baby does not recognize the mother's smile as a smile, and from the beginning, there is no bond or interaction. It is not difficult to imagine how hard it would be for the mother to continue to do all the things she must do without getting an appropriate response from the child.

Suppose a child at the age of six months has a disorder of hearing and cannot tell where sounds are coming from. When his mother talks to him, he sees her, but the sound of her voice comes from somewhere else. He cannot, therefore, associate his mother's voice with the mother and so does not respond to her. Her voice then has no more significance to him than the ticking of the clock, the radio, or the refrigerator. This kind of change could explain why mothers of such children believe that their children are deaf.

Let us assume that an adult schizophrenic develops a disorder in the perception of time, so that time is moving more slowly for him. Imagine what it might be like to hold a conversation with him. When a statement is made, the patient should respond in a time interval that we would consider normal. But since his sense of time is slow, he responds to the normal person only after a prolonged pause. Subjects would, therefore, be out of step with respect to their own conceptions of time. The normal subject might become impatient and repeat his statement before the patient could reply, and in a louder voice. The patient might then wonder why the other person was raising his voice or why he was speaking so quickly to him.

Or imagine what would happen if a schizophrenic patient could no longer judge how loud he would have to speak to project his voice to another person. He might speak so loudly, not knowing he was doing so, that he would irritate everyone about him. If people pointed out to him that his voice was too loud, he might not believe them and become hostile and suspicious.

With these handicaps, the patient would be less able to pick up all the cues of normal social intercourse, which are so important. He would be placed at a tremendous disadvantage and would have to decide intellectually how to act in the absence of these cues. This would be difficult, for he would have to know first what was wrong, and even then, he would be unaware of much that was happening, because he would assume it was perfectly natural.

We have seen many patients whose entire bizarre behavior was readily accounted for by a few perceptual changes. One was a schoolteacher whose hearing became so acute he could hear people talking several rooms away from him. Another patient found that he could not distinguish one face from another and, therefore, concluded the same person was everywhere and following him about.

Schizophrenics will talk to their hallucinations and hold conversations with them. They may even follow imaginary instructions. Many patients will refuse to eat because their stomachs feel dead or they taste something bitter and assume they are being poisoned. Disorders of smell can lead them to believe they are being gassed.

With the perceptual hypothesis of schizophrenia, it is no longer necessary to consider that the schizophrenic is the most obvious symptom of a

sick family. There is little doubt that a schizophrenic member of a family could easily disrupt the entire family dynamic, especially if the family was unaware that he was sick. For they would merely think that the patient was responding in unusual and inappropriate ways to their attempts to interact normally with him.

This has led some sociologists to place the cart before the horse and to blame the family for producing the schizophrenia in the sick member. Some have even speculated that many mothers deliberately make their children schizophrenic in order to satisfy some deep-rooted complex of their own.

We have seen many so-called schizophrenic families with schizophrenic mothers. The families were tense, unhappy, and hostile. Yet, when the patient returned home cured, the same family became normal, and the mother no longer seemed so pathological. Strange as it may seem, mothers and fathers are human and make mistakes, and become distressed when their children are sick. When they are anxious and upset, they do not always behave as wisely or as kindly as one would hope. However, we have found many relatives of schizophrenic patients to be devoted to them. Not all relatives of schizophrenics are amiable paragons of virtue, and in this respect, they resemble the rest of us. But considering how badly informed they often are, in our experience, they do as well as anyone could expect.

④ | WHEN DOES SCHIZOPHRENIA BEGIN?

Schizophrenia knows no age – children, adolescents, adults, and seniors are all subject to its onset. But in each age group, the onset of symptoms is distinctive and can be used to diagnose the causes of this disease.

During Childhood

Childhood is the period in life when schizophrenia can do the most harm. The earlier the onset, the graver the consequences will be, unless the illness disappears spontaneously or as a result of early treatment.

The illness will have the most damaging effects if it comes on either before or shortly after speech has fully developed. One of the serious effects of the disease at this time is that vocalization seems to stop. Normally, babies babble, and when, from the variety of gurglings and bleatings, they produce one that seems to make sense to mother or father, there is an appropriate response. The word "ma," for example, is responded to by parents with great enthusiasm. This occurs until "ma" becomes firmly attached to a person, mother. Words are learned so gradually that we hardly realize what is happening, until the child grasps the uses and symbolic meaning of words.

But if the child never babbles or vocalizes, there is nothing for parents to respond to, and so language could not develop. Schizophrenic babies are unusually quiet, or make single monotonous sounds to which parents cannot respond, and we think this is why they cannot learn to speak. If it were possible to stimulate babbling, perhaps they could learn to speak in the usual way. Young children who have learned a few words seem unable to learn more and often forget the ones they have already learned. It seems, therefore, that schizophrenia at this stage prevents the further learning of new words.

If the disease vanishes, the degree to which speech will recover depends upon the duration of the illness. There is a critical period of several years when speech is learned. If it is not learned within this period, it will not be learned at all, or at best, it will be imperfect and rudimentary, unless a major and sustained remedial effort is made by competent teachers.

Schizophrenic children seem to have many of their senses altered. They may have trouble recognizing people, and therefore, they do not learn to respond appropriately to their parents, who are understandably puzzled and disappointed. If hearing is affected, they may be unable to localize sources of sound and may, therefore, pay no attention to sounds. If the sounds ignored include those of mother calling, this can be very disruptive to the normal development of the mother-child relationship.

These children may have perceptual abnormalities severe enough that they will be unable to learn, and will most likely be labeled mentally retarded. When this happens, they are forced into the mold devised by society that keeps them segregated. Once labeled in this way, it is very difficult to become 'unlabeled'.

If the illness comes on after speech has developed, these children may stop speaking, but there is a better chance that speech will be re-established if the disease is properly treated. These years before puberty are crucial ones in human development, and a year lost here may be very difficult to regain. But the closer to adolescence the illness comes, the better the prognosis will be. Growth will be more affected at this time, of course, than after puberty. These children are often dark, slender, and narrow from front to back.

It is easy to find fault with parents at this period. There is no doubt that the mother-child relationship is disturbed. The prime reason is that the junior partner, due to illness, does not behave the way a normal child does.

The mother, therefore, is left unrewarded for all the love, attention, and care given to her child, and becomes irritable, frustrated, and worried. This does not help her in her care for a very sick child.

If the mother herself, which occasionally happens, is somewhat disposed to schizophrenia, it might be even more difficult for her to react appropriately. The system of rewards and punishment that worked with her normal children no longer applies, and an impossible situation is created. Her problem is not made easier by those psychiatrists, psychologists, social workers, and others who have, on slender evidence, decided that the mother has made her child ill.

The only hope for these children is early identification of the illness. Just as special diets may be too late after one month in phenyl pyruvic oligophrenia (a form of retardation caused by lack of a protein enzyme), so it goes with schizophrenic children. They must be recognized as early as possible by skilled psychiatrists, who will use the mauve factor urine test, if necessary, to help them.

Vitamin B-3 Deficiency

One effective means of identifying children with schizophrenia is to test for vitamin B-3 deficiency. Diagnosis of disturbed children is in a very chaotic state, there being close to 50 different diagnostic terms for hyperactive or hyperkinetic children, as I have described in my book *Dr Hoffer's ABC of Natural Nutrition for Children with Learning Disabilities, Behavioral Disorders, and Mental State Dysfunctions*. The disorders in children I have studied and treated range from perceptual disturbance and minimal brain disorders, to hyperkinetic disorders, autism, and schizophrenia. Because of my work on the adrenochrome-androlutin hypotheses, it occurred to me that we might be able to identify these disturbed children by their response to megadoses of vitamin B-3.

Is there a syndrome that could be labeled "the vitamin B-3 responsive syndrome?" This could be determined by giving a fairly large number of disturbed and sick children ample quantities of vitamin B-3. Children who became well would then be examined for some constant features that could become an indication for using vitamin B-3. In principle, it is the same as labeling every person who recovers on vitamin doses of B-3 as having suffered from pellagra or subclinical pellagra.

To examine this question, I began a single blind placebo controlled study on children under age 13 who were referred to me because of disturbed and disturbing behavior. Many had been treated by various psychiatrists before this.

All seriously disturbed children referred to me by family physicians were carefully examined in my office and later by a colleague, Dr B. O'Regan. They were then placed upon nicotinamide or, rarely, on nicotinic acid if there was no response to nicotinamide. The dose was increased from 1 to 6 gm per day. They were also given ascorbic acid, 3 grams per day and, rarely, very small doses of tranquilizers or anti-depressants. They were then seen every three months to evaluate their progress. At no time were they given or were their parents given any dynamic psychotherapy.

As soon as the child recovered, whether it took three months or two years, he was taken off nicotinamide and given the same dose of equivalent placebo tablets. The ascorbic acid and other chemotherapy was not altered. The child was not aware of any change in medication. The mother was, as I consider it medically unethical for me to use any more double blind experiments with vitamin B-3.

As long as the child remained well, she was kept on placebo. But as soon as the parents were convinced that the child had regressed to a substantial level, they stopped the placebo and started her back on the nicotinamide.

After three years, I made a final evaluation of each child, taking into account performance in school, relation to his family, and the presence of any symptoms. They were also re-evaluated by Dr O'Regan. Each child was given a diagnosis, but irrespective of this, they were placed into the research group.

The results of the study were as follows. Of the 38 children entering the study, six were terminated before they had completed their three years. Of these, one, a mongoloid child whose father is a recovered schizophrenic, did not respond after six months and there seemed then no point in carrying on with him. A second child was making excellent improvement but would not keep her appointments. Her parents seemed quite disinterested and she was dropped from the study. A third child would not take his medication. Whenever he was forced to take his vitamin, he would begin to recover, but the battle between him and his parents was too difficult and eventually he was sent to a home for disturbed children. The remaining

three children were the products of a schizophrenic, alcoholic father who killed himself, leaving a severely schizophrenic widow. It was impossible for her to ensure her children's cooperation, nor was she herself able to cooperate.

Twenty-four children went through the treatment-placebo-treatment cycle. In each case, he or she recovered on treatment, relapsed on placebo within one month, and recovered again on vitamin B-3. In many cases, recovery was slower after a placebo-induced relapse. The remaining eight were well or nearly well in the first phase of the study.

Thus, of 33 children who took medication as directed, only one was a failure.

I should emphasize that by "well" or "recovered" I mean they were free of symptoms and signs, performed well in school, and got on well with their families and with the community. Some are now members of Schizophrenics Anonymous.

Twenty-seven families were included in this study. In 13 families, neither father nor mother was ill. Of their 47 children, 16 were included in the group; i.e., 34 percent of their children were ill. Since they were target families with at least one sick child, this is close to what one would expect, assuming an average family size of around three. In nine families, one parent had been ill and had recovered from a vitamin B-3 responsive illness, usually schizophrenia. Six had sick fathers and three had sick mothers. Out of 29 children, 13, or about 45 percent, were ill. In five families, both parents had schizophrenia. From 22 children, 18, or 82 percent were ill.

Most of the children who were given the medication regularly recovered, but a few parents were too ill or too indifferent to cooperate, and their children's recovery was too interrupted by failure to maintain medication.

In other words, most of the children are vitamin B-3 responsive. The main variable was vitamin B-3, for when this was replaced by placebo all children relapsed within 30 days. There was no change in ascorbic acid, in other medication, or in nutrition. In every case, good nutrition was emphasized. When vitamin B-3 was re-started, the children recovered again, although in many cases, more slowly.

Diagnosis of these children was as varied as with any group of disturbed children. The only thing in common was that they were ill and very disturbed, and that most were hyperactive. Diagnosis was no indicator of response.

Therefore, I must conclude that the condition I call a vitamin B-3 dependent disease can manifest itself in a variety of forms. I consider it a vitamin B-3 dependent disease because they require 3 to 12 gm per day of vitamin B-3 and because good diet alone has absolutely no effect upon them. My data shows that vitamin B-3 dependency is inherited. In more than 100 families that I have examined in the past 10 years, I find that if one parent is vitamin B-3 dependent, one-quarter of the children also will be. If both parents are vitamin B-3 dependent, one will expect more than three-quarters of the children also to be vitamin B-3 dependent.

There has so far been no generation gap. One can trace this from one generation to another. I have now in my care five patients, including one mother, three of her nine children, and one hyperkinetic grandchild, son of one of the three. The grandfather was a paranoid, depressed personality. Of his 10 children, three, including the mother of the nine, were mentally ill with schizophrenia or retardation.

Another example comes from this controlled study and covers two generations. Peter and Mary were patients in this study.

Peter, 9 years old, was the first member of a vitamin B-3 dependent family who was referred to me for treatment. For over a month, he had markedly changed from a happy, too quiet, obedient boy to one who was hostile, irritable, and fearful. He was terribly worried he might give way to his murderous impulses against his parents or against himself. Thus, he was afraid to take a bath because he was afraid that he might drown himself. These fears had been present over one year, but not at the same intensity. Peter described his life as a nightmare of visions, perceptual illusions, and fears.

He was started on nicotinamide 1.5 gm per day, ascorbic acid 1.5 gm per day, and continued on thorazine 50 mg at bedtime.

After one month he was slightly better. After the third month, he was even better, but he still reported hearing voices and a choir of voices singing church songs. His performance in school had improved substantially. He reported that rubbing his ears no longer masked out the voices the way it used to and he described a vision he had seen before starting on megavitamin therapy. He saw Christ sitting on a chair.

After seven months, he was normal. He was started on placebo while continuing with ascorbic acid and thorazine. After two weeks, he began to

relapse and his behavior began to revert to his pre-treatment condition. He could no longer sleep, nightmares came back, objects seemed far away, and he became fearful and disobedient. There was no doubt he had relapsed. After one month of placebo, he was placed back on nicotinamide, and thorazine was discontinued. Within a month, he was well. When seen after three years, I found him normal, as did my colleague, who had examined him earlier. He reported that Peter was "a normal 12-year-old boy." Peter's HOD scores were as follows:

Date	Total	Perceptual	Paranoid	Depression
January 1968	76	18	2	11
April 1968	56	14	3	8
July 1968	36	9	4	3
October 1968	13	1	1	2

Peter's sister, Mary, age 7, was next referred. She was considered retarded. She had started to walk late and had learned to speak slowly. For two years, she was a placid, quiet baby. Then she became disturbed and suffered many temper tantrums. She was first classed as dull normal. She went to kindergarten but was too disturbing to the class and she was sent to a class for the retarded. She had not responded to tranquilizers.

When I saw her, I did not consider her retarded because she was very alert and perceptive, but she was typically hyperactive. She was noisy, irritable, and short-tempered. She had a marked epicanthal fold that gave her a mongoloid appearance. She was started on nicotinamide and ascorbic acid, the dose increasing to 4.5 grams per day of vitamin B-3. She was also prescribed thorazine and 200 mg per day of pyridoxine.

After six months, there had been no improvement, and the parents, in discouragement, stopped all medication. For one year, she remained the same, but several years later, she began to hear voices and television in her head. She was again started on nicotinamide 3 grams per day, ascorbic acid

3 grams per day, glutamic acid 2 grams per day, and pyridoxine 100 mg per day. Improvement was very slight.

Two years later, she became violently psychotic. She heard voices telling her to kill, and she was in a constant panic and terribly fearful. It appeared she would have to be treated in an institution.

As a last resort, she was started on nicotinic acid 12 grams per day, ascorbic acid 3 grams per day, and, as a sedative, dilantin 150 mg per day. For the next month, this family lived through a nightmare, in which they had to give Mary 24-hour nursing care. Then she began to improve slowly.

When seen a year later, she had shown dramatic improvement. She was relaxed, at ease, no longer fearful, able to sleep alone, and getting on much better in school. It was very clear she was an intelligent girl slowly recovering from a very severe psychosis.

Peter's and Mary's father was referred next. He had been under psychiatric treatment for depression for two years. These episodes of depression had troubled him all his life. Medication had leveled out his mood to a chronic state of depression. He had read our book *How to Live with Schizophrenia* and concluded that he too suffered from schizophrenia.

When examined, he was not very ill, but he described having experienced visions and other perceptual changes. He had also been paranoid in the past, but his main complaint was depression and fatigue. As he was obese, I ran the five-hour glucose tolerance test and found he had relative hypoglycemia. After six months of orthomolecular treatment, he was well. (His father had been very irritable and suspicious for 10 years before he died at age 65.) His HOD scores were as follows:

Date	Total	Perceptual	Paranoid	Depression
January 16	27	5	0	6
April 2	15	3	0	4

The next family illustrates another two-generation transmission of vitamin B-3 dependency. Mr J. D., born in 1933, was seen in 1967 because of severe marital disharmony. Their marriage was normal until their first

baby died in 1957. Gradually, the marriage deteriorated and had been especially bad for the past five years. He had concluded that he and his wife must separate because he had no feeling toward her whatsoever and was sexually disinterested and impotent.

When examined, he was very suspicious, but admitted peculiar perceptual changes, complained that his memory was bad, and he was very depressed. He denied any paranoid ideas, but these were reported to me by his wife. He also had a severe form of relative hypoglycemia.

He was started on vitamin B-3, 3 to 6 grams per day, ascorbic acid 3 grams per day, and elavil for one month. In three months, he was normal. His HOD scores were down substantially:

Date	Total	Perceptual	Paranoid	Depression
Nov. 30, 1967	47	7	1	12
Dec. 14, 1967	62	14	3	6
Jan. 19, 1968	23	3	0	0

Early in January 1968, the second child, a girl age 8, was brought in because her performance in school was so erratic. This was due to her violent temper and because of a reading problem. Words moved on the page and faces pulsated. She also saw vivid hallucinations, heard voices, and complained of being tired.

She was started on nicotinamide and ascorbic acid, 1 gram of each per day. By May 1968, she was normal. She was started on placebo to replace the nicotinamide. She deteriorated to her pre-treatment level within four weeks.

She was started again on nicotinamide but responded very slowly. The dose of nicotinamide was increased to 4 grams per day by February 1969. However, by October 1970, she was well again, and the dose was reduced to 2 grams per day. At the end of the three years, she was still normal.

Based upon this study and upon hundreds of other cases – my own and those reported by Cott and Hawkins – there is a syndrome in children arising from a vitamin B-3 dependency. This syndrome is characterized by:

1. Hyperactivity.
2. Deteriorating performance in school.
3. Perceptual changes.
4. Inability to acquire or maintain social relationships.

Any child showing three or more of these features should be given a trial with the orthomolecular approach. In each case, there should be a titering of dose until the child is exposed to the optimum dose. Once the child is recovered, it can be slowly reduced to a maintenance dose.

I do not know how long they will require vitamin B-3, but I suggest it not be discontinued until they have achieved their final physical growth. One schizophrenic girl has been taking vitamin B-3 for 17 years but will need it for the rest of her life. Another man stopped his vitamin at age 16 and is still well two years later.

Dr R.G. Green has treated a large number of disturbed children with nicotinamide. From the dramatic responses to this treatment, he has concluded they suffered from subclinical pellagra. There is one major difference between pellagra and schizophrenia. It is entirely quantitative. Pellagrins require vitamin doses and schizophrenics require *mega*vitamin doses. But even this distinction is not absolute. Chronic pellagrins, who should be compared with chronic schizophrenics, also require megadoses for long periods of time.

There is, thus, a quantitative continuum from pellagrins who fail to ingest vitamin doses of vitamin B-3 – say 50 mg per day or less – to chronic pellagrins who require up to 1 gram per day, to acute schizophrenics whose needs are 3 to 6 grams per day, to chronic cases who will require 6 to 30 grams.

The group who require 50 mg per day or less will develop pellagra if their diet is deficient. The group requiring over 1 gram per day will develop schizophrenia, since no modern diet will provide this amount of vitamin B-3. What I do not know is how much vitamin B-3 per day given to this latter group will prevent them from developing schizophrenia. To be on the safe side, I recommend 1 gram per day for children of parents who are vitamin B-3 dependent. One could study this very easily by placing a large number of children from schizophrenic parents on various doses to see how much is required to prevent anyone from becoming ill.

Administering Vitamins to Children

Getting children to take their vitamins and other medication is sometimes difficult. There are two main reasons why children have difficulty accepting medication. Most often, they do not know how to swallow capsules or tablets. Secondly, the tablets may taste bitter or sour. If the problem is one of taste, the medication can be made available in capsules. These have the advantage of being neutral in taste and not sticking in the throat. Children generally prefer capsules to tablets.

If the child does not know how to swallow pills, then the medication will have to be given in a powdered form, which can be mixed with juice or (rarely) in the food. Nicotinic acid and other acid-tasting (sour) vitamins can be dissolved in liquid (not in milk), and if the acidity is a major problem, it can be titrated with baking soda powder until the solution ceases effervescing. This will remove the sour taste. Nicotinamide is very bitter and difficult to mask, but preparations are being developed that are overcoming this problem.

Children may be taught to swallow pills or capsules. One informant reported how she had trained her child. She crushed the tablets and placed the powder in the smallest available gelatin capsules. These are available in any drug store. The child had no problem. As soon as the small-size capsule was swallowed easily, she increased the size of the capsules until the child was able to swallow 1/2 gram capsules, which are available commercially.

With patience and perseverance on the part of the parent, any child can be persuaded and taught how to take the medication. Of course, it is essential that the child be given an explanation for taking the medication that he can understand.

During Adolescence

Adolescent schizophrenia is often extremely difficult to diagnose. Adolescents are often labeled personality problems with adolescent turmoil, behavioral problems, and so on. As the years pass, it becomes clear that many of these children were, in fact, schizophrenic.

We think there are two main reasons for these failures to diagnose the disease early. Adolescence is a transition between childhood and adulthood. Most young people go through it without difficulty, but many

psychiatrists have accepted the cultural myth that puberty and adolescence must be a turbulent period marked by many excesses of emotion and behavior. While adolescence may be a time of change and uncertainty, it is also a time of great hope and expectation, when life is very well worth living. There is even some slight evidence that emotional upheaval is more frequent between the ages of 21 and 41.

The great majority of young people do not display unusual behavior during these years. There are fewer adolescents in psychiatric wards than one would expect from their numbers in the population. But if one were to judge from novels, plays, television, and articles in national lay journals, it would appear, to an interested visitor from Mars who did not meet any of them, that nearly every young person is a juvenile delinquent or close to it. Abnormal behavior is considered much more interesting than any other kind.

The unfortunate result is that there is a tendency for psychiatrists to assume that, when they see a disturbed child, the child is going through normal adolescence, but to a higher degree. The child's behavior and his relationship with his parents, brothers, sisters, teachers, and so on are scrutinized most carefully, while the possibility that these may be disrupted by a devastating illness can be, and very often is, ignored.

The perceptions of young people are, in fact, less stable than those of adults. Boys and girls live in a very different world from that of their parents. When they are reading, lines move up and down and words may be blurry. This may have something to do with "reading problems" in primary schools. In adolescence, these may still be present, although the basic character of the young person is nearly formed.

We were only dimly aware of these striking differences between adolescent youths and adults until we began to use our HOD test, where people with schizophrenia score high. In order to understand the importance of high scores, we had to know what scores were common to normal people. We tested as many normal people as possible in a wide range of ages. When we gave the test to adolescents between the ages of 12 and 21, we were surprised to discover that a large number of them had scores that were in the schizophrenic range. Yet there was no doubt that they were not schizophrenic. One of these was an intelligent young man of 17, with no psychiatric problems of any sort. He completed the test very carefully and his

perceptual score was high. He was questioned about each card and easily described the changes that he had indicated were present.

In all, we tested a large number of normal young people in the city of Saskatoon. Seven schools were sampled, using students aged 12 to 19. We found that the older the age group, the lower the HOD scores. In other words, the normal students aged 13 had much higher scores than the normal students aged 19. If one drew a graph with age on the bottom base line, and scores on the vertical axis, it was nearly a straight line. The scores for each age are shown in the following table.

Age	Number of Students	Mean Perceptual Score
12	139	10
14	144	9
15	147	8
16	162	6
17	145	5.5
18	263	5
19	173	3
20	71	3
21-25	104	2
26 and over	99	1

But there are wide differences in the way adolescent students mature. Maturity consists in seeing the world in a stable way. We thus defined perceptual maturity as a lowering in the perceptual scores on the HOD test. But young people vary widely one from the other. Most adults, when well, are more stable – that is, they are more like each other than most healthy adolescents.

Not only is perceptual instability common in adolescence, but also the ability to see and hear things in a stable way develops at different rates in different people. This explains why some adolescents have very low (adult) scores at the age of 14, whereas others have very high scores at the age of 18. We have also found that adolescents who mature more slowly than their mates are handicapped in modern schools.

When we examined all the 15-year-old students in one large sample, we found that those who were in grade 11 had much lower scores than those who were in grade nine. In the same way, in the 16-year-old group, those who were in grade 12 had much lower scores than those who were in grade nine. Intelligence alone was not the reason for the poor showing of the older students in the younger grades, since intelligence ratings are independent of age. Our perceptual scores decrease with age, but IQ does not.

Perceptual instability in students is a handicap, but they will mature, and there is no reason to suppose that they will then be worse off than others their age who go through school with better records. In fact, it is possible they will be more creative and productive, since some degree of perceptual instability seems to favor creativity.

Most adults forget the perceptual world of their youth. Indeed, what they accepted normally when they were young can be very disturbing in adulthood. If a 15-year-old normal boy hears his own thoughts (and many do), he will be little disturbed by hallucinatory thoughts coming from outside his head. But at the age of 25, most people no longer hear their thoughts. Furthermore, they tend to forget that they ever had these experiences. If hearing of thoughts now occurs, it would be disturbing to the subject and he would make much of it to his psychiatrist. Unfortunately, most psychiatrists will not diagnose schizophrenia until they know visual or auditory hallucinations are present, and the schizophrenia of the 15-year-old has less chance of being detected than that of the 25-year-old.

Whatever the reason, the fact is that too many adolescents are being treated for other illnesses when a careful perceptual history would have revealed they are suffering from schizophrenia. If schizophrenia occurs during this period of life, the effect of the disease will therefore depend, among other things, upon age and the degree of perceptual instability already present.

The first and most easily detectable change in adolescent schizophrenics will be in their performance at school. There will be an unaccountable downward drift of grades. A student who had 'A's in grades nine and 10 may have 'B's in grade 11, and 'C's and 'D's in grade 12. The student may be perplexed and may work even harder but will find it very difficult to concentrate or read, and this will lead to a further decline in school performance. A large number of young schizophrenics from Saskatoon high

schools have shown this downward trend in grades and have even failed. If the schizophrenic student is dull-normal in intelligence, there may be little change in school performance, simply because the student is already getting moderate or poor grades, and the difference will not be so noticeable.

Sometimes, but not always, the onset of schizophrenia is heralded by a marked improvement in schoolwork. Students then become extraordinarily alert and creative, and do much better than ever before in school. But this is followed by the more usual downward progression. Whenever parents find their child showing such a change and can find no satisfactory reason for it, they should consult a psychiatrist who is not afraid to diagnose schizophrenia.

The second major early change is unaccountable fatigue. The students complain they are continually tired, will sleep much more than normal, and will not awake refreshed from their sleep. This, combined with the inability to concentrate, adds to the difficulty of getting on in school.

These changes are followed by others, including perceptual, thought, and mood changes, which are the same as in adult patients, as discussed in previous chapters. But thought changes are more difficult to assess, for adolescents are usually more reticent about their inner world than adults. Since younger generations also tend to rebel against the ideas of their elders, the strange or bizarre ideas that may be the first signs of schizophrenia thought disorder are easily misinterpreted as signs of youthful rebellion.

A common mood change is depression, but occasionally the patient becomes overactive, together with an undue and tireless cheerfulness, punctuated by inexplicable outbursts of rage and sudden passionate weeping. This change is rare, but when it does occur, it is a sign of schizophrenia.

The depression will be expressed in the usual way, with irritability or outbursts of anger. Several days of depression are often followed by several days free of it, only to be followed by depression again. Periods of deep depression often occur several times a day and are usually worse in the evening.

All these changes finally culminate in changes in behavior, and these can take any form. The variety of human reaction is enormous. The adolescent may become reclusive or act out the symptoms, or may swing from one or the other. One of our young patients became sexually promiscuous and rebellious of parental authority, and remained so for several years. This was followed by the development of visual perceptual changes that

forced her into seclusion. She was a very pretty girl, but now, whenever she looked in the mirror, she saw lines and wrinkles and bags under her eyes. Her face appeared so ugly she did not wish it to be seen by anyone.

She was diagnosed as an adolescent behavioral problem by a couple of psychoanalytically-oriented psychiatrists who did not question her at all about her perceptual world. After nearly two years of psychotherapy, she was ill enough to be transferred to one of us. She recovered, with the aid of ECT (electroconvulsive therapy) and nicotinic acid.

There may be increasing shyness, moodiness, and an increasing reluctance to take part in normal social activities. Behavior becomes unpredictable. The sick child and the family are often only too ready to find some convenient reason for this altered outlook. At one time, unrequited love was a favorite peg to hang it on, and Victorian novels abounded with heroines plunged into madness by heartless lovers.

One of our young patients was diagnosed by his psychiatrist as a malingerer because at school he gave completely bizarre answers to problems in arithmetic. It was assumed that he was trying to attract attention because his mother didn't understand him properly. He was given four years of individual psychotherapy by another psychiatrist, and his mother was also seen many times. As a result, she became full of fear and guilt feelings, and he managed to limp along.

During the long years, more than a quarter of his whole lifespan, he remained moody, retiring, unpredictable, and troubled by recurrent periods of deep depression. He left home, entered the University of Saskatchewan, and a few months later developed a full-blown attack of schizophrenia, with visual and auditory hallucinations. He had to be admitted to hospital for treatment, where he was given a short series of electroconvulsive therapy and nicotinic acid. He recovered, but he missed his year at university and did not go back.

He remained well for several years while he continued to take nicotinic acid. But because he was so well, he stopped taking his medication, and about six months later, he relapsed. Again he was admitted to hospital, where he once more recovered on similar treatments.

This case illustrates how schizophrenia, when improperly treated, prevents the unfortunate person from doing as well as his natural endowment would have allowed. Fortunately, this young man will do as well as his

parents socially, and will not drift down the social scale as many other schizophrenics do. But it was possible to have diagnosed him correctly at the age of 16, since one of us at the diagnostic conference had in fact made the diagnosis of schizophrenia. Had the diagnosis been accepted, and had he been treated accordingly, he might have been spared two admissions to hospital, he would have completed his university education, and his mother and family could have been spared needless guilt and anxiety.

Not every adolescent who suffers a personality change, fails in school, and becomes troublesome is schizophrenic. But so serious are the consequences of this illness, and so easily are they overlooked, that each case must be investigated for the disease so that early treatment can be begun. If it is present and properly treated, most young schizophrenics can be cured. If it is not present, other factors can then be examined and no harm will have been done.

Our malvaria studies showed that about one-third of the young patients under the age of 21 admitted to University Hospital were positive when examined for malvaria. Of this group, those fortunate enough to have been given massive doses of nicotinic acid have responded well, whereas many of those who were treated in other ways have continued to suffer and to require prolonged treatment.

In Adult Men

While we cannot describe every form that schizophrenia can take in adult men, we can indicate some of the common consequences.

If schizophrenia occurs before education and training are complete, it can interfere with, and prevent, the student from finishing his courses. We have seen this in young schizophrenics, who eventually end up in occupations below their natural aptitudes.

One of our patients, now 55 years old, obtained his M.A. degree in history. Shortly after that he developed schizophrenia. Since then, he has lived a solitary life on a Saskatchewan farm. He has been able to remain in the community because his family devotedly looks after him. A very intelligent electronics technician had a brilliant future until he became schizophrenic. After that, he could only do simple farm labor, and only with careful direction.

With the knowledge we now have of schizophrenia, this waste of human potential is unnecessary. If properly treated, many of these young men will be able to continue their education and achieve what is possible for them. We have seen many young university students receive nicotinic acid treatment and continue to complete their education. We have today students and graduates in law, engineering, teaching, chemistry, and medicine who were once severely ill with schizophrenia.

The more usual case is that of a young man, married, father of several children, running a business or working in one of the trades or professions. The illness may come on quickly or slowly. In the first instance, treatment is usually successful because the speed of onset focuses attention on the fact that something is gravely wrong with the sick person. There is no ambiguity or doubt in the minds of the family, friends, and community, and the family is spared months and years of soul searching, trial, and tribulation. In these cases, it is much easier to receive the recovered person back into the family and community.

When the illness comes on slowly, the family must endure long periods of doubt, confusion, and uncertainty. The ailing husband (his illness is yet unknown to the wife) becomes moody, irritable, and fatigued, and now and then displays unusual ideas or behavior. This may shock or frighten his wife, but only briefly, for these are usually followed by periods of relative normality. But then the irrational moments become more frequent and more intense, and last longer. The husband may become hostile and paranoid and direct this paranoia against the community. He is full of bitterness against his fellow workers, his employers, and eventually his friends. Finally, he is irrational most of the time.

It can easily happen that his wife will accept his delusions as true and thus cease to be a bridge to reality, further hindering early effective treatment. For as long as she can maintain that his ideas are not true, so long will it be possible to maintain the patient in the community and delay coming to hospital.

Sometimes, however, a wife will mirror her husband's psychosis, and then we get a minor variant of a double psychosis. In one instance, the suspicious and deluded husband believed the entire community was plotting against him. His wife was convinced this was true, and the pair of them spent their days in a small apartment with the door barricaded against the

world. Only his elderly mother retained a link with reality and sought help.

The suspicions may envelop the wife, too, and then her life becomes full of horror, for she suspects he is unfaithful, watches every move, searches for evidence to justify his delusions and indeed behaves very much like Othello. If this goes on for a long time, the gulf between husband and wife may become so great that even his complete recovery will not help reunite them. We have seen several cases where the psychiatrist treating the husband entered his delusional system and advised the husband to divorce his "unfaithful" wife, thus playing the part of Iago.

In Adult Women

This is not much different from schizophrenia in men except that, since women have a different part to play in society, their illness has a different impact upon them. Because women are less often breadwinners, their illness may not drive them to seek help as quickly, for we tend to be much more tolerant of women who are poor and inefficient housewives than we are of men who are bad plumbers, doctors, electricians, and so on. The demands upon them become less and less, their work is often done by husbands, mothers, sisters, or even daughters, and so no one realizes how very ill they are.

Apart from this, schizophrenia in adult women is distinguished by two situations peculiar to women. The first of these is the period that follows having had a baby, and the second is the period known as the menopause.

Women who are pregnant are not more predisposed to schizophrenia than other women. In fact, the opposite may be true. It is likely that pregnancy itself protects women against becoming schizophrenic. As we have shown earlier, the placenta manufactures ceruloplasmin, the protein that is successful in alleviating schizophrenia in many patients, especially if it occurs in women shortly after delivery. The major increase in blood ceruloplasmin occurs in the last three months of pregnancy, when the placenta is biggest. One might expect that some women might become better during pregnancy, and in fact, we have seen several women whose illness was much improved during the last three months of pregnancy. But it is not a panacea for schizophrenia, for not every woman is benefited, and many who are relapse after the baby is born.

Although childbirth and pregnancy are not especially dangerous, there is nevertheless a period for several weeks after childbirth when the danger seems greater. Women are not more likely to become schizophrenic during this period than women not pregnant, but most schizophrenic psychoses do come on within two weeks after birth. This should be considered a critical time for women who have been sick with schizophrenia. It may well be that childbirth produces a false statistical increase in schizophrenia by decreasing the incidence for the last three months of pregnancy and by producing the especially vulnerable period for two weeks afterward. If one averaged the incidence over the whole year, however, one would find no increase in the schizophrenic incidence rate.

The content of the schizophrenia will of course be different, since schizophrenia in this puerperium period removes a mother from her family and creates many hardships for them. The results of treatment are every bit as good as for schizophrenia occurring at any other time.

The greatest danger here is that of incorrect diagnosis, for some psychiatrists, preoccupied with stress ideas and assuming the puerperium is very stressful, will only notice that the patient is low-spirited. Treatment for the disease must be started early and be carried on vigorously.

The question will arise as to whether the schizophrenia will come back with subsequent pregnancies. It may, but if patients are placed on nicotinic acid throughout the pregnancy, the danger will not be very great. Nicotinic acid is safe and has no injurious effects on the baby. Furthermore, the patient must be taught how to recognize her earliest symptoms and report them without delay so that help can be given. When this is done, the patient becomes far more confident, and this in itself may prevent the possibility of a recurrence, or make it easier to bear by reducing panic and dismay.

In Old Age

The illness is no different at this time of life than it is during the middle years. The main danger is that schizophrenia will not be considered and that the changes will be labeled senile changes. There may be senile brain changes and the two conditions may be indistinguishable one from the other.

In Schizophrenic Families

We should be especially alert to the onset of schizophrenia at any age in families with a history of the disease. The following case illustrates this need.

In 1954, Mr E. S. began to suffer repeated episodes or 'spells' of a peculiar type that he could not describe. He was admitted to University Hospital for treatment from February 26 to April 10, 1958, where a thorough investigation failed to yield any reason for his complaints. These peculiar episodes tended to come when Mr E. S. was among people, and at times when he was very anxious. He described them as a feeling of boiling up inside, during which he was weak and faint. His eyes went haywire and he felt a surge of something flash through his head. (Later he discovered these were transient mini-psychotomimetic experiences.)

A psychiatrist described this patient as an aggressive, very successful, very intelligent businessman who had no interest in anything but his business. He was diagnosed as having an obsessive-compulsive neurosis with a paranoid personality.

Fortunately for Mr E. S., he also had hypercholesterolemia (345 mg per 100 ml of blood) and several troublesome xanthomatoma on his eyelids. At a teaching conference, the majority of physicians present agreed with the therapist who presented the case, but one psychiatrist supported me in my view that Mr E. S. was a paranoid schizophrenic. I suggested he be given nicotinic acid 3 grams per day to lower his cholesterol (pointing out that this would also remove his paranoid personality).

While in hospital, he fell in love with an alcoholic patient who had been given treatment with LSD-25 as a psychedelic. She was then married to a psychopathic man from whom she had separated and intended to divorce. Mr E. S.'s psychiatrist tried to break up the romance because he and other members of the staff concluded it could only be harmful to both. Mr E. S. had also been separated from his wife because they were incompatible.

While in hospital Mr E. S. reported that his daughter, of whom he was very fond, was normal, but that his son was a difficult and irresponsible alcoholic.

The discharge prognosis was pessimistic, and the therapist reported to the referring physician that there would be no change in Mr E. S.

The patient continued to take nicotinic acid (3 grams per day) regularly, developed no more xanthomata, and lowered his cholesterol blood levels to normal. He also remained free of spells and slowly found his personality began to change. He continued his romance, divorced his wife amicably, leaving her well provided for, and planned to marry again.

In March 1960, he consulted me. Until then, I had no personal contact with him, and as far as I knew, he had never been informed of any diagnosis. He knew that the nicotinic acid was recommended only to lower blood cholesterol, which he knew it had done very effectively.

He asked me what his diagnosis was. I replied that, in my opinion, it was paranoid schizophrenia. He immediately relaxed, slapped his thigh and exclaimed, "I knew it!" He added that he had read as much material as he could get on psychiatry and had himself concluded he must have schizophrenia. He was not pleased with his tendency to view people with suspicion and wished to be rid of this symptom. The woman he intended to marry had described her psychedelic reaction and how it had been beneficial for her, and he hoped I would let him have a similar experience.

Schizophrenia, uncontrolled, was one of my contraindications to giving anyone treatment with LSD-25, but, as he had been much improved for nearly two years and regularly took nicotinic acid in anti-hallucinatory doses, I concluded this could be done with safety in hospital. On March 22, 1960, he was given a psychedelic treatment with 300 ug of LSD-25.

The next day he was very enthusiastic about it, especially because he was able at last to describe the episodes from which he had suffered for four years. He said they were identical with some of the LSD-25 experiences. In other words, he had been experiencing minor and transient perceptual changes like the ones he had seen under LSD-25.

When free of his LSD-25 experience, he completed two HOD tests, one retrospective for his condition in 1958 and one for his present state (four weeks after LSD-25).

Date	Total	Perceptual	Paranoid	Depression
1958	51	18	4	15
1960	17	9	0	5

The patient remained well and was directly responsible for the successful treatment and recovery of his two children from his first wife and his daughter from his present wife. In addition, he has provided help to a large number of other schizophrenics in his community.

In June 1970, he was normal, and I advised him to reduce his nicotinic acid to 3 grams per day from 6 grams to determine if this would maintain him. One month later, he was moderately depressed and fatigued. His dose was increased to 6 grams per day, which he will now take the rest of his life.

Mr D. S. (Mr E. S.'s only son) began to develop many unreasonable fears at age 16. Shortly afterwards, he became an alcoholic. But he completed grade 10 in school and worked with his father until he was 24. There was continual friction and difficulty between father and son. Mr. E. S., when he recovered, accepted responsibility for much of this. In 1959, Mr D. S. began to drift from place to place and job to job – meanwhile continuing as an alcoholic.

Due to his father's persuasion, he came for treatment of his alcoholism, expecting LSD-25. He was positive for malvaria, which is another contraindication for LSD-25 therapy. But because he had come a long way and had expected so much relief from it, he was treated on April 21, 1960, with 300 ug. Careful examination before this showed he was a paranoid schizophrenic with many visual and auditory hallucinations, even when sober. During the LSD-25 session, he again suffered auditory hallucinations.

He was started on megadoses of nicotinic acid, 3 grams per day, and discharged. He was somewhat better and remained abstinent for a few weeks, but then reverted to his previous pattern. In my experience, alcoholic schizophrenics are not helped by psychedelic therapy until their schizophrenia is controlled.

He returned for treatment of his schizophrenia in April 1961, and was given six electroconvulsive treatments and his chemotherapy was adjusted. Following this discharge, he continued to take nicotinic acid regularly and gradually continued to change his personality, repaired his numerous marital difficulties, and remained gainfully employed. In February 1969, he became severely depressed and was given another series of ECT. Since then, according to his father, he has been well. His maintenance dose is between 15 and 20 grams per day.

Miss J. S. (Mr E. S.'s daughter) was well until she was 38 years old, when

she became depressed and fatigued. She was seen in the emergency rooms of the Department of Psychiatry by the psychiatrist who had treated her father. In his letter to her referring doctor, the psychiatrist reported: "As you know very well, the whole S. family is pretty mixed up psychologically, although since Mr E. S.'s admission here in 1958 they have established a reasonably satisfactory *modus vivendi*. The compromise is based on each member carefully controlling his or her feelings while recognizing the weak spots of other members. This need to bottle up her own feelings is inevitably taking some toll on Miss S. She is fearful of the impact of any argument on her father's health; she is fearful that they will die and leave her alone; she is fearful that they may have a serious psychiatric illness like schizophrenia and that she herself may get it. She has very little in her own life which is truly her own and feels as a consequence greatly deprived. This was made much worse when her dog died some months ago, and I suspect that this animal served a useful purpose in helping her to control her feelings.

"I therefore advised her against the use of any medication directed toward the alleviation of psychiatric symptoms and suggested that she get a new dog, and begin to care for and worry about it rather than herself. I mentioned this to her father and I hope they will be returning home in order to get her a pup."

On returning home, she filled the prescription by purchasing a dog, but there was no improvement. She was then given trifluperazine 4 mg per day by her family physician and she recovered.

In the spring of 1966, her depression recurred, and she was referred to me for examination. She complained of a persistent ringing in her ears; obsession with the future and what might happen to her family; difficulty concentrating and reading; and depression and anxiety. She tested positive for malvaria. I diagnosed her schizophrenia and started her on nicotinamide 3 grams per day, ascorbic acid 3 grams per day, and chlorpromazine 50 mg per day. By May 1967, she was nearly normal, and in July was normal with only one fear – a fear her illness would recur.

She was seen again in July 1970, and was even better, stating she had missed no time off work, was sleeping normally, was not depressed, and was free of all her former fears. In order to determine her optimum dose of nicotinic acid, it was reduced from 6 grams to 3 grams, but after a few

days, her symptoms began to return and she immediately went up to 6 grams. She had not required any tranquilizers for three years. Her HOD scores are shown below.

Date	Total	Perceptual	Paranoid	Depression
April 6, 1967	45	4	1	11
May 4, 1967	11	0	0	4
June 2, 1967	21	2	1	8
July 10, 1970	9	0	0	1
Normal Range	0-50	0-3	0-5	0-5

Miss S. S. was born in 1963 to Mr E. S. and his second wife, both of whom had received pure LSD-25. She was physically and mentally normal. (In Saskatchewan, there are no records of any congenital abnormalities in children born to parents who had received LSD-25. From 1954 to 1970, more than 2,000 subjects had received LSD-25.) However, in October 1968, this girl was referred to me because her parents were convinced she was developing schizophrenia.

She reported that every night she saw a large, white, tall ghost – as tall as her room. At first she had been very fearful of this, but later she concluded that this was her mother walking through her room with a white sheet over her and there was no reason to be afraid. This ghost often spoke to her and told her she, too, would become a ghost. She also had visual hallucinations of many deer and foxes in her room. Her parents reported she slept poorly and was disturbed at night. During the day, she played with several imaginary playmates she saw.

I diagnosed her schizophrenic and started her on nicotinamide 1 gram each day and ascorbic acid 1 gram each day. In a few months, she recovered and remained well.

There is little doubt that the father and his three children are all vitamin B-3 dependent. There is no doubt this entire family, once described as "psychologically mixed up," is now normal, and none of the factors said to have caused Miss J. S.'s anxiety seem to be operative; Mr E. S. is well and by

no stretch of the imagination can be termed paranoid; Mr D. S. is nearly well; Miss J. S. is normal, and so is Miss S. S.

This family demonstrates the kind of family described by Dr Heston. A superficial examination of mental state and an exaggerated interest in dynamics led to a diagnosis of obsessive-compulsive state in a paranoid personality in Mr E. S. and anxiety neurosis in Miss J. S. Mr D. S. could have been termed an alcoholic psychopath, and Miss S. S. emotionally disturbed. But if major perceptual disturbances (visual and auditory hallucinations) are basic in diagnosing schizophrenia as was described by Dr Conolly and as many psychiatrists now believe, only Miss J. S. had none of these, yet all responded to megadoses of vitamin B-3. The speed of response was nicely related to chronicity or age of onset, as shown below.

Relation of Response to Chronicity

	Age of Onset	Chronicity	Rate of Response
S. S.	5	Several months	One month
J. S.	38	2 years	Several months
E. S.	49	4 years	2 years
D. S.	16	14 years	5 years

Vitamin B-3 or nicotinic acid treatment for schizophrenia, combined with other nutritional therapy, has certainly been proven effective in these and thousands of other cases we have treated.

⑤ | HOW CAN SCHIZOPHRENIA BE TREATED?

With an understanding of the symptoms, causes, and onset of schizophrenia, we can develop an effective treatment program. Because it is based on the biochemical nature of the disease process, our orthomolecular treatment program may differ from traditional psychoanalytical and pharmaceutical drug programs. While you finally must decide if any one form of treatment is potentially effective based on your reading and counseling, we have proven over 50 years of practice that the majority of people with acute schizophrenia and a significant number of people with chronic schizophrenia will recover using orthomolecular treatment.

In the first edition of this book, published in 1966, we referred to our form of treatment as "megavitamin" therapy, but we now prefer to use the term "orthomolecular" therapy – a term coined by Dr Linus Pauling in 1968, as we discussed in the introduction to this revised edition. This means that optimum diets are used with vitamin supplementation in large doses – chiefly, vitamin B-3 (nicotinic acid and/or nicotinamide), vitamin C (ascorbic acid), and vitamin B-6 (pyridoxine). However, an orthomolecular treatment program is complementary to most of the other treatments in use today – including tranquilizers, anti-depressants, and most other

drugs – but these are secondary or adjunctive to a proper consideration of nutrient therapy. For each patient, the non-nutrient chemicals (tranquilizers, anti-depressants) are gradually withdrawn until the patient can remain well on nutrient therapy alone. Likewise, electroconvulsive treatment (ECT) is a temporary adjunct to orthomolecular therapy, though ECT is seldom used today.

We will not present a complete treatment prescription to be followed like a recipe. Each patient requires individual attention because individuals are biochemically unique. Although biochemical treatments must be individualized, we can provide here the basic information doctors, patients, and family members need to create the right individualized prescription. The first stage in this process is counseling.

Counseling

We consider that helping a patient learn about this disease, and teaching what can be expected because of it, is an important part of treatment. We tell our patients that schizophrenia is a disease in which biochemical abnormalities affect the working of the brain and produce distressing symptoms, such as changes in perception. We discuss symptoms frankly. If, for example, you are frightened because objects appear to get larger as they get closer – a well-known but irritating symptom – or if you were to complain about extreme fatigue, we would then explain these as being well-known results of schizophrenia due to disturbances produced in the brain resulting from the illness.

If you are suffering from delusions, we would tell you so and explain them as delusions. Some delusions are, in fact, reasonable but incorrect explanations for changes in perception, and they should be explained in this way. Many patients who fear that they are being poisoned develop this notion because foods taste bitter to them, and bitterness in our society is associated with poison. Few patients object to a frank discussion and many welcome a matter-of-fact explanation from a medical professional who listens carefully to their complaints and is an expert on their disease.

No one must be blamed for your illness. While it may be a common practice to blame relatives, spouses, or friends for the patient's condition, this is not wise and is very rarely fair. There is little evidence to support the

claim that schizophrenic patients become ill because their parents loved them too little or fussed over them too much. We do not believe that schizophrenia is caused by parental mistakes any more than diabetes is. Psychotherapy of a deep and interpretive kind has not been shown to bring about any improvement in this illness, and many medical professionals, in fact, believe that it disrupts the patient and may impede recovery. Blame can, and must, be attached directly to the disease, where it belongs; it is enough for the patient to have to struggle with a grave disability without adding a further burden of guilt and hatred with dubious interpretations of an old-fashioned, psychoanalytic kind.

It is true that some close relatives of schizophrenics are themselves more or less ill. If this is so, then the patient and the psychiatrist need to decide whether it will be possible for the patient to continue living with them. If the patient leaves, this needs to be done as amicably as possible. If the patient is going to continue living with his family, the family needs to be included in the treatment program.

Patients often make life difficult for themselves by alienating their friends with their peculiar (or even repugnant) ideas and bizarre or unusual behavior. For this reason, we would teach you not to act upon, or speak about, the peculiar things you may see, hear, feel, or think. Some patients are surprised to learn that other people are frightened and repelled by their strange remarks and actions. It is not easy for them to understand that experiences that seem to be real to them are not shared by others, just as you may have trouble believing that a color-blind person does not see color the same way you do. Yet every day men survive by ignoring their senses. Disregarding one's senses is, we know, very difficult, yet clearly possible. Pilots flying airplanes are a common example of this skill. Our culture is one in which learning to disregard one's senses plays a large part in our well-being. Who would fly, drive a car, or ride a bicycle if they took heed of what their senses tell them? Schizophrenics can also learn to disregard those sensations they know are misleading, confusing, and wrong. But many patients have to be taught not to discuss their experiences with anyone except their doctor and closest relatives, or with well-informed, compassionate friends.

Your doctor must know schizophrenia just as well as your internist must know stomach ulcers if you suffer from this illness. Your must receive a

proper diagnosis, using adequate tests, to determine if you are suffering from schizophrenia or such related diseases as malvaria. You need to act upon the advice of your doctor, even though your illness may make it difficult for you to do so. Doctors and other health care professionals must discuss the disease with you in a manner that leaves no doubt about their knowledge and expertise, and explain to you exactly what treatment is involved, emphasizing that if you follow it faithfully your chances of recovery will be very good.

Once recovered, we then teach patients how to be alert for signs of recurring illness. We might tell you, for example, if you have dizzy spells, as you did before, or if you find yourself becoming depressed once again, or notice any of the changes of perception that you experienced during your illness, to resume treatment without delay. For the sooner treatment begins, the better chance you have of remaining well. If such a relapse occurs, you should stay on your treatment at least another five years. We have found that very few patients get sick again if they take their medicine regularly.

Certain medicines are dangerous for schizophrenics and should not be taken. These are amphetamines, preludin, and some anti-depressants. We have seen schizophrenia return because patients were given amphetamine to help them lose weight. In fact, we do encourage our patients to put on weight if possible, and do not allow reducing diets at this stage of treatment because of the danger of relapse. One of our patients who began putting on weight as she recovered was placed on dexedrine by her family doctor when she became 20 pounds overweight. The gain in weight was a good sign, but her doctor did not know that, nor did he know the danger of reducing pills for schizophrenics. As a result, her illness came back.

Of course, as a patient on our treatment program, you will have had a complete physical examination. If your teeth are infected, you will have had something done about it. Any source of chronic infection should be removed or treated. If there are hormone deficiencies, this will have been corrected. Any concurrent infections and other illnesses should be treated promptly and vigorously. Every time a person smokes, substantial quantities of adrenaline are released in the body and this is not good for schizophrenics. For this reason, schizophrenics should not smoke and should be discouraged from doing so. Smoking also depletes the body of ascorbic acid.

Schizophrenics must ensure they get enough sleep. The ideal situation is one where they can sleep regular hours each night. Obviously there are times when it is not possible to do so. In this case, it is a good idea to catch up on sleep whenever it is possible. The weekends are most useful for this. It is a good idea to sleep in late on either Saturday or Sunday. If the week has been especially fatiguing, it may be desirable to spend a whole day in bed. The bad effect of fatigue on group reaction can be reduced if patients are aware fatigue makes this more difficult. Patients should, whenever possible, make their major contacts with other people in the mornings and reserve their afternoons and evenings for private rest, quiet reflection, or conversations with one person. If afternoon and evening group reaction cannot be avoided, then patients should not hesitate to excuse themselves, leave the group, and rest away from the group for a while.

If you are following this treatment, and if your disease has been caught early, in all likelihood you will get well without having to enter hospital. If you have not made a sufficient recovery, if you have been ill for too long, or if your schizophrenia is so severe it would throw too heavy a burden on you and your family to treat you at home, you will be required to come into hospital for further treatment.

Clinical Nutrition

By clinical nutrition, we mean eating foods that offer the optimum level of nutrients and avoiding foods that cause allergies. Popular or 'fad' diets should also be avoided. For people suffering from schizophrenia, even a nutrient rich diet will not be sufficient to treat the disease, however. Vitamin and mineral supplements, often in large doses, will be needed.

Schizophrenics tend to lose weight and become thin and emaciated, especially during the severe phases of their illness. If identical twins are about to develop schizophrenia, it will, as a rule, appear first in the thinner member of the pair. If a patient is gaining weight, it is a good sign of improvement. When insulin was used more frequently than it is now as a form of treatment, the patients who got well gained much more weight. For these reasons, a high-protein and high-calorie diet is needed. As long as patients are sick, they will waste tissues, no matter what is done, and there will be little weight gain until recovery begins. After recovery, an effort

should be made to remain a little overweight, if possible, for this reason.

The first step in devising an optimum nutrition program is to analyze the patient's current diet and to improve it so that it follows the principles of good clinical nutrition. In my book *Hoffer's Law of Natural Nutrition: Eating Well for Pure Health*, the principles and practices of good nutrition are described at length, but for our purposes here, I can summarize these. I advise my patients suffering from schizophrenia to follow two simple rules:

1. *First, avoid as much as possible all foods to which sugars have been added.* These foods include pastry, pies, desserts, and commercially processed foods. This simple rule will not only cure your sugar addiction (which can create significant physiological and behavioral problems) but also eliminate about 90 percent of all other additives from manufactured foods. When sugar is listed on the food label, many other additives are also likely included. Thus, by avoiding all foods to which sugar is added, you not only decrease the total amount of ingested free sugars but also remove most of the additives that are present in our prepared foods.
2. *Avoid foods you are allergic to.* Your doctor will work with you to determine these foods by taking a history of your eating habits and testing for allergies. The most accurate and the least expensive test is the elimination diet. Elimination diets should be supervised by therapists who are familiar with this diagnostic and treatment procedure. You eliminate those foods that may be involved for several weeks (often food groups like dairy products or grains), and then reintroduce them. If at the end of the trial diet, you feel better, and if after you reintroduce the test foods, you are worse again, this will be the proof that you are allergic to these foods. If you are allergic to many foods, you may need to do a four- or five-day water fast, to be followed by the introduction of individual foods, one per meal. The foods that cause reactions are then avoided. I have seen patients change in one hour from being calm, reasonable, cheerful people, into hostile, bitter, paranoid, overexcitable individuals, just from eating cheese.

In about 1965, Dr Allan Cott observed a fasting treatment used in Moscow for the treatment of schizophrenia. When he tried the same program in New York on a few patients, he observed the same results. Following this, I

began to fast a few of my intractable patients. To my surprise, I found that they were well in five days and did not need the 30-day fast that the Russians were using. I was asked to see a chronic schizophrenic woman who was unable to come to my office because she was rigid and catatonic. I visited her in her home. She had been ill at least 10 years and had not responded to treatment. I had her delivered to hospital by ambulance. She agreed to try a 30-day water fast, and to my amazement, she was well on the fifth day. She completed the fast and lost about 30 pounds, but a few days later, her psychosis recurred. During her fast, she had felt so well that she begged me to allow her to do another long fast. I agreed to do so, but only after she had regained some weight. Once again, five days into her fast she was well.

By this time, I was becoming more knowledgeable of cerebral allergies and clinical ecology. I terminated her fast and began testing for food allergies. She was allergic to all meats: as soon as she ate meat her major symptoms recurred. She then went on a vegetarian diet and remained well. Since then I have fasted at least 200 schizophrenic patients. More than 60 percent were well after the fast.

Around this time, Dr W. Philpott observed that half of all the schizophrenic patients he saw had major allergic reactions to foods. Over the past few decades, evidence has accumulated that a large proportion of patients with chronic schizophrenia are allergic to something in the environment – a food group or an air-borne or water-borne pollutant. In 1962, Dr T. Randolph reported at an International Congress of Psychiatry that he had treated 5,000 patients for allergy; of this group, 500 were mentally sick. When the substance to which they were allergic was removed, they recovered. The introduction into North America of the fasting treatment by Dr Cott further roused interest in the effects of food on mental illness. In the meantime, Dr E. Rees reported that many sick (hyperactive) children were responding to an allergy and became much better when they were placed on an allergy-free diet. Dr H. Newbold, Dr W.H. Philpott, and Dr M. Mandell reported that a large proportion of chronic schizophrenics were allergic to many common foods, primarily dairy products, but also grains, such as wheat and corn. They were able to cure them by removing the food. This provided an explanation for the chronicity of the condition, for the person is usually allergic to his favorite food and continues to expose himself to it every day or two.

During our study with fasting, over a four-month period 60 patients went through a fast, usually at home. They took no food, no medication, and did not smoke, but consumed 6-8 glasses of water per day. Forty were well at the end of the fast and have remained well since. They do not need any medication but must avoid the food to which they are allergic. The other 20 did not improve whatsoever. The 40 who recovered have remained well since. Thirty were allergic to dairy foods. Two were also allergic to beef. One was allergic to smoking, one to aspirin, and the rest to sugar and other foods. Other orthomolecular physicians have found similar recoveries.

Vitamin Supplements

Vitamins are organic molecules used by nature to catalyze essential reactions in the body. They cannot be replaced by any other molecules. On the contrary, molecules that resemble them too closely and which attach to the vitamin receptor sites will be toxic by interfering with their natural reactions.

Beginning in the early 1900s when vitamins were first isolated as nutrients, the 'vitamins-as-prevention' paradigm was developed. This paradigm is built on two main assumptions: that vitamins are needed only for the classical vitamin deficiency diseases, such as scurvy, beri beri, and pellagra; and that vitamins are needed in very small amounts, since they are used over and over and not burnt in the body. It followed that there was no reason to use vitamins for any other condition and no reason why they should be used in doses larger than those needed to prevent these major diseases. These are very small doses, defined by the U.S. Food and Drug Administration (FDA) as the 'RDA' or recommended daily allowances. Most psychiatrists did not consider vitamins for the treatment of schizophrenia because schizophrenia was not considered a deficiency disease (although it may well be a dependency disease).

The 'vitamins-as-treatment' paradigm originated with publication of our finding in 1955 that niacin (vitamin B-3) lowered cholesterol levels. Niacin is the 'gold-standard' compound for lowering cholesterol, since it does much more: it also lowers triglycerides and elevates the good cholesterol fraction, called high-density lipoprotein cholesterol. It decreases the death rate from coronaries and extends life. Therapeutic doses are

over 100 times as high as the RDAs, around 1,000 milligrams three times daily and more.

While our research with vitamin B-3 and cholesterol was the first study of 'vitamins-as-treatment' to be widely accepted in the medical field, earlier Drs Evan and Wilfred Shute had found that large doses of vitamin E were helpful in heart disease and for treatment of burns. In 1945, Dr W. Kaufmann found that vitamin B-3 was very effective in treating the arthritides, and about the same time, Dr Fred Klenner showed that large doses of vitamin C were the treatment of choice for a large number of acute toxic reactions and chronic diseases, such as multiple sclerosis and poliomyelitis.

Today, this 'vitamins-as-therapy' paradigm is rapidly gaining ascendancy in general medicine, though not in psychiatry, and is being applied to all the nutrients. Vitamins may be useful in treating many non-deficiency diseases, used in optimum doses, which may range from very small (e.g., vitamin B-12, using 1 milligram orally daily) to very large (e.g., vitamin C or ascorbic acid, where up to 100 grams orally daily have been advocated and used).

Vitamins are inherently very safe. Excess amounts are rapidly eliminated. The fat soluble vitamins are not eliminated as rapidly and one should be somewhat more cautious with these, but even here, the toxicity has been grossly exaggerated. The rule I follow with vitamins is that it is better to use slightly more than is needed, whereas with drugs the rule I follow is to use slightly less than is recommended. Over the past 30 years, there have been reports of about three patients who died from using an unknown slow release niacin preparation in the United States. This almost-zero figure, considering the millions of people taking vitamins, is astonishing. It should be compared with the 100,000 deaths in hospitals during the same years in the United States alone from the proper use of drugs and the equally large number of deaths from drugs used outside of hospitals.

Vitamin B-3

We suggest you take either nicotinic acid (also called niacin) or nicotinamide (also called niacinamide) as your basic medicine for schizophrenia, as both vitamins have the same effect on you. Both substances are B-3 vitamins. Nicotinic acid has an advantage over nicotinamide in that it lowers the fatty substances – cholesterol and fatty acids – in the blood.

These substances play a role in the hardening of the arteries. Since hardening of the arteries (arteriosclerosis) can lead to high blood pressure and senile changes in the brain, it may be desirable to use nicotinic acid in cases where these additional changes are present. Niacin in the form of inositol niacinate (also called 'no-flush' niacin) can be also used. It is a combination of inositol and niacin, both vitamins. It has the main advantage that there is no flush reaction, but it is as effective as the other two forms in treating schizophrenia. NADH (nicotinamide adenine dinucleotide) has also become available, but the only reports of useful therapeutic activity were studies we did in Saskatchewan many years ago using pure NAD. NADH may be more effective and, therefore, active in smaller doses. We used 1 gram of NAD each day in a carefully formulated capsule designed to prevent destruction of the NAD in the stomach.

Vitamin B-3 is indicated for a large number of other psychiatric and physical conditions. It can be used therapeutically for depressions; for children with learning and behavioral disorders; for many cases of senility, especially those caused by cerebrovascular problems, though it is not effective against Alzheimers disease; for arthritis; for hypercholesterolemia; for its useful anti-allergy properties (since niacin lowers histamine levels in the body); and for its remarkable anti-stress properties.

It may seem odd to some people that a vitamin should be so effective against such a wide range of diseases, especially against schizophrenia. In 1952, we began looking around for a treatment that would cure schizophrenia, if our adrenochrome-andrenolutin theory of the cause of schizophrenia was in fact sound. An ideal treatment, we decided, should be aimed at the biochemical process that was producing the schizophrenia; but we also decided that it should also be safe, easy to administer, and cheap, so that patients could afford to take it for many months or years. Anything that would slow down the formation of adrenaline, we reasoned, might help. The full history and detailed results of these studies are presented in my book, *Vitamin B-3 & Schizophrenia: Discovery, Recovery, Controversy.*

Nicotinic acid in the body can absorb methyl groups that are needed to convert noradrenaline into adrenaline. Large amounts of the vitamin would, therefore, prevent the formation of excessive amounts of adrenaline and this would slow down the production of the toxic adrenochrome and adrenolutin.

By the time we began considering nicotinic acid as a treatment for schizophrenia, it had already an impressive history as a treatment for several delirious diseases. One of these was the vitamin B-3 deficiency disease pellagra. When nicotinic acid was added to American flour, this psychosis was all but eliminated. This public health nutritional measure is the first major example of a preventive program in psychiatry.

Nicotinic acid had also been used for treating bromide-induced deliria, some depressions, and some organic brain diseases, in what was then considered to be large doses. We later learned to appreciate that these "large" doses were very small doses indeed, and decided to administer the vitamin in more massive doses.

In February 1952, we treated our first case, a 17-year-old boy admitted to Saskatchewan Hospital in Weyburn with an acute schizophrenic illness that had started only a few days before admission. He was excited, overactive, silly, and at times deluded. He responded only occasionally to ECT and was put on deep insulin, but this had to be stopped after less than 10 days because he developed palsy in the right side of his face. During the next three weeks, his condition deteriorated to the point where he required complete nursing care.

In May, he was started on 5 grams of niacin and 5 grams of ascorbic acid, divided into five daily doses. Within 24 hours he was better, and 10 days later he was described as almost normal. We stopped giving him vitamins a month later and observed him in hospital for three weeks before he was discharged to his home in July. A follow-up three years later showed that he was in good health and had finished his final year of school.

Encouraged by the success of this case, we started our first clinical trial of massive doses of niacin and nicotinamide, using a placebo, a sugar-coated pill, for comparison. These were the first prospective double blind placebo controlled studies in the history of psychiatry. Between 1952 and 1960, we conducted six more double-blind controlled trials. This method is now the gold standard of modern clinical research. We chose 30 patients from the psychiatric ward of a general hospital who were diagnosed schizophrenic by psychiatrists not associated with the research. We divided them into three groups at random and started 10 on placebo, 10 on niacin, and 10 on nicotinamide. Neither patients nor nursing staff knew which medicine the patients were taking; one-half from each group also received

ECT. Of these, the placebo group did the worst. On the average, they were well only half the time for nearly two years after discharge. Patients who had niacin or the amide were followed up for just over two years, and they were well most of the time.

The success of treatment cannot be judged on length of stay in hospital, since most hospitals today are making every effort to discharge patients into the community, cured or not. The criterion for effective treatment of schizophrenia is the same as the criterion for effective treatment of any disease: does the patient get well?

The best way to determine the value of any treatment is to find out how well the patient does outside of hospital, and how soon and how often he needs to come back. This we did with a larger sample of patients. We found that patients with schizophrenia treated in Saskatchewan without niacin or nicotinamide had a gloomy future; over half had to be re-admitted to hospital at least once within five years of discharge. The niacin patients did better; only about a sixth needed more treatment in hospital during the same period.

In 1962, we followed up the first 16 patients treated with the vitamin in 1952, and compared them with a group of 27 schizophrenic patients who were receiving the treatments popularly in use at that time, psychotherapy, barbiturates, tranquilizers, and ECT.

We found that the 27 non-niacin patients did not fare very well. Seventeen of them, or almost 63 percent, had to return to hospital for further treatment a total of 63 times, and altogether the group spent 34 years in hospital over the 10-year period of this study. By comparison, 12 of the 16 vitamin-patients, or 75 percent, did not have to return to hospital for further treatment, and are well today. The remaining four who did have to come back required a total of six re-admissions for only brief periods, and between them the whole group spent only 1.4 years in admissions to hospital. None of this group are in hospital today.

To satisfy ourselves that our enthusiasm was not being conveyed to our patients and coloring the results, we followed up those treated with niacin by uninterested and even skeptical doctors while in hospital. Even these niacin patients did better. The results nearly five years later were similar to ours.

Other studies in our research program showed that the niacin group remained well longer than the non-niacin group. The results of one more

study we did on schizophrenic patients treated at University Hospital in Saskatoon between 1955 and 1962 illustrates the great savings made in human and financial resources when niacin was used. Of the 76 schizophrenics given niacin during that period, 21 were re-admitted a total of 43 times, spending 2,453 days in hospital. Four remained in hospital and none committed suicide. Of the group of 226 patients not receiving niacin, 122 were re-admitted 275 times for a total of 25,341 days. Seventeen of these stayed in hospital and four committed suicide.

Had the latter group been given the vitamin as part of treatment, assuming they were in no other way different from the niacin group, they would have needed only 8,520 days more in hospital, saving themselves a total of 16,821 days, and four more people might well have lived. If we like to think of saving in financial as well as human terms, we can say that with niacin costing, at that time, about $4.00 a pound, the outlay of $226 dollars for niacin to get the patients well might have saved the Saskatchewan government what it cost to keep them in hospital.

Included in these statistics are men and women who, except for their schizophrenia, had the capacity to work and were fathers, mothers, brothers, and sisters who had something to contribute to society and who had the potential and the right to enjoy what society had to offer. One of these was a young man whom we shall call Bill Young. Bill was admitted to a psychiatric ward in 1954 with repeated episodes of severe anxiety and depression. He was found to be normal in perception and thought, but very anxious and depressed. He was diagnosed with anxiety hysteria and given intensive psychotherapy, including interviews under amytal, the 'truth' drug. He was discharged, improved, but anxiety and panic continued to plague him, and he was back a short time later with the same problems, except that he was, in addition, suspicious. In hospital, where he received psychotherapy, his condition became steadily worse. He lost weight rapidly. He began having hallucinations of sight and hearing, felt things about him were unreal, and was obviously schizophrenic.

Bill was again discharged, but returned to hospital off and on until 1957, when he was diagnosed with "character disorder and pathologic personality," a strange diagnosis in view of his symptoms. He was, nevertheless, started on nicotinic acid, he gained weight, began to face every day with a good sense of humor and a feeling of well-being, he married and became

the father of two children. But he recognized that if he stopped taking the vitamin, his symptoms would return within a few days: his world would change, objects would seem smaller than they really are, and crowds of people would frighten him.

Dose: For children, we prescribe 3 grams per day of either form of vitamin B-3. Children do not like the flush, and it is difficult to persuade them to stay on nicotinic acid. They must stay on the vitamin until they are 21 years of age, but they might need to remain on the vitamin forever. If they discontinue the program and later begin to suffer a resurgence of the disease, they must resume and thereafter stay on the program.

For patients aged 14 to 65, we prescribe either nicotinic acid or nicotinamide at the beginning. If you start treatment with nicotinic acid, you will be given a prescription for one month's supply at a dose level of 3 grams per day. Doses are available in 500 mg or one-half gram tablets. You will take two half-gram tablets after each meal. If either vitamin produces any unpleasant side effects, we prescribe the other. If you have a history of coronary disease, for example, or if there is a marked rise in blood cholesterol level, in your case we would prescribe nicotinic acid, for it lowers cholesterol, reduces high blood pressure, and slows down the process of hardening of the arteries. Or if you have a history of peptic ulcer, we would prefer nicotinamide, but nicotinic acid can also be used since it can be obtained in a buffered form.

You will continue on this treatment for one to three months. There is no point in taking smaller doses. If within this treatment period you show substantial improvement, then you will be advised to keep taking the medicine for five years, after which it can be stopped on a trial basis. If you remain well, you will not need to start again unless the symptoms you had originally begin to come back.

Patients who do not respond significantly are advised to increase the dose, which may go up in increments of 3 grams until a proper response is seen or until side effects are produced.

Side Effects: The first time you take vitamin B-3 in niacin form you will probably experience a marked 'flush'. Niacin opens the capillaries by releasing histamine and prostaglandins, causing this flush. This repeated

release of histamine has therapeutic value as well. About one-half to one hour after you take the tablets you will become aware of a tingling sensation in your forehead. Then your face will turn red and you will feel hot and flushed. The flush will spread down your body. Usually it will include your arms and chest, but very rarely will your whole body flush. There is no need to be alarmed. This is a normal reaction to this vitamin. There will be no change in your blood pressure and you will not faint.

You will be uncomfortable the first time and you might be wise to take the first tablets in the evening while lying down in bed. Each time you take the pills the reaction becomes less strong, and within a few days to a few weeks, you will have become accustomed to them. Eventually, as long as you take the medicine regularly, you will stop flushing altogether, or it will be so mild that it will not trouble you. Some patients like to take the nicotinic acid right after meals. Sometimes patients are bothered by the acidity of nicotinic acid. If this happens to you, you can take one-half teaspoon of bicarbonate of soda with the tablets.

The flush can be moderated by using larger tablets after meals with a cold drink, or by pre-treating the patient with an antihistamine. If the flush remains troublesome, it may be markedly reduced by crushing the tablets, allowing the crushed powder to stay in a few ounces of juice for 10 minutes, and then adding to it 1/2 teaspoon of inositol powder and allowing it to stand for another 10 minutes. This also often removes the nausea.

If, however, after you have taken nicotinic acid (niacin) regularly as prescribed, and you are troubled by it, you may be advised to take nicotinamide instead. Nicotinamide produces no flush at all, and for this reason it may be preferable for some patients. However, it does not lower cholesterol and can cause some nausea. The treatment also depends on how old you are and what other physical complaints you may have.

Besides the flush reaction, the most common side effect is nausea, occasionally followed by vomiting. This occurs at lower doses with nicotinamide. If nausea (or marked loss of appetite) does occur, the medication is stopped for one day. It is then restarted at a lower dose. In other words, it may be necessary to bump up the dose until nausea develops in order to find out the best maintenance dose. The dose will rarely be very high – up to 30 grams per day. When the patient has recovered, the dose is slowly

reduced in order to find the best maintenance dose. It may be possible to reduce it to 3 grams per day or so. If symptoms recur, then the dose must be increased.

Nausea can be dealt with by reducing the dose by 1 gram below the nausea-producing dose. If nausea remains a problem, it may be necessary to change to the other form of vitamin B-3. On occasion, the dose of nicotinic acid just below the nausea-producing level is used in combination with the dose of nicotinamide that is below the nausea-producing level. This allows the total vitamin B-3 level to be twice the nauseant level of either one alone.

Nausea is apt to be worse during a virus infection. It may be necessary to stop the vitamin B-3 for a few days until the height of the viral attack has passed. If medication is not discontinued when the nausea is severe, it may lead to severe vomiting and dehydration. On a few occasions (out of 2,500 cases), this required intravenous fluids to control. In this instance, a side effect could become a toxic reaction if not treated properly.

However, the most feared side effect of vitamin B-3 is its alleged adverse action on the liver. The evidence for this is scant indeed, but the fear in the medical profession is great. As early as 1952, after we had started treating our schizophrenic patients with large doses of niacin, we were aware of the fear that it caused liver damage. This was based on two observations. In toxicity experiment with rats, the use of 4 to 5 grams of niacin per kilogram caused fatty livers. However, this is similar to giving humans about one half a pound of niacin. This experiment was repeated by Professor Rudy Altschul, Chairman, Department of Anatomy, Medical College, University of Saskatchewan, using the same method. In rat colonies free of virus infection, he found no change in their livers. Another observation was that niacin caused jaundice. In many cases, the enzyme values for liver function are elevated, but these are transient. The incidence of jaundice in patients taking niacin has never been found to be higher than it is in the general population.

The first physician to confirm our niacin-cholesterol-lowering effect was Dr William Parsons Jr. at the Mayo clinic. Dr Parsons was fully aware of the hypothesis that niacin could be toxic to the liver. After his first series of patients had been on the niacin for one year, liver biopsies were done on each one. They were all normal. After two years, a few patients showed some

abnormality in these tests, but these were caused by various slow release preparations then being studied. However, two weeks after these substances were omitted, the liver-function tests were normal. After one week, Dr Parsons found the results were normal. Finally, he found that when these preparations were replaced by plain niacin, without any wash-out period, the results came back normal one week later. Normally, when the liver is damaged, as with alcohol cirrhosis or liver damage from chemicals, it is considered fortunate if the results are normal in six months. These tests convinced Dr Parsons that the abnormal results represented changes in liver function rather than in anatomic liver changes. This was the first indication that abnormal tests do not necessarily mean damage to hepatic cells. Since then, the FDA has recognized many substances that may cause minor changes in hepatic function tests, but which have no clinical significance. They are examples of induced microsomial enzyme activity.

In searching the medical literature on niacin and the liver, Dr Parsons found only 18 cases of liver problems. These varied in degree. Two were serious and irreversible. "Not bad for a drug used for more than 40 years," he concluded, "with more widespread use in recent years — much of it as a result of the NCEP guidelines of 1988 and 1993."

The Coronary Drug project provided the next demonstration of niacin's safety. In this study, 1,100 post-coronary men received niacin for five to eight years. Dr Paul Canner, head statistician for this study, told Dr Parsons that there were no abnormalities that could be attributed to niacin. On the contrary, niacin was the only substance that increased longevity by two years and decreased the death rate by 11 percent.

Dr Parsons concluded that minor elevations in enzymes in tests reflecting liver function are a normal part of niacin therapy and are not a reason to discontinue treatment. If the enzyme results exceed two to three times the upper limit of normal, the changes are significant and require discontinuation of niacin, to be resumed later at a lower dosage. Dr Parsons further recommends that a liver test be done after the correct dose has been found. The test can be done with annual examinations.

In my opinion, doing these liver function tests may be more protective to the physician than to the patient. I advise physicians who consult me that if they wish to do the test, they discontinue the niacin for five days. By

then, the enhancing effect of niacin on liver function enzymes is gone. Is there any positive value in the enhanced activity of these enzymes? No one has examined this possibility.

I have given niacin to more than 5,000 patients since 1952. I can recall a handful of cases of jaundice, which promptly cleared when the niacin was discontinued. In one case, when the niacin was stopped and the schizophrenia came back, I resumed the niacin and the jaundice did not recur. This suggests that the few cases of jaundice in patients taking niacin have to be examined very seriously to determine what other factors were causal. Plain ordinary niacin is effective and non-toxic. Some sustained-release preparations are not quite as safe. I have seen no Canadian reports of any toxicity from the sustained-release preparation available there. Inositol niacinate does not elevate liver function test values.

It is very interesting, even if frustrating, to witness the efforts to discredit vitamin B-3 as an effective nutrient therapy. Dr R. Garg has reported that niacin increases plasma homocysteine levels that are recognized as playing a role in atherosclerotic heart disease. However, niacin reduces abnormal cholesterol levels and increases HDL, thus decreasing the risk of heart disease. The Coronary Drug Study showed, over a 15-year follow-up, that mortality was decreased by 11 percent by niacin and longevity increased by two years.

Niacin is a methyl acceptor, and this may be the mechanism that leads to the elevation of homocysteine levels. Niacinamide is also a methyl acceptor, but it has no effect on blood lipid levels. Its effect on homocysteine levels is not known, but there is no evidence that it reduces life expectancy. On the contrary, it has great value in the treatment of senile states, both physical and mental, and in my series, if anything, tended to prolong life.

But Dr Garg's report does raise very interesting questions that will have to be studied. The first is whether the elevation of homocysteine is an important factor in subjects who are not taking adequate levels of the other B vitamins; i.e., are not well nourished, in orthomolecular terms. It is possible that, in the presence of good nutrition, the increase in homocysteine levels is not pathological at all and may even be beneficial.

Vitamin C

Dr Irving Stone has shown that man cannot make any ascorbic acid, and that if he could, his liver would produce about 3 grams per day when not stressed and a lot more when under stress. Dr Linus Pauling summarized the evidence that these quantities of ascorbic acid decrease the frequency of and disability from colds, published in his best-selling book, *Vitamin C and the Common Cold*. The therapeutic value of vitamin C in the treatment of various forms of cancer has been shown in my collaborative studies with Dr Pauling, published in our book, *Healing Cancer: Complementary Vitamin and Drug Treatments*.

Dose: We also recommend taking vitamin C or ascorbic acid, beginning with 3 grams per day, as a general supplement in orthomolecular therapy.

Side Effects: Vitamin C is a remarkably safe vitamin. The major side effect is diarrhea when the sublaxative dose is exceeded. However, this is a very valuable property for many older people who suffer from constipation. Since the human species cannot make any in the body, we all suffer from hypoascorbemia. We are totally dependent on the supplies in our diet. In my opinion, every person should take vitamin C in doses ranging from 100 to thousands of milligrams daily. I was once asked on a television talk show whether everyone should take this vitamin. I replied, "No, I don't think so. Only those people who want to be well should." The dose is variable and depends on the degree of stress, the disease being treated, one's age, and the sublaxative tolerance levels, among other factors.

In spite of its remarkable safety, some medical professionals claim otherwise, alleging that megadoses of vitamin C may cause kidney stones, kidney damage, pernicious anemia, decreased fertility in women, liver damage, iron overload and toxicity, and cancer. Vitamin C, they claim, may inhibit chemotherapy, prevent radiation from being effective, prevent surgical scars from healing, and interfere with glucose tests for diabetes. Based on the evidence of thousands of published papers in medical literature and hundreds of books, these claims are not true. Indeed, the opposite is often true – vitamin C is therapeutic and preventive for many of these disease conditions.

The unfortunate result of these allegations against the therapeutic value of vitamin C and other vitamins is that patients are made fearful – some

will stop taking their vitamins, medical costs will increase (since patients want to see their doctor again to discuss these matters), and more patients will relapse. The harm done by these claims over the years is immeasurable in terms of suffering and lives lost, but fortunately is slowly decreasing, as the population becomes more knowledgeable and sophisticated about nutrition and nutrients.

Vitamin B-6

Another vitamin, pyridoxine or vitamin B-6, is being used more and more frequently, especially for children with schizophrenia. In fact, there are a few children who do not respond well to orthomolecular therapy until vitamin B-6 is added to their program. Recently, a hyperkinetic did not respond until B-6 was added to the nicotinamide, but by itself, it was not therapeutic. Obviously, this patient was dependent upon both vitamins.

Vitamin B-6 is recommended for schizophrenic patients who have kryptopyrrole in their urine and is then used in combination with zinc. I also use it for many children with learning disorders and for women with premenstrual tension (PMS). The most obvious indictors of when it should be used are white, chalky-looking areas in the body of the nails, stretch marks (stria) on the body, PMS, and acne. The urine test for KP will indicate when it should be used.

Dose: The dose range varies between 250 to 1,000 milligrams per day, but one may go much higher, since it is also a water-soluble vitamin. I seldom use more than 250 milligrams, and often the 100 milligrams available in any of the B 'Complex 100' preparations is adequate.

Side Effects: Like many other vitamins alleged to be dangerous, pyridoxine's reputation for toxicity is based upon one study. Six patients, using between 2,000 and 6,000 milligrams daily without any other vitamins, suffered peripheral neuropathy, which cleared in nine months after they stopped taking it, leaving no residual disability. Others have claimed that even 500 milligrams is dangerous, but I have not ever seen this in the over 30 years I have used this vitamin to treat a large number of conditions. A few people are allergic to the pills, which means that they are allergic either to the active ingredient or to some of the fillers that are used. It must be

remembered that about 10 percent of subjects on any placebo have side effects.

On rare occasions, B-6 increases irritability and restlessness, suggesting either that it is not required or that the patient is allergic to one of the ingredients of the tablet, which may or may not be pyridoxine.

Other Vitamins

Other vitamins may be required in orthomolecular therapy for schizophrenia. These include vitamin A, for any surface lesions on the skin and mucosa (mouth, nose, etc.), and vitamin E (1 tocopherol), for aging patients or patients with vascular problems affecting any portion of the circulatory system, including the heart and the brain. The dose ranges from 400 to 2,000 I.U. or more per day. For patients who have had rheumatic fever, it is wise to build up the dose slowly.

Calcium pantothenate (or pantothenic acid) is especially valuable for elderly people. This vitamin, discovered by Professor Roger Williams, increases longevity in animals, has anti-allergy properties, and relaxes a few patients so they sleep better. The dose range is 250 to 1,000 milligrams per day or more. In some cases, a multi-vitamin preparation containing most of these water-soluble vitamins is very helpful.

Folic acid has become much more popular since it was found that women deficient in this vitamin more often than not gave birth to deformed babies. It is now recommend for all pregnant women. I usually use it to treat depression. The dose range is 25 to 50 milligrams daily. I have found it very helpful for schizophrenic patients who are also very depressed.

Other water-soluble vitamins that may be used are thiamine, or vitamin B-1, for depression, in a dose range of 100 to 3,000 milligrams per day (usually under 1,000 milligrams) and vitamin B-12 combined with folic acid. The dose is determined by the response. Vitamin B-12 blood assays may be helpful in indicating when treatment is required and how much.

Orthomolecular Treatment Results

On the basis of our clinical experience, accumulated since 1955, the following treatment results can be obtained by any physician following the orthomolecular treatment program:

Group	Duration of Treatment	Well and Much Improved
A. Sick one year, or in 2nd or 3rd relapse	Up to 1 year	90%
B. Sick 2-5 years	Up to 5 years	75%
C. Sick over 5 years, but out of mental hospital	5 or more years	50%
D. Sick over 5 years, and in mental hospital	5 or more years	25%

These results are better than those obtained by using popular drug treatments. In fact, it is not possible to recover and to stay well on drugs alone.

Drug Treatments

Just as it is important to give the most effective dose (optimum dose) for each vitamin, so is it important to give the optimum dose of non-nutrient chemotherapy, drugs such as tranquilizers and anti-depressants. Most psychiatrists are knowledgeable about these substances. The optimum dose must be that which controls or alleviates disturbing symptoms but which does not produce serious side effects or immobilize patients to the point where they cannot study, work, or perform adequately in society. Sometimes performance may have to be sacrificed in order to produce relative comfort for the patient and effective control of symptoms. However, for every patient the final objective is a recovery sustained by nutrient therapy alone, with the only occasional use of non-nutrient chemicals, such as tranquilizers, anti-depressants, sleeping pills, anti-anxiety medications, and so on.

Life is composed of thousands of different chemicals forming a fluid, semi-solid (gel), or three-dimensional solid structural grid, in which these chemicals interact in order to provide structure, function, and energy. These are compounds that have been made by life or have been absorbed, and that are essential (indispensable) or tolerable to the living cell. When

they are extracted from this living material, they become the compounds that we know as vitamins, minerals, amino acids, and so on. In this living system, the individual molecules are readily exchangeable. Thus, vitamins present in this living mass are easily exchangeable with the same vitamin present in the fluid surrounding or interacting with the living material. There is no 'synthetic' replacement for vitamin C, or for niacin or niacinamide. A mirror image of any of the essential components will not be used by the body because it cannot fit into the structure of the chemical reactions.

Substances that are totally unlike any of these living orthomolecules are highly toxic and play no role in the living cell, since life has not developed mechanisms for tolerating them until they are eliminated. These compounds are poisons, even in very small amounts. They are poisons because they insert themselves into receptor areas of the body's chemical reactions and inhibit or stop the reaction because they have replaced the natural substances for which these receptors are available. It is like putting a truck into a passageway that will only allow cars. All traffic will stop. The optimum level of these toxins in the body is zero.

There is an in-between group of molecules that are not identical to anything in living cells but that have some similarity to them. These the body can tolerate to a limited degree because there are mechanisms for detoxifying and eliminating them. These are the 'xenobiotics'. They constitute the vast majority of compounds used in medical therapeutics, including the tranquilizers, anti-depressants, and anti-inflammatory drugs used in treating schizophrenia. These compounds do not participate in the body's normal reactions, for these reactions are highly specific and require molecules of the same shape, form, and structure. The degree of tolerability to these xenobiotics depends on how closely they resemble the orthomolecules. The closer they are to these molecules, the more tolerable they are. This often means they are derivatives of these orthomolecules and, therefore, may be converted into the orthomolecules in the body.

In searching for new chemicals that might be therapeutic, the molecules that most closely resemble orthomolecules are most apt to be suitable for further therapeutic trials. The problem for the pharmaceutical companies is that natural molecules cannot be patented. For the bottom line, it is more profitable to use derivatives of these natural molecules, for which a

patent can be obtained. If niacin were patented for lowering cholesterol levels, it would be the premiere substance today instead of lurking in the shadows of statin drugs, which are much more toxic, much less useful, and do not have any vitamin B-3 properties.

Xenobiotics may be helpful when they interfere with a reaction that is harmful to the body, but they may also interfere with reactions that are essential. Thus, the statins block the synthesis of cholesterol, but they also block the synthesis of coenzyme Q10, a very important vitamin and antioxidant. Young people, who can make Q10 more easily, will therefore tolerate the statins better than older individuals, who cannot make enough Q10. The elderly population on statins will be subjected in time to a variety of diseases caused by the scarcity of this enzyme, unless they also take ample quantities of coenzyme Q10.

Living matter is geared toward functioning at a steady state. This does not mean that it is static. It means that variations in function are maintained as a system, with minimal fluctuations. This is what homeostasis means. Thus, the acidity of blood, the pH, is maintained very close to 7.35. Blood glucose levels fluctuate over a small range in healthy people. When the fluctuations are extreme, that person is sick – and the greater the fluctuations, the sicker he is. It is also important that these normal variations lie within a range that keeps the individual functioning at an optimum level: pH varies between 6.9 and 7.0 when there is something dreadfully wrong, whereas variation between 7.42 and 7.47 is normal. I sometimes think that my patients who have been sick for a long time have established a sick homeostasis, from which it is very difficult to escape, and when they are finally well, they have a different homeostasis that will keep them well. Like moving an electron from one orbit to another, it may be very difficult to move patients from one state of homeostasis to another one.

Not every reaction is operating at its optimum level. Nor could the cell survive if it did. The activity of the cells may depend upon slow rates of reactions or high rates, depending upon the need. This is determined by the supply of natural nutrients. These nutrients are present in the environment surrounding the chromosomes. In some cases, very tiny amounts are needed. Thus, to prevent the onset of pellagra, less than 10 milligrams of niacin per day is needed. But for many reasons, many people need much more than that for optimum functioning of the cell. If only the tiny

amounts are available, that cell will function, but at a minimum level of activity, whereas providing much more, or the optimum range, will allow the cell to work at a level closer to its optimum. For each nutrient, there is a range from the minimum necessary for life to the optimum and above where the extra quantity begins to interfere with cell function. This has been the crux of the debate between the vitamin-as-prevention paradigm and the modern vitamin-as-treatment paradigm.

With xenobiotics, the optimum level for cell function is zero – since these are not essential, they are not needed to sustain life. The optimum clinical levels are those levels at which the toxicity is tolerable while its clinical activity is evident. Toxicity increases with dose, the action of the drug increases with dose, and the optimum level is where the clinical effect is evident and the toxic levels are tolerable. The toxicity of a drug is described by referring to its "LD 50," the dose that, over a period of time, will kill one-half of a group of test animals, or its therapeutic dose. If one unit is therapeutic but two units are dangerous, then the drug has a narrow therapeutic index. If the toxic dose is 100, the drug has a wide therapeutic index. For tranquilizers and other xenobiotic drugs, this therapeutic index is very narrow, but for vitamins, it is very wide.

With drugs, there is a very small dose range that can be used, while with orthomolecules the dose range is enormous. Thus, the optimum dose of olanzapine, a modern drug for schizophrenia, varies between 5 and 10 milligrams daily, whereas the toxic dose begins at 15 milligrams daily. For vitamin B-3, the therapeutic dose for humans is 3 to 30 grams per day for nicotinic acid, and 3 to 6 grams per day for nicotinamide. There is no toxic dose for humans, since no human has died from an overdose or from using large doses. For ascorbic acid, it is even higher. There is no toxic dose for vitamin C, though at some level it cannot all be absorbed by the bowel and may cause diarrhea.

Orthomolecules are safe because living matter is familiar with them, having adapted to them over millions of years. A little too much is no problem, since they are easily metabolized (and for this need little extra energy) or excreted (so that there is no buildup in the body); and because when much too much is given, the buildup is less toxic than it is for xenobiotics. There have been no deaths from vitamin overdoses in the past 20 years. When excessively large doses are stopped, recovery is very quick.

Xenobiotics are toxic or dangerous because the body is not familiar with them – they are difficult to metabolize and require extra energy to do so. It is because they are difficult to metabolize that the amount in the body builds up before they can exert their clinical effect. It may take three to four weeks before there is the proper buildup, as with the anti-depressants. If they were readily metabolized and excreted, they probably would not be used clinically. But the buildup can be dangerous. In the United States each year, there are about 100,000 deaths in hospitals from the administration of xenobiotics like tranquilizers.

While tranquilizers are potentially toxic, with side effects that can threaten life or lead to permanent disability if administered wrongly, when a disease is very serious, as is schizophrenia, one is justified in using this potentially dangerous treatment. Schizophrenia is so serious a disease that this is tolerable, but it must be controlled by careful medical observation and control. These non-nutrient or 'xenobiotic' compounds are essential at the beginning of most therapeutic regimens because they provide clinical relief to the individual, although they are not essential for every schizophrenic patient. Tranquilizers do initiate the process of recovery, but they may not be needed if the treatment is started very early after the disease has started. Many patients I have treated never had to take any tranquilizers. They recovered on orthomolecular treatment alone.

Tranquilizers transform 'hot' symptoms to 'cold' symptoms, an effect that is beneficial in the short term but dangerous in the long term. Hot symptoms cause major disturbances in social relationships. For example, hot symptoms include vivid, disturbing hallucinations that generate inappropriate, bizarre behavior. Irrational fears and confusion are hot symptoms. Hypomania and manic behavior are hot, as is agitated depression. The more severe they are, the more intolerable will be the behavior and the more quickly the person will be forced into treatment. If the behavior is primarily antisocial, patients may find themselves enmeshed in legal sanctions. The most common of these is committal to a psychiatric hospital. Cool symptoms are just as disabling to the patients, but do not create as much social stress. In one case, a chronic schizophrenic patient was tolerated at home as he sat quietly in his chair in the kitchen; however, a few days after he began to hop up and down on his foot all day long, he was brought into hospital for treatment. His earlier psychotic behavior

resulted from his cool symptoms, but his agitation and inappropriate behavior indicated they had become too hot to handle.

In the presence of cool symptoms, patients and their families usually can carry on. The 'advantage' of cool symptoms is that they can be treated at home, thus enabling the patient to avoid some of the dehumanizing effects of prolonged hospital treatment. The main advantage of hot symptoms is that they force the patient into treatment much sooner. With early treatment, patients recover much more quickly, especially on an orthomolecular regimen.

While tranquilizers reduce or moderate hot symptoms, they maintain or worsen cool symptoms. Tranquilizers cause the following changes in symptoms:

Perception: Hallucinations and illusions are dampened down, but acuity of perception is decreased so that, for example, reading becomes much more difficult.
Thinking: Delusions may remain the same or be weakened, but the intensity of the reaction to them is moderated. Thinking becomes more sluggish, there is more blocking, memory is impaired, and concentration is decreased.
Mood: Mood is flattened and less subject to swings, but this may lead to a general attitude of indifference as joy and sorrow are not felt as keenly.
Behavior: Hyperactivity and agitation are decreased. Most patients become sluggish. It is more difficult to get up in the morning, and they spend a greater proportion of the 24-hour day sleeping. They can be aroused from this sluggish state with some effort and can then function fairly well with simple tasks. Because of their inactivity, they expend fewer calories and may gain a good deal of weight, which they blame on the tranquilizer.

While cooling hot symptoms may be seen as the benefit of tranquilizers in a treatment program, they do not address the cause of the disease – and may cause other disease processes, namely tranquilizer psychosis (t.s.) and tardive dyskinesia (t.d.)

Tranquilizer Psychosis

Tranquilizers are essential evils for some patients with schizophrenia, for they convert a natural psychosis called schizophrenia into an iatrogenic or

drug-induced psychosis, called the tranquilizer psychosis. The first stages of their activity (recovery) are essential; the later changes (the tranquilizer psychosis) are very dangerous. The tolerance for the two different psychoses depends upon the community's assessment of risk and discomfort. In the same way, society will tolerate and support addiction to methadone – as long as patients follow carefully prescribed rules – but will not tolerate heroine (which in many cases is better, cheaper, and less harmful). Society prefers the iatrogenic psychoses, while many patients prefer to have the natural one. Both society and patients have to know that there is a third option: it is called recovery.

That tranquilizers improve the clinical condition of these patients is a well-known fact, but they hardly ever restore them to a state of normality. The same drugs can make normal people sick. This is the basis for what I call the tranquilizer dilemma. We want our patients to become normal and so we treat them with these drugs, but as they start to become normal, they begin to respond to the same drugs as normal people would – they become sick. If you do not believe that tranquilizers cause psychosis, start taking 15 milligrams of olanzapine today, stay on it for a few months, and see what happens to you.

The tranquilizer psychosis is a mixture of the original psychosis, under partial control, combined with the toxic effect of these drugs. A significant association has been found between the amount of tranquilizers taken over years in grams and cerebral cortex atrophy. The estimated risk of atrophy increases by 6.4 percent for each additional 10 grams of tranquilizer drug (in chlorpromazine equivalents). Tranquilizers increased subcortical volumes in schizophrenic patients. These changes were not present in patients not on this medication, suggesting that these changes were in response to receptor blockades and could decrease the effect of treatment. In other words, these drugs damage the brain and decrease the odds these patients can ever recover. Xenobiotic psychiatrists provide the schizophrenic patients with two choices: remain psychotic without drugs, or become psychotic with drugs. It is not surprising so many patients have to be forced by legal sanction or by parenteral administration to take drugs. They do not like the tranquilizer psychosis and often will go to any lengths to be freed of it.

This, then, is the dilemma. How can patients benefit from the moderate

improvement induced by the drugs but not become psychotic? The usual way is to withdraw the drug, but in most cases the original psychosis recurs and the process is repeated over and over. Or one can very slowly decrease the amount of drug, but in most cases the same disease recurs. There appears to be no escape, because when the drug dose is so small that the side effects are gone, its therapeutic effect is also gone.

Orthomolecular psychiatry provides a way through this dilemma, however. Nutrients have no side effect in the recommended doses. They gradually start the process of real recovery in most cases, but they do so slowly. It takes at least two months before they kick in. But once they are effective, the disease seldom recurs, as long as the nutrients are taken. This means that one can combine the therapeutic effect of nutrients, which is slow but enduring, with the rapid therapeutic effect of the drugs, and as the patients begin to recover, the amount of drug is slowly decreased until the dose is nil (or so close to it that there are no side effects). I have several patients on haldol 1 milligram daily who remain well on this very small dose.

Some time ago, I treated a young woman with schizophrenia who had gained 50 pounds of weight in half a year on olanzapine. Previously, her psychosis had been responding to an old drug, haldol, without any weight gain, but her psychiatrist wanted to try the new drug that he was investigating. The weight gain was very distressing to her, and she had decided she would not take it any more. She had asked her psychiatrist to put her back on the haldol, but he refused, telling her and her father, "better fat and well, than lean and psychotic." She was overweight, but she was not well, by my criteria, and she preferred to be lean and psychotic. Her father was swinging over to her view. With orthomolecular treatment, I provided her with an alternative, to become normal by gradually reducing the amount of olanzapine while following my therapeutic regimen. She agreed to stay on this regimen for one more month. I assured her that as she recovered, she would gradually lose that extra weight that she found so distressing. Being well means freedom from symptoms and signs, it means having a good relationship with family and community, and it means being engaged in some useful and satisfying activity. She soon lost weight and became well with orthomolecular therapy.

Another case involved a young man, age 19, with schizophrenia. He had been psychotic several years. His mother told me that she had had him on

the orthomolecular program, with adequate doses of vitamins, for six months, but during that time saw no response. "I want my son back," she pleaded. She then remarked that he had been taking olanzapine throughout that period. I modified his program and instructed her to start reducing the dose of drug very slowly, starting in two months, and taking about a year to reduce it to a very low level (or zero). She got her son back.

Tardive Dyskinesia

Tardive dyskinesia (t.d.) is a major toxic reaction to tranquilizers that can come on within a few months of treatment and is more or less dose-related. Patients develop uncontrollable, random muscular movements that can affect any or all of the muscles. When the dose is reduced in order to decrease the severity of the reaction, it may become worse. Mild or moderate symptoms will be tolerated fairly well, but severe t.d. will incapacitate the patient. Several years ago, I saw a patient on parenteral tranquilizers whose whole body was affected. All his muscles quivered, twitched, and jumped as if he were a bowl of jelly in a mild earthquake.

Tardive dyskinesia severely limits the use of adequate doses of drugs. For many years, it was considered irreversible by standard psychiatric treatment, but recent work suggests that it is not irreversible, but it does not clear until many years after the drug is withdrawn. The problem is that while t.d. is going away, the psychosis is returning once more, forcing the use of tranquilizers again. This is one reason why patients refuse to remain on medication and have to be forced to take the drug by injection. Most relapses come when the medication is withdrawn by the patient or by the doctor.

Drug companies are searching desperately for a newer drug that will not have this dreadful side effect. Clonazepine may be such a drug. It does not cause this side effect as frequently as do some of the other drugs, but it does cause a different set of side effects and toxic reactions. One of the worst is a marked decrease in white cell count. Worldwide, over 60 patients have died because of this. This is why in the United States and in Canada the white blood count has to be monitored frequently, with the good result that there have been no deaths reported in these countries.

Patients on orthomolecular treatment do not develop tardive dyskinesia. If orthomolecular treatment had become popular, it is doubtful clonazepine would have come onto the market. Dr David Hawkins, one of the

pioneers in orthomolecular psychiatry, has reported that no cases of t.d. developed from an estimated 50,000 schizophrenic patients treated by orthomolecular methods. This confirms our experiences with several thousand patients. None of our patients developed this condition, but we have seen many who were referred to us already having this disease.

The only effective treatments, apart from discontinuing the drugs, have been orthomolecular. Large doses of lecithin have been helpful in 40 percent of the cases. Had it been combined with vitamin C, the results might have been even better, as vitamin C helps regenerate vitamin E. Vitamin E, once a very unpopular vitamin in the medical profession, is now much more popular because it is an anti-oxidant and quenches free radicals. Free radical theories are becoming very popular. The psychiatrists who have reported that vitamin E does help believe it does so by preventing the formation of free radicals from the catecholamines – from adrenaline or noradrenalin. However, most have refused to name these oxidized derivatives as they are aminochromes. Adrenochrome is still a taboo word in psychiatry. These compounds, or aminochromes, are very reactive and can be very destructive in the body.

Neither lecithin nor vitamin E removes all the symptoms of t.d., but this has been achieved by using a combination of manganese and vitamin B-3, as reported by Dr R. Kunin, an orthomolecular psychiatrist from San Francisco. But since manganese is not used routinely by orthomolecular psychiatrists, vitamin B-3 alone must have good protective properties. It may also function in this way because with the use of this vitamin, much lower doses of tranquilizers are needed and doses may be reduced much more quickly. In 1952, we found that niacin given by vein to epileptics whose electroencephalogram had been made worse by adrenochrome made them normal within a few minutes of receiving it. Niacin also protects patients with Parkinsonism from the psychosis-producing properties of l-dopa.

In our opinion, the presence of t.d. in a patient is a measure of the failure of psychiatry to use all modern information on treatment, and ought to be considered unethical. It contravenes the use of informed consent. If patients were told they need not get t.d., they would have a choice – to use only drugs or to use orthomolecular treatment. There is no doubt which choice they would make.

Orthomolecular therapy is a program that combines the best of nutritional modification with megadoses of a few nutrients and the best of modern drug therapy. The drugs are rapidly effective in initiating the recovery process, and the nutrient program, while slow, is steady and enduring. As treatment proceeds, and the patients show clear evidence of recovering, the drugs are slowly withdrawn. With this combination, the psychosis remains under control and the tranquilizer psychosis is not allowed to develop. If the drugs are not withdrawn, the tranquilizer psychosis will develop and this will not be prevented or ameliorated by the nutritional therapy. Vitamin B-3 does not cure the tranquilizer psychosis. Only withdrawal of the tranquilizer from the patient will do this.

Psychotherapy

You may wonder whether you will be given psychotherapy, since it has been so often repeated that it is the basic treatment in psychiatry. The best psychotherapy is given by a physician when he listens carefully to your complaints (symptoms), diagnoses promptly and accurately, advises you firmly of the diagnosis, and then prescribes for you a treatment program that works. We will discuss with you whatever problems worry you, and we will advise you what is real and what is not real. When you are aware of changes happening to you, we will expect you to bring them up for discussion. However, we will not give you psychotherapy that probes your past life, nor will you be advised to seek psychoanalysis, for these treatments have been proven to be futile for schizophrenia.

We will encourage you, as our patient, to study your place in your society, for schizophrenia produces difficulties for you and for people about you. Even if you are not fully aware of some perceptual changes, we will explore them with you, for they may profoundly alter your reactions to your family. We will go over the side effects and uses of nicotinic acid with you rather carefully. As a rule, patients who are so prepared will continue to take medicine until their doctor advises them they do not need it any more. They will not be worried by side effects. We hope you will gradually learn to ignore perceptual oddities and to recognize them as transient recurrences, due to fatigue, when they do return. You should then increase the dose to 6 grams per day for a few days.

This then will be our form of psychotherapy. It will be rooted in the doctor-patient relationship in which you will feel free to discuss with us what troubles you, and you will have confidence in our advice about reality and how to overcome your perceptual difficulties and to reduce their injurious action on your relationships with your family and friends.

Occupational and Recreational Therapy

One day, these forms of therapy will not be required, for every schizophrenic will be treated early and will recover. Unfortunately, too many patients have received treatment too late, or with too little skill. For them, we require these additional aids.

In most cases, some social re-education is required. Chronic patients who have begun to recover may need re-training in simple matters, which are most important. Patients may need instruction in up-to-date dress; how to apply makeup; how to cook, shop, and use public transportation; and other things patients must know to get along and with which they may not be familiar.

Treating Chronic Schizophrenia

Schizophrenia is a syndrome; that is, it is a characteristic way the brain has of reacting to some disturbance in its operation. The majority of patients with schizophrenia are acute and subacute. This group responds best to orthomolecular therapy. Still, a substantial group of patients are chronic and respond very slowly to orthomolecular therapy.

If the family can tolerate the patient's unusual behavior, and if they are able to live with the patient, treatment can be continued at home. It should never be given up too early. We have seen many very chronic patients recover after several years of such treatment. We have also seen many patients who were getting well suffer a relapse when indifferent doctors took them off their medicine or permitted them to stop taking it.

Mary Jones (not her real name) is one of our many patients who is well today because we refused to give up hope. We have chosen this case to illustrate that every patient suffering from schizophrenia deserves a fair trial and treatment, that 3-6 grams of nicotinic acid or nicotinamide a

day is effective treatment, and that a chemical treatment together with a carefully planned program for rehabilitation is useful in combating the disease.

By her own psychiatrists, Ms Jones was given little chance of recovering. Mary, in fact, was not only diagnosed schizophrenic, but retarded as well. We did not believe that we could do much for Mary. We wanted to try to help her because we wanted to study schizophrenia first hand, and because her case was so severe, it presented a challenge we could not ignore.

What better way to do this than to take her into our own home? Mary moved into the Hoffer home after spending 14 years in a grossly overcrowded, understaffed mental hospital. She was 17 when first admitted, and had reached only grade four in special classes for 'defectives'. Here she was one of over 1,600 patients. She slept in a large ward with 100 other women. She did not know what it was to have a place of her own to put a handkerchief or keep a mirror. She had to stand in line to use one of the four bathrooms.

Little attempt was made at treatment. The hospital staff described her as impulsive, suspicious, and quick-tempered. When she became violent and difficult to control, as she sometimes did, the staff had to restrain her or give her heavy sedation. She was often depressed and heard voices. While in hospital, she required ECT and other treatment frequently and, after showing some improvement, was allowed to do housework in the homes of staff members. She worked during the day in Dr Osmond's home and eventually was discharged in my care.

There were three children in the Hoffer household. The home Mary came to was situated in a quiet, tree-lined residential street about two miles from the center of the City of Regina, and 74 miles from the hospital where Mary had been for 14 years. Mary had never been to Regina before. She had never seen a streetcar or streetlights that turned now red, now green. She could not use a telephone dial and did not know how to take a message on the telephone. She did not know what to expect from the bustling household. She had much to learn.

When she came to the Hoffer household, a pale, dark-haired, dark-eyed, and frightened girl, she was very quiet and did not talk. But she loved children and liked housework. She knew how to use a vacuum cleaner, how to dust, and how to wash and polish floors. She was willing to work, was thor-

ough, and was very efficient. My wife, with great patience, began teaching her the simple things she would need to know to get along in the city – how much fare she would need for the bus, how to count her change, how to get on a bus, how to use the telephone, how to buy a ticket for a film, and how to do her own shopping. She progressed well for the first few weeks, and then became depressed until one day she tried to kill herself.

That day I came home from the hospital early in the afternoon. Just as I entered the house, I heard my son Bill, age seven, shout downstairs, "Mummy, where is the electric light cord? Mary wants to kill herself." Bill was engrossed in a radio cowboy program when Mary asked him for the cord in order to kill herself and was too absorbed to realize the meaning of his message. I quickly ran upstairs and found she had the light cord wound twice around her neck and was beginning to tighten it. I immediately drove her to the hospital, angered and frustrated, having decided our experiment had failed. In hospital, I gave her one emergency ECT because she was very disturbed. The next morning, I told her she would be returned to the mental hospital. But she was somewhat better and wanted to try again. She was given one more ECT and that afternoon returned to our home. That day she started on nicotinic acid, 3 grams per day. Some time later, we began giving her nicotinamide when she complained of the nicotinic acid flush. At first, whenever she stopped taking the vitamin, her physical complaints and depression returned.

There were times when Mary went into fits of temper and brooding. The slightest thing at times unaccountably aroused her anger. Loud voices sometimes seemed to disturb and frighten her. Perhaps she misinterpreted a look or a word. But during the next two and a half years, she improved to the extent that we considered her ready for discharge from this sheltered life into the community. Mary, we decided, had to be out on her own, working at a job and learning to be independent.

I found her a job on the cleaning staff at Regina General Hospital and a light-housekeeping room close to the hospital. She would have to make her own breakfast, be at work at seven every morning, have lunch in the hospital cafeteria, and make her own evening meal. There would be no one at her side to tell her what to do or how to do it. If she failed in her job, she

would lose it. She was on her own for the first time in her life. Although Mary was frightened, she agreed to try.

When we moved to Saskatoon, Mary wanted to move, too. We were now her family. I found her another job at a Saskatoon hospital. For the first few weeks, she lived with a niece in Saskatoon before finding a room for herself. Finally she found an apartment.

This story, we are pleased to say, had a happy ending. She remained well on no medication. Any psychiatrist unaware of Mary's history would not call her schizophrenic or retarded. Mary became one of the senior workers on the hospital cleaning staff and was efficient and reliable. Her income rose steadily and she became completely independent. She owned her own furniture, including a television set, managed her own money (a remarkable accomplishment when one remembers how incompetent she was with money on discharge from hospital), saved money in the bank, and had a reasonably active social life, including boyfriends. She became a girl of good moral character and had no difficulty in her relationships with men. The efficient, self-possessed Mary she became was a far cry from the frightened, uncommunicative girl who first arrived in Regina many years ago to try to live away from the hospital. Mary retired after 30 years of excellent service to the Royal University Hospital in Saskatoon.

If we had not taken Mary into our home and placed her on nicotinic acid treatment, she probably would have died in the mental hospital. If she had lived in the hospital as a chronic patient or if she were placed in the community, in a chronic nursing home or intermediate home, she would probably have cost the government of Saskatchewan about $35,000 each year in today's costs, or over $1 million in total care. Instead, not only did her recovery save the province this amount of money, she also paid income tax for 30 years and became a productive citizen of the City of Saskatoon. Mary may be the only recovered schizophrenic patient who has met and spoken to royalty. Princess Anne visited the hospital where Mary worked (later named the Royal University Hospital). While she was being shown the hospital, Mary, in her clean and attractive uniform, was watching. Princess Anne came up to her and spoke to her. Mary replied without any hesitation.

6 | WHO WILL BE TREATING ME?

Once you have been diagnosed with schizophrenia, your doctor will create a treatment plan that will include not only the doctor but also nursing care, your family, your community, and the hospital itself, if your doctor recommends admission. You will also play a vital role on this treatment team.

The Hospital

It is quite possible that you will not have to go to hospital if your treatment program is started early. But if you do, what kind of hospital will you be in?

If you broke your leg, you would be going to a local hospital you likely know. Perhaps you have visited friends there or been in yourself once or twice for some other physical ailment. But as a patient with schizophrenia, you may not be so fortunate, and find yourself being sent to a regional hospital many miles from home. You may have seen these institutions with their large remote brick buildings reaching up over the treetops, far off the highway and outside city limits.

Hospitals should be of the kind that will help and not hurt the patient. But few of them are. Within the past few years, studies have been made on

the role that hospital design plays in the recovery of patients with mental illness. It was found that there are two main ways of looking at a hospital. One way is to put more emphasis on economy. The result is large hospitals built to 'store' up to several thousand patients at a time. The wards were made very large, some of them holding up to 100 patients, and the corridors had to be very long. Since it was not known how to treat the mentally ill or what else to do with them, they were steadily stuffed into these institutions, many of which seemed about to burst at the seams.

The main objective of society in building these large institutions seemed to be to get the mentally ill out of the way, and to save money at the same time. It was also believed that the mentally ill lived in their "own fantasy dream world," where they were happy in their wild imaginings. A few patients, out of terror of shackles, other physical restraints, and unkind treatment, were violent and hard on the furniture. Why then bother giving them the ordinary comforts of life? In many large hospitals, one still finds a noticeable lack of attractive beds with spring mattresses and headboards, private rooms, and private lockers.

The second approach is to build an ordinary ward for the mentally ill attached to a general hospital. Psychiatric patients in these wards are separated from other patients by locked doors. These wards are generally attractive and comfortable. They have fewer patients per room and enough space per patient. They provide more of the necessities of life than the very large wards in large hospitals. Yet these too often manage to make a patient's life a little less than enviable.

Until a few years ago, these wards, like large mental hospitals, locked patients up "for their own protection and the protection of society." Any time patients felt like leaving, they had to do so through an open window, although until recently there were bars across the windows. Tranquilizers, plus more humane attitudes, made it possible to allow some patients greater freedom, and the "open door" policy was cautiously tried out in a few of the old-fashioned hospitals. When it was found to work out well, the idea spread to the smaller psychiatric wards.

The "open door" theoretically means there are no restrictions on patient movements. Many wards accepted the idea in principle, but retained the right to restrict patient movement whenever anyone on the staff felt like it. While doors were theoretically open, the staff held a firm grip on the leash.

When one ward in Saskatchewan was first opened 10 years ago, for example, any psychiatrist who had a patient he thought might run away could say, "I want the doors locked today." So, under the "open door" policy, the doors were locked 90 percent of the time. Even today, psychiatrists on some "open door" wards use excessive doses of tranquilizers to keep their patients so doped up they won't feel like running away.

Hospitals find a variety of ways of getting around the open door. We visited one large hospital that made no attempt at subtleties. One ward was open, but any patient who wanted to go out of that open door had to do so over the dead body of the guard hired to sit beside it.

Many hospitals have no locked doors at all, and these provide the most humane treatments. They have nothing to hide and are not ashamed to let the public in. At Saskatchewan Hospital, Weyburn, one of the province's two large mental hospitals, staff members no longer dangle heavy key rings from their pockets. The wards that are still kept locked include only senile patients who may harm themselves by wandering away.

Patients on open wards in this hospital may come and go as they please, shopping or visiting downtown, as long as they remain within the hours set by ward staff. Those wishing to be out after hours may do so by special agreement. As a result, there are fewer escapes now than there were when the wards were locked. In fact, in the early hours of one morning, an 'escapee' was seen at a window begging to be allowed to come back. The current trend is towards creating smaller home-like hospitals in the patient's own community.

Unfortunately, hospital design was rarely considered an important part of treatment for much of the last century. This is all the more surprising, since the basic elements of design for housing patients with schizophrenia humanely were clearly described about one century ago by Dr Thomas Kirkbride, a famous American superintendent of mental hospitals. Patients living in the hospitals are never asked what they like or don't like about their quarters. Nurses are hardly ever consulted about the needs of their patients or asked how hospitals might be built to lighten the routine housekeeping load and so give them more time for nursing. Psychiatrists are surprised if they are consulted. Even if they are, there are hardly any architects who can talk intelligently with them – and vice versa – because their language and frame of reference are so different. Even when they do

manage to achieve a useful interchange of ideas, it is the architect's ideas that usually find their way into the final design.

Fortunately, there are signs of change. One of our colleagues, Mr K. Izumi, a Regina architect, carried out extensive research into the design of the best kind of hospital for the mentally ill. There was only one sure way he could find out what the patients' needs were and that was to become one, temporarily, himself. By experiencing some of the patients' perceptual difficulties, he thought, he might have some inkling what problems the old hospitals imposed upon the seriously ill.

Mr Izumi spent a great deal of time studying what mental illness was by discussing it with psychiatrists and trying to understand the world in which patients live. Then he asked to be given LSD-25, so that he might see for himself what it was like to be mentally ill. He took the drug several times and, while under its influence, went through hospital wards as he would if he were a patient. He noted the impact on himself of long corridors, patients crowding around him, and other features of large hospitals. At each step, he discussed his impressions with one of us.

As a result of his studies as an architect and, briefly, as a patient, he concluded that patients would do better in small, cottage-type hospitals, with only a few patients in each ward. He then designed new wards, in collaboration with Dr Osmond, and these led to the construction of several new hospitals in the United States. Reports on these hospitals have been favorable. They are considered by many to be the ideal hospital for the schizophrenic.

We do not imply that hospital design is the most important single factor in the treatment of patients with schizophrenia; in fact, we believe that the standard of nursing and medical care is more important. Patients may be treated as well, with good nursing and medical care, in the worst possible wards as in luxurious rooms where untrained, incompetent, and coldhearted staff are in charge. But we do believe that every facet of treatment must be maintained at the highest possible level.

Nursing Care

Nurses are important members of the treatment team. They need to understand what their patients feel, their pain, their altered perceptions, and what effect these will have. Knowing what is happening to the patient makes it much easier for nurses to decide what to do.

If you were to suffer from delirium, for example, the ideal nurse would recognize that it would be wrong to place you in a shifting environment, for this would only intensify your problems. She would understand your need for a single room with subdued lights, where noises are at a minimum and a quiet nurse is in attendance to provide support and help. If you did not know where you were or what time it was, such a nurse would see the importance of making newspapers, calendars, or a clock available to you. Visitors would further help keep you in touch with your environment. If your time senses were distorted, the nurse would see no point in saying to you, "Your doctor will see you soon." For to a patient with no sense of time passing, how long is soon? The nurse would tell you, instead, "Your doctor will see you at three p.m.," or whatever the time may be. The nurse would make a precise time statement, and the doctor would have to make every effort to see you at that exact time.

If you were having trouble with your memory, a nurse would expect to have to repeat statements for you over and over again. Your nurse would know she must act as another link between the reality of the average person and the unreality of the sick one, and not make vague statements. If you had one or more delusions, the nurse would in a matter-of-fact way make it clear this is an erroneous belief that you have only because you are ill, and where possible, relate it to the peculiar perceptions that produce it. One patient was convinced that everyone with a name resembling Aly Khan was after her. She used to get messages from the planets warning her about the deep plots being perpetrated against her. These delusions came from the distorted messages she was getting from her senses. An understanding nurse would know that humoring such a patient in her beliefs would only reinforce them and do her no good.

At the same time, you would have the right to expect nurses to treat you with the same respect as they would if you were well. This means that simple courtesies are followed. Mr Doe should still be Mr Doe and not become 'John' as soon as he comes into hospital. We have observed that too often nursing staff look upon schizophrenic patients as childlike and, therefore, adopt childlike language and attitudes toward them.

Finally, nurses themselves can learn very quickly what your inner life is by taking one of the hallucinogenic drugs, like LSD-25. They should, of course, do so under the care of a qualified doctor who is not an amateur with these

drugs. But they can learn as much, though more slowly, simply by being interested in these matters and reading appropriate books, such as *Varieties of Psychopathological Experiences* (Holt, Rinehart and Winston, Inc.).

Your Family

The family plays an important role in the recovery of patients, for they have to bear the brunt of the problems presented by the sickness. Your family can help before treatment is begun, during active treatment, and after treatment has been completed.

Before Treatment Begins

This stage is often the most difficult. The illness may come on in one of two ways, so swiftly that the change is obvious, or so gradually and insidiously that one is not aware of it until after it is well established.

If the change is swift, it is merciful, for the patient either seeks or is easily persuaded to seek advice and treatment. If the illness causing the change is found to be schizophrenia, the patient and family are again fortunate, for then treatment can be instituted early, the disease has less chance of becoming firmly established, and assuming the patient gets proper treatment, the results will be good.

Sometimes, however, the disease comes on so slowly that it is unrecognizable in the early stages. Only when looking back on it can most families realize how long it has been present. This sort of onset is most treacherous and holds many dangers for patient and family. Because it is not yet known the patient is ill, it is assumed the patient is bad-tempered, perverse, unreasonable, lazy, and indifferent. Bewildered and upset by this strange behavior, parents persuade their child to change by berating the child with rules of good conduct. Meanwhile, a disapproving community sometimes makes it plain that it not only agrees with the family, but thinks the whole lot are at fault – the patient for being weak, and the parents for failing to give their child discipline and love. While the patient's illness progresses, the burden of guilt and anger in the family grows.

Everyone then applies sanctions or measures for suppressing bad behavior and encouraging good behavior. But the patient, the center of all this, is ill and cannot respond in a normal way. Punishment may seem to

be proof there is a plot against the patient and even kindness may seem to be a threatening blackmail. Because the patient is ill, he does not do as well at work or at school as others expect, or as he himself hopes. Only when the patient's behavior becomes bizarre, queer, or irrational will the family realize the patient is ill.

One might logically expect that at this point the danger has passed. It would appear that all that needs to be done now is find proper treatment and all will be well. But it is not always as simple as that, for now the family may be recruited as partners in the treatment or they may be alienated, depending largely upon what the psychiatrist does and says. The psychiatrist can help the family cooperate in a rational guilt-free treatment by telling them as accurately as possible what the problem is, and assuring them that they are in no way to blame. The psychiatrist can help them see the patient's behavior as being part of his illness and make it possible for them to withdraw the pressures they applied earlier. Or the psychiatrist can endanger the patient and delay recovery further by assuming the family to be responsible. This approach often precipitates another series of reactions that only add to the damage already done.

The first interview the family has, when a patient enters hospital, is usually held with a social worker. The questions asked are designed to probe the patient's early life in detail. "What was he like as a child?" "Was he treated as well as the others?" "How did he do in school?" "How did he get along with his brothers and sisters?"

Rather than looking upon this as a joint discussion, parents might understandably interpret this interview as an accusation, and suspect they have somehow failed their child. This would be a natural reaction in view of the fact that parents are being held responsible for everything these days from bedwetting and thumb-sucking to car-stealing and schizophrenia. Seeds of self-doubt are being steadily and diligently planted in the minds of men and women who, sometimes through no fault of their own, become parents, and who, in most cases, are conscientiously doing the best they can in their difficult roles.

Everyone, including chiefs of police ("parents are most often to blame for juvenile crime") to nursery school teachers ("we will teach you how to be better parents") have something to say about what parents must do to be good parents, and all have media through which to say it. Since it is assumed

in our society that parental neglect causes schizophrenia, it is important for the psychiatrist to make it very clear early in the association with the parents that they are in no way to blame. Doctors must do this explicitly, and not by implication. Relatives are often greatly relieved, surprised, and grateful to find they are not to blame, and pleased and flattered to be invited to become part of an enterprise for helping the patient to get well.

If the seeds of self-doubt are allowed to grow, however, which they often are, they can turn into destructive shame, guilt, and anxiety, which may operate against the patient's well-being in one of two ways: the offended parents may turn away from the patient and his doctor, or they may take the patient out of hospital and away from active treatment.

We sometimes hear of parents who refuse professional help for their sick children, but we don't very often hear why. While the professionals have a soapbox from which to expound their theories, the parents are seldom given an opportunity to tell their side of the story. And even if they were given the chance, who would give them a fair hearing? It is rather surprising that these parents, many of whom are intelligent men and women in other areas of life, have not yet formed an 'Association for the Protection of Maligned Parents'.

Some doctors, psychologists, and social workers seem to realize the shame, guilt, and worry that build up in parents when told they are in some way to blame for the child's illness. The first thought may be to hide the patient and themselves from these accusations, and removal of the patient from hospital may be a natural reaction. This only adds to their unhappiness, however, for now their consciences bother them even more, making them less able than before to deal with the patient's disturbed behavior in the home.

Brenda Gallagher was 17 years old when she first came to us as a patient. She had become a victim of an insidious form of schizophrenia beginning about four years earlier. During that time, her behavior was such that her parents could only describe her as being immoral, difficult, unreasonable, and many other things besides. It took them a few years to realize that she was not ill-behaved, but was ill. They then placed her under psychiatric care.

Her psychiatrist was well known to us for being dedicated to the idea that all schizophrenics are ill because their mothers or fathers have brought them up the wrong way. Brenda received psychotherapy, a "talking out"

treatment, for many months, when she was encouraged to speak freely against her parents, and to talk about any problems she could bring to mind. For six months more, in hospital, she was treated with permissive psychotherapy. Instead of getting better, she got worse. Her behavior, which before was merely bad, was now intolerable. She was then transferred to our care as a last resort before being committed.

In our first interview, we informed her for the first time that she was ill, that she had schizophrenia, and that she would be treated with nicotinic acid plus ECT. She spoke very angrily about her parents, whom she blamed for her difficulties. We told her that they were in no way responsible for her illness. She was treated for some months in this way and began making great improvement. When she was discharged, her relations with her parents were good, and she no longer voiced her delusional hostility against them. She gets along well with her parents.

After Treatment Has Started

Once treatment has started, it is the job of all relatives to see that everything is being done to help the patient get well. If the patient receives treatment at home, all the family must accept the fact that the patient is ill and be as considerate and cooperative as possible. They must help the patient decide what is real and what is not real. They must make it clear to the patient that they love and trust her, no matter what the patient might think at times, that they are trying to help in every way possible, and that they are making an effort to understand how the patient feels. They must act as a link between the patient and the community, at the same time making it clear to the community that the patient is ill and not a perverse person.

If treatment is given in hospital, relatives should visit frequently, bringing news from home, school, or friends. If visiting is impossible, they should write, telephone, or in other ways show their affection and concern. They should not make promises to visit that they cannot keep. When they see the patient, they should be interested in what the patient has to say and remain calm and reassuring. If the patient is confused because of ECT or drug treatment, they should reassure them that this is part of getting well. Maintaining this attention will be most difficult when patients must be treated in hospital from several months to several years. But relatives must not lose interest or drift away.

Patients are very often too sick to speak for themselves. If hospitals are overcrowded, show lack of concern in any way, and treat patients as though they are somewhat less than human, relatives should not be put off merely by statements that schizophrenia is a disease that 'prevents' better care. Some doctors and nurses once had, and still have, fantastic notions about schizophrenia. They may believe, for instance, as many once did, that if patients with schizophrenia refuse to wear clothes, it is because it is in the nature of some schizophrenics not to wear clothes. This is nonsense. It is in the nature of people with schizophrenia to be ill. If they will not wear clothes, it is because there has been a complete misunderstanding among hospital staff how to treat them.

In badly run hospitals, patients look shabby, dilapidated, and even ragged. In well-run hospitals, they may look ill and unhappy, as they often are, but they are dressed like everyone else, so that they need not feel ashamed or degraded when they begin getting better. In the Weyburn Hospital, it is often difficult to tell patients from visitors. Most female patients wear makeup, and their hair is neatly kept. All patients are allowed to wear the clothes they bring with them. It may be that in some hospitals the clothing is of such quality and style that even a normal person might prefer to be nude rather than wear it. It could even be that clothes are not provided often enough. Properly run hospitals have no patients who refuse to wear clothes.

It is a relative's duty and right to insist that the hospital will not hurt their loved ones, and that it will not add to the feeling of disgrace presently attached to the disease called schizophrenia. If the hospital is not doing its job – and its job is to give the patient the best possible care in pleasant, attractive surroundings – the relatives should make this emphatically known to their doctor, to the hospital superintendent, to their senators, congressmen, members of parliament, civic officials, and anyone else in a position to do something about it.

Relatives must not accept the often spurious claim that the government is giving the patient better care than could be found anywhere else. Governments like to deal with statistics that show their mental health programs are better than the mental health programs of any other government. This is not good enough. Relatives should demand that the care is as good as the care given to a neighbor who is in hospital with a duodenal

ulcer. A patient's relatives should, furthermore, be skeptical of the claim that governments are looking after all the needs of the mentally ill. If they were, there would be no need for mental health associations. Many of these are filling the gap in mental health services by providing rehabilitation services not given by governments, such as White Cross centers being operated by the Canadian Mental Health Association. Relatives can make their wishes known by supporting such an organization and seeing to it that it exerts pressure on reluctant governments on behalf of the mentally ill. Only when legislators realize that for each patient in hospital there are two or more ex-patients outside who vote, and numerous concerned relatives who support them, will there be a great change in mental hospitals.

After Discharge

Now the family member with schizophrenia is home from hospital. Relatives should continue to cooperate with the treatment, seeing to it that the discharged patient takes any prescribed medicine regularly, gets enough sleep, and so on. They might have to bear with the patient for a while and show patience. However, as the patient recovers, more can be expected of him and he can gradually be treated as any normal individual. It must now be accepted that the illness is in the past, and any of the ill behavior must be forgotten. The patient must be accepted as he is now and not as he was before.

The patient's past illness must never be used as a weapon against him, or to make him feel inferior. A relative must remember that his own genes are the same as the patient's and that the latter was ill because he happened to get a larger number of certain genes or inherited factors. This does not make him inferior any more than it makes a sane relative superior.

The Community

The community has responsibilities no less important than the family's. Unfortunately, it does not often realize it. It is said that no community is stronger than its weakest link. The effects of illness in one individual involve other members in ever-widening circles until everyone is directly or indirectly enmeshed.

Whole systems have been devised to pick up the pieces after sick members in our communities – police, police courts, and jails; welfare agencies,

including social aid; heavily staffed civil servant organizations; and private organizations, some of which are effective in planning their programs to encourage cure and rehabilitation, and some of which are ineffective, ignoring causes and treatment.

The trend seems to be to shift treatment responsibility to the community. More home care is needed because more patients are being discharged, yet they are not being cured. Better treatment would result in less time spent in hospital and less suffering and shame. It would make rehabilitation less essential and reduce the demands on the community.

The responsibility of the community is to:

1. Provide adequate hospitals.
2. Staff them with competent psychiatrists and adequate professional staff.
3. Encourage and demand effective treatment of the sick.
4. Accept them back as soon as they are ready without attaching any stigma to them, and help to rehabilitate them by providing jobs and homes.
5. Support research that will give us answers to puzzling questions.

When this is done, there will be a noticeable reduction in the efforts we must now make and the money we must now spend to endure sick people who have not been helped.

Your Role as a Patient

As a patient, you have a grave responsibility to yourself and to your family to get well. You will have no problem if you are convinced that you are ill. But no matter what you think, you must do all you can to accept the statement of your doctor that you are ill. And, of course, you have a right to know the name of your illness.

You should be honest and frank with your doctor. Give your doctor all the information you can about your illness and do not withhold any facts. But you are not obliged to tell anyone else about your hallucinations or delusions. As we have pointed out before, it is better to discuss some things only with those who you know will understand.

When a certain medicine is recommended, you must cooperate to the best of your ability by taking this medicine as prescribed for you. Some people are proud of taking "nothing stronger than aspirin." Some complain they are taking too many pills already. Either way, this is no excuse for refusing to take your medicine, for you may be hurting only yourself. This attitude is no more sensible than refusing to take insulin when one has diabetes.

If the doctor finds it necessary to treat you in hospital, you should ascertain what your legal rights are before you go there. If you find these are infringed upon, you should spare no effort to have this situation corrected. Patients' rights are violated in peculiar ways, and unless patients and their families do something about it, they will continue to be deprived of their rights as citizens of their own countries.

Legislation about mental patients is apt to be peculiar, and varies from state to state, province to province. In the Province of Quebec, at one time, for example, in order to get into a mental hospital, you had to create a public nuisance on the streets, get arrested, be put in jail, and only then, if found bizarre, were you allowed to go to hospital. In some parts of the United States, sanity hearings are required in court before you can be committed, and the presiding judge, himself a layman in these matters, makes the final decision, ignoring if he wishes the advice of a psychiatrist. Each state has its own laws on patient admission. In Saskatchewan, as in the United Kingdom, the laws have been modernized to permit a patient to enter hospital voluntarily. You can also be committed on complaint by a psychiatrist, a close relative, or another responsible person before a magistrate.

A more understanding society reduces the number of patients who have to be committed against their will. Voluntary admissions are the best kind of admissions from the point of view of human dignity and the willingness of the patient to undergo treatment. The patient who admits himself voluntarily can discharge himself at any time.

In some jurisdictions, patients do not have the right to vote while in hospital. Some medical professionals approve, saying that patients must be protected from the "pressure" of having to make up their minds for whom to vote. This is nonsense. Patients in mental hospitals should be allowed the same privileges of citizenship as anyone else, whether they wish to

make use of them or not. If patients had the right to vote while in hospital, governments might be more careful how they treat them. But if you have a grievance, you must be certain that it has a basis in fact and is not a delusion resulting from your illness. To make sure that you have real cause for concern, you should discuss these matters with your doctor, who will be well informed on the laws and regulations.

Again, we would like to remind you that you should insist upon receiving the best treatment possible. You should remember that your family is not to blame for your illness, and should try to spare them as much trouble as possible. You should not blame yourself for being sick, but must accept responsibility for doing something about it. Your responsibility to get adequate treatment is greater than that of your relatives since it is you who are sick, not them.

⑦ CAN SCHIZOPHRENIA BE PREVENTED?

Although we now know the causes of schizophrenia and therapies have been developed to treat this disease successfully, we do not know definitively how to prevent the onset of schizophrenia. One cannot prevent until one is able to predict. We can predict, for example, that chlorinating drinking water will prevent certain diseases in a population because we know what causes these diseases and we know that the chlorine treatment will remove these causes. We can predict that adding nicotinic acid to flour will practically eradicate pellagra because we know that the latter is a vitamin-deficiency disease. We know that vaccinating everyone with attenuated smallpox virus will eradicate smallpox because of its protective action in the body.

But we do not know how to prevent schizophrenia because there is no certain way to predict who will suffer from the disease. Our knowledge of the genetic inheritance that pre-disposes individuals to schizophrenia and our knowledge of the environmental factors that trigger the disease are not yet adequate. Based on what we do know about the biochemical causes of the disease, we could consider taking extraordinary measures and force everyone to take large quantities of nicotinamide each day, more than they

receive in the RDA amounts added to flour. This might well produce a marked decrease in schizophrenia over a period of years, though we suspect that the necessary legislation would be hard to pass in jurisdictions where pharmaceutical companies have vested interests in selling drugs. At present, it seems premature to get involved in this type of campaign to prevent schizophrenia.

Many other less scientifically based suggestions have been made for preventing schizophrenia, some sensible, some not.

1. Identify 'schizoid' children and give them psychotherapy. Since most 'schizoid' (quiet) children do not become schizophrenic, this prescription is useless. And even if they were destined for this disease, psychotherapy wouldn't help.

2. Treat all disturbed children in out-patient clinics. This is no better than the suggestion above, for no one has ever shown that schizophrenia can be prevented by psychotherapy of any sort. Of course, the suggestion would be helpful in creating a demand for more clinics, creating more jobs, and increasing the professional treating force. All we are saying is that this would serve no useful purpose in preventing schizophrenia.

3. Love all your children equally. Since there is no useful definition of love, this prescription is of no value. Even if it could be valuable, there is much evidence that whether or not we love our children makes any difference. It is, of course, desirable that parents love their children for moral, ethical, and many other reasons, but not because it will prevent them from becoming schizophrenic, for it won't.

4. Sterilize schizophrenic patients. Even if this were morally and ethically advisable, it would not decrease the incidence, for, as we have shown earlier, most patients who develop schizophrenia come from normal parents.

5. Change family structure. Some professionals say that the oldest child has the most stress, since the parents are inexperienced and the child has the most responsibility. Others claim that the youngest is dominated by the older children. Alternately, some claim that the parents wanted a girl to

follow the boy or vice versa. And let us not forget the middle child, who is said to have difficulties because the parents concentrate their love and attention on the older and younger ones. No one has yet come up with any practical suggestions for altering the sex or the order in which a child is born in the family, nor is there any evidence that family structure has a bearing on schizophrenia.

6. Reduce poverty. This is a very important function of society. Poverty is degrading and stifling to human energies and talents. Raising living standards is a worthwhile project in itself. So why look for reasons for tackling this great social problem other than it needs to be done? We have been told that eliminating poverty would reduce the incidence of schizophrenia, but we have found no connection between poverty and this disease. It does not seem likely that poverty 'breeds' schizophrenia but that badly treated schizophrenia leads to poverty. In curing schizophrenia, therefore, we might accomplish two things: get sick people well and reduce poverty.

7. Decrease stress. Since there is little evidence that stress can produce schizophrenia, it will make little difference if stress is decreased. Almost anything is called stress these days. If the patient's mother's death precedes the onset of the disease, this is stress. If the patient happened to be moving from one city to another at a crucial time in his health history, this is stress. If we look upon mortality and morbidity as true measures of stress, however, we find there is less stress in many Western cultures than in primitive or undeveloped societies. Yet the incidence of schizophrenia remains the same throughout the world. Finally, even if it were a significant factor, it is impossible to reduce stress quickly enough to do any one patient any good. Perhaps in several centuries stress will be under control, but none of us will live long enough to benefit.

8. Since schizophrenia cannot be prevented by these means, what can be done? Perhaps the day will come when malvaria tests, and other diagnostic tests still to be developed, will be as routine as TB tests are today. When that day comes, schizophrenia will no longer be the scourge it is now, and we will have come as close to prevention as possible.

Meanwhile, it is at least possible to prevent schizophrenia from becoming chronic with early diagnosis, effective orthomolecular treatment, and proper follow-up supervision. This is enough to restore many people with schizophrenia to normal and productive lives at home and in society.

HOD (HOFFER-OSMOND DIAGNOSTIC) TEST FOR SCHIZOPHRENIA

This inventory consists of numbered statements. Read each statement and answer it either True or False on the attached Answer Sheet according to how well it describes what is happening to you.

Example of how to record an answer
26. (T) F
37. T (F)

You are to put your answers on the answer sheet. Look at the example of the answer sheet shown at the right. If the statement is True as applied to you, draw a circle around the T opposite the number of that statement on the answer sheet. (See item number 26 at the right.) If, for example, statement number 37 is False as applied to you, draw a circle around the F opposite number 37 on the answer sheet. (See number 37 in the above example.)

Answer every statement.

Each statement in this questionnaire is numbered, but the numbers are not arranged in consecutive order. The order of the numbers in the booklet and on the answer sheet, however, are the same. In marking your answers on the answer sheet, be sure that the number of the statement in the booklet is the same as the number you are answering on the answer sheet. Erase any answer you wish to change. Do not make any marks on this questionnaire.

Remember, answer every statement as it applies to you, and be sure that the number of each statement in the booklet is the same number you are answering on the answer sheet.

NOW GO AHEAD.

47.	Some foods which never tasted funny before do so now.
143.	Most people hate me.
68.	There are some people trying to do me harm.
61.	I can no longer smell perfumes as well as I used to.
60.	I sweat much more now than when I used to.

59.	My body odor is now much more unpleasant.
134.	People interfere with my body to harm me.
66.	My mind is racing away from me.
81.	People are watching me.
73.	At times when I come into a new situation, I feel strongly the situation is a repeat of one that happened before.

10.	Sometimes I have visions of animals or scenes.
70.	I have a mission in life given to me by God.
2.	People's faces seem to change in size as I watch them.
86.	A dress is like a glove because they belong to women rather than because they are articles of clothing.
5.	People watch me all the time.

46.	I sometimes feel strange vibrations shivering through me.
15.	When I look at people they seem strange.
22.	Sometimes when I watch TV the picture looks very strange.
141.	I don't like meeting people – you can't trust anyone now.
117.	My hands or feet sometimes feel far away.

107.	Life seems entirely hopeless.
106.	I usually feel miserable and blue.
51.	Water now has funny tastes.
121.	I often hear my thoughts inside my head.
92.	An axe is like a saw because they have handles rather than because they are tools.

110.	I have to be on my guard with friends.
82.	A cow is like a horse because they are both in North America, not because they are both animals.

78. My thinking gets all mixed up when I have to act quickly.
126. Other people's cigarette smoke smells strange – like a gas.
50. I have more difficulty tasting foods now.

49. Foods taste flat and lifeless.
7. Most people have halos (areas of brightness) around their heads.
35. I have often felt that there was another voice in my head.
31. I now have more trouble hearing people.
140. I get more frightened now when I am driven in a car by others.

6. I feel rays of energy upon me.
28. I sometimes feel that I have left my body.
1. People's faces sometimes pulsate as I watch them.
123. I hear my own thoughts as clearly as if they were a voice.
109. I am often misunderstood by people.

45. I now have trouble feeling hot or cold things.
27. My hands or feet sometimes seem much too large for me.
39. I sometimes have sensations of crawly things under my skin.
64. At times my ideas disappear for a few moments and then reappear.
88. A pen is like a pencil because they are like sticks, rather than because they are used for writing.

85. A chair is like a table because they are usually used together rather than because they both have four legs.
84. A chair is like a table because they have four legs, not because they are usually used together.
19. Sometimes the world becomes very bright as I look at it.
133. Many people know that I have a mission in life.
80. Strange people or places frighten me.

21. Sometimes when I read the words begin to look funny – they move around or grow faint.
52. I can no longer tell how much time has gone by.
127. The world has become timeless for me.

116. I often become scared of sudden movements or noises at night.
43. I sometimes feel my bowels are dead.

58. My body odor is much more noticeable than it once was.
14. When I look at things like tables and chairs they seem strange.
37. I have heard voices coming from radio, television, or tape recorders talking about me.
137. People interfere with my mind to help me.
11. Sometimes I have visions of God or of Christ.

34. I often hear or have heard voices talking about or to me.
25. Pictures appear to be alive and to breathe.
145. I am not sure who I am.
138. I know that most people expect a great deal of me.
41. Some of my organs feel dead.

30. My sense of hearing is now more sensitive than it ever has been.
4. People watch me a lot more than they used to.
108. I am very painfully shy.
20. Sometimes the world becomes very dim as I look at it.
114. I am constantly keyed up and jittery.

54. Some days move by so quickly it seems only minutes have gone by.
3. People's eyes seem very piercing and frightening.
103. I very often suffer from severe nervous exhaustion.
36. I have often heard strange sounds, e.g. laughing which frightens me.
125. Cigarettes taste queer now.

32. I often have singing noises in my ears.
42. I sometimes feel my stomach is dead.
124. My bones often feel soft.
38. My sense of touch has now become very keen.
9. Sometimes I have visions of people during the day when my eyes are open.

100. A fly is like a tree because they both require humans rather than because they are living things.
17. Now and then when I'd look in the mirror my face changes and seems different.
8. Sometimes I have visions of people when I close my eyes.
16. Often when I look at people they seem to be like someone else.
33. I often hear or have heard voices.

111. Very often friends irritate me.
40. I sometimes feel rays of electricity shooting through me.
101. A fly is like a tree because they both are living things rather than because they both require humans.
71. At times some other people can read my mind.
120. When I am driving in a car objects and people change shape very quickly. They didn't used to.

75. I am now much more forgetful.
56. I have much more trouble getting my work done on time.
115. Sudden noises make me jump or shake badly.
55. I have much more trouble keeping appointments.
90. An orange is like a banana because they both have skins rather than because they are fruit.

98. Praise is like punishment because they both start with p rather than because they are given to people.
132. People are often envious of me.
62. Foods smell funny now.
136. People interfere with my mind to harm me.
69. There is some plot against me.

76. I now am sick.
118. My hands or feet often look very small now.
94. The eye is like the ear because they are on the head rather than because they are sense organs.
89. A pen is like a pencil because they are both used for writing rather than because they both are like sticks.
113. I am often very shaky.

104.	I very often have great difficulty falling asleep at night.
48.	I can taste bitter things in some foods like poison.
130.	People look as if they were dead now.
112.	My family irritates me very much.
139.	Lately I often get frightened when driving myself in a car.
13.	Sometimes I feel very unreal.
119.	Cars seem to move very quickly now. I can't be sure where they are.
23.	Sometimes I feel there is a fog or mist shutting me away from the world.
91.	An orange is like a banana because they are fruit, not because they both have skins
93.	An axe is like a saw because they are tools rather than because they have handles.
87.	A dress is like a glove because they are articles of clothing rather than because they are owned by women.
95.	The eye is like the ear because they are sense organs rather than because they are on the head.
102.	I very often am very tired.
53.	The days seem to go by very slowly.
24.	Sometimes objects pulsate when I look at them.
129.	Other people smell strange.
44.	I sometimes feel I am being pinched by unseen things.
18.	My body now and then seems to be altered – too big or too small, out of proportion.
135.	People interfere with my body to help me.
122.	I often hear my own thoughts outside my head.
57.	Things smell very funny now.
144.	I find that past, present and future seem all muddled up.
12.	Sometimes the world seems unreal.
105.	I usually feel alone and sad at a party.
131.	I feel as if I am dead.

29. I often feel I have left my body.
26. I often see sparks or spots of light floating before me.
97. Air is like water because they are needed for life rather than because they are both cold.
99. Praise is like punishment because they are both given to people rather than because they start with the letter p.
65. I am bothered by very disturbing ideas.

83. A cow is like a horse because they are animals, not because they are in North America.
128. Time seems to have changed recently, but I am not sure how.
79. I very often get directions wrong.
72. I can read other people's minds.
77. I cannot make up my mind about things that before did not trouble me.

74. I now become easily confused.
63. At times my mind goes blank.
142. More people admire me now than ever before.
96. Air is like water because they are both cold rather than because they are needed for life.
67. At times I am aware of people talking about me.

HOD ANSWER SHEET

Name _____

Sex _____ Age _____ Date _____

47. T F	110. T F	21. T F	32. T F	76. T F	57. T F
143. T F	82. T F	52. T F	42. T F	118. T F	144. T F
68. T F	78. T F	127. T F	124. T F	94. T F	12. T F
61. T F	126. T F	116. T F	38. T F	89. T F	105. T F
60. T F	50. T F	43. T F	9. T F	113. T F	131. T F
59. T F	49. T F	58. T F	100. T F	104. T F	29. T F
134. T F	7. T F	14. T F	17. T F	48. T F	26. T F
66. T F	35. T F	37. T F	8. T F	130. T F	97. T F
81. T F	31. T F	137. T F	16. T F	112. T F	99. T F
73. T F	140. T F	11. T F	33. T F	139. T F	65. T F
10. T F	6. T F	34. T F	111 T F	13. T F	83. T F
70. T F	28. T F	25. T F	40. T F	119. T F	128. T F
2. T F	1. T F	145. T F	101. T F	23. T F	79. T F
86. T F	123. T F	138. T F	71. T F	91. T F	72. T F
5. T F	109. T F	41. T F	120. T F	93. T F	77. T F
46. T F	45. T F	30. T F	75. T F	87. T F	74. T F
15. T F	27. T F	4. T F	56. T F	95. T F	63. T F
22. T F	39. T F	108. T F	115. T F	102. T F	142. T F
141. T F	64. T F	20. T F	55. T F	53. T F	96. T F
117. T F	88. T F	114. T F	90. T F	24. T F	67. T F
107. T F	85. T F	54. T F	98. T F	129. T F	
106. T F	84. T F	3. T F	132. T F	44. T F	
51. T F	19. T F	103. T F	62. T F	18. T F	
121. T F	133. T F	36. T F	136. T F	135. T F	
92. T F	80. T F	125. T F	69. T F	122. T F	

RECOMMENDED READING

Bravermanm, E.R. and Pfeiffer, C.C. *The Healing Nutrients Within: Facts, Findings and New Research on Amino Acids.* New Canaan, CT: Keats, 1987.

Carrigan, C. *Healing Depression.* Santa Fe, NM: Heartsfire Books, 1997.

Cheraskin, E., and Ringsdorf, W.M. *New Hope for Incurable Diseases.* New York: Exposition Press, 1971.

Cheraskin, E., Ringsdorf, W.M., et al. *The Vitamin C Connection.* New York, NY: Harper and Row, 1983.

Cott, A., Agel, J., et al. *Dr. Cott's Help for Your Learning Disabled Child: The Orthomolecular Treatment.* New York, NY: Times Books, 1985.

Edelman, E. *Natural Healing for Schizophrenia.* Eugene, OR: Borage Books, 1996.

Hippchen, L.J. *Holistic Approaches to Offender Rehabilitation.* Springfield, IL: CC Thomas, 1982.

Hoffer, A. *Vitamin B-3 & Schizophrenia: Discovery, Recovery, Controversy.* Kingston, ON: Quarry Health Books, 1997; rpt. 2002.

Hoffer, A. *Hoffer's Laws of Natural Nutrition: Eating Well for Pure Health.* Kingston, ON: Quarry Health Books, 1996; rpt. 2001.

Hoffer, A. *Dr Hoffer's ABC of Natural Nutrition for Children with Learning Disabilities, Behavioral Disorders, and Mental State Dysfunctions.* Kingston, ON; Quarry Health Books, 1999; rpt. 2001.

Hoffer, A. and Pauling, L. *Vitamin C & Cancer: Discovery, Recovery, Controversy.* Kingston, ON: Quarry Health Books, 2000.

Holford, P. *Mental Health: The Nutrition Game.* London, UK: ION Press, 1996.

Horrobin, D.F. *Omega-6 Essential Fatty Acids.* New York, NY: Alan R. Liss, 1990.

Horrobin, D. *The Madness of Adam and Eve: How Schizophrenia Shaped Humanity.* New York, NY: Bantam, 2001.

Huemer, R.P. *The Roots of Molecular Medicine: A Tribute to Linus Pauling.* New York, NY: WH Freeman, 1986.

Jansen, M. *The Vitamin Revolution in Health Care.* Greenville, NH: Arcadia Press, 1996.

Kunin, R. *Meganutrition For Women.* New York, NY: McGraw Hill, 1983.

Manthey, M. *Nature's Medicine Handbook for People Over 50.* Kent, WA: The Foundation for Excellence in Health Care, 1998.

Pauling, L. *How To Live Longer and Feel Better.* New York, NY: WH Freeman, 1986.

Pfeiffer, C.C. *Mental Illness and Schizophrenia: The Nutrition Connection.* London, UK:. Thorsons, 1987.

Reed, B. *Food, Teens and Behavior.* Manitowoc, WI: Natural Press, 1983.

Rudin, D. *Omega-Oils: A Practical Guide.* Garden City, NY: Avery Publishing Group, 1996.

Segal, D.S., Yager, J., and Sullivan, J.L. *Foundations of Biochemical Psychiatry*. Boston: Butterworth, 1976.

Stone, Irwin. *The Healing Factor: "Vitamin C" Against Disease.* New York: Grosset and Dunlap, 1972.

Smythies, J.R. *Every Person's Guide to Antioxidants*. New Brunswick, NJ: Rutgers University Press, 1995.

Werbach, M.R. *Modern Treatment for Persistent Symptoms*. New York, NY: Routledge & Kegan Paul, 1986.

Werbach, M.R. *Nutritional Influences on Illness*. New Canaan, CT: Keats, 1990.

Williams, Roger J. *Nutrition Against Disease*. New York, NY: Pitman, 1971.

Williams, R.J. and Kalita, D.K. *A Physician's Handbook on Orthomolecular Medicine*. New York, NY: Pergamon Press, 1977.

Québec, Canada
2007